Life 24× a Second

Life 24× a Second

Cinema, Selfhood, and Society

ELSIE WALKER

OXFORD
UNIVERSITY PRESS

Oxford University Press is a department of the University of Oxford. It furthers
the University's objective of excellence in research, scholarship, and education
by publishing worldwide. Oxford is a registered trade mark of Oxford University
Press in the UK and certain other countries.

Published in the United States of America by Oxford University Press
198 Madison Avenue, New York, NY 10016, United States of America.

© Oxford University Press 2024

All rights reserved. No part of this publication may be reproduced, stored in
a retrieval system, or transmitted, in any form or by any means, without the
prior permission in writing of Oxford University Press, or as expressly permitted
by law, by license, or under terms agreed with the appropriate reproduction
rights organization. Inquiries concerning reproduction outside the scope of the
above should be sent to the Rights Department, Oxford University Press, at the
address above.

You must not circulate this work in any other form
and you must impose this same condition on any acquirer.

Library of Congress Control Number: 2023043005

ISBN 978–0–19–760092–4 (pbk.)
ISBN 978–0–19–760091–7 (hbk.)

DOI: 10.1093/oso/9780197600917.001.0001

Paperback printed by Marquis Book Printing, Canada
Hardback printed by Bridgeport National Bindery, Inc., United States of America

In memory of Danijela Kulezic-Wilson
"i carry your heart(i carry it in my heart)"

Contents

Acknowledgments ix

 Introduction: Cinema Is Life 1

1. Black Lives Matter, Talking Back, and the Life of *BlacKkKlansman* 24

2. Levels of Listening to *Nobody Knows*: Uniting Personal Experience, Pedagogical Practice, and Social Purpose 52

3. HeartMath: Listening to the Organ of Fire and *Dancer in the Dark* 78

4. Hearing Life in the Midst of Death: Psychological Healing within *Life of Pi*, *Ikiru*, and *A Star Is Born* 106

5. Turning the Microphone Around: Hearing from Alumni 142

6. Life After Life: Rehearing *Call Me By Your Name* and *Portrait of a Lady on Fire* 178

Notes 191
Select Bibliography 213
Index 215

Acknowledgments

I must begin by thanking senior editor Norm Hirschy for his leadership and care. He has been a steadfast guide to me for over ten years, and I am deeply thankful for that. I also thank the reviewers he found for my book proposal: they led me to push myself further than I thought I could, and all of their suggestions have had decisive and lasting influence on me.

I feel deep gratitude to many scholars who have helped me develop my writing and take new risks with it. First, I thank the founding and groundbreaking creators of the *Music and the Moving Image* (MaMI) conference at New York University and its associated journal of the same name (published by the University of Illinois Press): Ron Sadoff and Gillian Anderson. They have led and fostered a community of scholars who have inspired me every year since 2009. There are too many friends and trailblazers to mention here, so I simply thank every single person in the *MaMI* collective whose work is crucial to the life of my mind. Some people I have met at *MaMI* have become very special friends, and their faith in me has helped me stay focused, even through the challenges of the COVID-19 pandemic and my related anxieties about doing work that matters in a real-life way: Katherine Spring, Randolph Jordan, Robynn Stilwell, and the legendary Claudia Gorbman.

I thank a kindred spirit I have never met in person but whose life has become a sustaining part of mine: Kristi McKim. I thank my friend Meredith Patterson for generously educating me about the psychology of subjective time, and I thank Adrienne Shoch for introducing me to the strength of HeartMath. I am profoundly thankful for my friend and colleague Ryan Conrath—I never imagined I would find an intellectual brother at this point in my life. I must also thank David Johnson for his great kindness as a friend and colleague: the fact of our working closely together for twenty years astonishes me. I cannot encapsulate the significance of what we have lived through and worked out together.

I am forever grateful to Maarten Pereboom, dean of the Fulton School of Liberal Arts at Salisbury University, for his unwavering support and belief in the worthiness of my research. Thanks to the Fulton School for a course release during the fall of 2022 to work on this book, and to the Salisbury

University Mini-Grant Program for sponsoring my survey study with alumni, as well as the Institutional Review Board committee of Salisbury University who approved that part of my research. Thank you to all my former students who participated in my survey for this book, and whose heartfelt responses exceeded all my greatest expectations.

I am grateful to some extraordinary women who have sustained me more than they know. They show me how to live in terms of integrity and selflessness (Chin-Hsiu Chen), honesty and humility (Jennifer Fleeger), speaking out and listening well (Annette Johnson) and unconditional love (Kat Dwyer). Throughout this book, I honor the values of these great friends. I also pay tribute to those dearly departed teachers who continue to propel me forward: Bryan Burns, Michael Hattaway, Colin MacMillan, and Terry Sturm. I thank them for all their lessons on the transformative power of art. I face their images in my office, and I feel them making me braver while I write. The images of my late parents (Varvara Richards and Marshall Walker) are there too, silently urging me on. Meanwhile, my family keeps me in the land of the living with earth-bound but boundless joy. I cannot fully express all that I feel for my husband, James (Jim) Burton, and my children, Charlie Hope and Dorothy Jane. With care, patience, energy, hope, and love, Jim has made it possible for me to write this book and be true to myself with every chapter. I am not sure he knows how much I needed him throughout the whole process. Charlie and Dorothy have always heard about this book with curious glee, and they are excited to be in these acknowledgments: one day I will be able to explain how their influence is in *every line I've written*.

This book is dedicated to the best friend I ever had: Danijela Kulezic-Wilson. Right up until her death in 2021, Danijela and I were talking about this book and she knew it was dedicated to her. I am still floored by her generosity in wanting to read chapter drafts when her time was running out, although she knew her opinion mattered the most of all to me. Danijela taught me how to hear films better, breathe deeper, trust my heart more, and accept life in all its complexities and death with all its pain. She showed me the beauty in all extremities of feeling, as well as leading me to understand that small joys can turn into big things. I am forever grateful for her being. This book is the best way I can express my love for the ideals she embodied and that shape my life now. Dear Danijela, thank you for making me "free in the knowledge that everything is change."

Introduction

Cinema Is Life

That nothing is static or fixed, that all is fleeting and impermanent, is the first mark of existence.

—Pema Chödrön[1]

The feeling when you step out of the cinema can result in a new realization, a change, "a little knowledge." Why do we feel this way? What does film do to create this feeling? It appears that film, in some of its forms, can rejig our encounter with life, and perhaps even heighten our perceptual powers.

—Daniel Frampton[2]

Even when I am surrounded by death, cinema sustains my life. As moving pictures, cinema records the flux that is the inescapable truth of my being in the world. Nevertheless, if I delve into how cinema connects me to others' lives, affirms my own life, and helps me live a better life for myself and others, I gain a foothold in something lasting. I have never been more aware of the importance of this than during the first months of the global COVID-19 pandemic in 2020. In *Braving the Wilderness*, Brené Brown explains that isolation can be a bigger threat to our health and longevity than air pollution, obesity, or excessive drinking.[3] During the pandemic, and along with millions of others, I was tested by the necessity of sudden isolation for an indeterminate period of time: the incremental impact of living away from others day after day was a new and increasingly bleak reality. Cinema helped my students and me stay anchored in what brought us together, and what connected us to the rest of the world, even while we were feeling the necessary physical separations of social distancing, sheltering in place, and remote learning.

Life 24× a Second. Elsie Walker, Oxford University Press. © Oxford University Press 2024.
DOI: 10.1093/oso/9780197600917.003.0001

In the immediate throes of the pandemic I began teaching all my classes virtually, replacing in-class conversations with scheduled Zoom meetings. More than ever before, I was grateful to talk with my students about the films I assigned them from week to week. I held on fiercely to the moments of those films that we agreed were most important. I also knew that many of my students were more delighted to talk in class than before the pandemic, while others preferred to contribute silently, but nonetheless meaningfully, to the Zoom chat. I realized that our conversations were sustaining me in my new pandemic life as well as feeding the lives of my students. Several students wrote me private messages about how they would have "gone crazy" without our Zoom classes.

With the transition to Zoom teaching, I heard my students differently. Their voices were all at mezzo-forte range through the equalizing Zoom audio. Since Zoom has a distorting effect on sonic overlaps, my students and I had to stop interrupting each other, even slightly. We weighed our words more carefully as a result. This slowed the rhythm of our conversation and made us more intentional about every utterance. We talked through our separate film experiences that happened in various locations, where before we had been together for the course screenings. We shared more individualized reflections in a new virtual space of shared screens.

The films we analyzed after the lockdown of March 2020 resonated in terms of our altered lives: for example, when we talked about *Lion* (2016), the students' reactions to Saroo's lost calls for his biological mother and brother took on special poignancy in the context of our knowing that millions of Americans had been suddenly separated from their loved ones.[4] Even the films I had taught my students of International Cinema *before* that first lockdown resonated anew. We revisited the lessons we had learned and the strength we could draw from our shared memories of *Babies* (2010), *Romuald et Juliette* (1989), *La haine* (1995), *Nobody Knows* (2004), and *Secrets and Lies* (1996). *Babies* offers moment-to-moment intimacy with its primary subjects, including many long takes that revel in the wonder of their existences. The babies are usually shown through medium close-ups and with restricted points of audition that match their undeveloped capacities for seeing and hearing. The documentary encouraged my students and me to appreciate the fragility and the gift of life, both of which meant more with the threat of the pandemic looming over us. *Romuald et Juliette* is a playful masterclass on the value of self-conscious optimism, offset by its candid exploration of racism in mainstream French society.

The first scene shows Juliette, a Black single mother returning home from her janitorial nightshift to care for her five children in a cramped apartment, and the last scene shows Juliette happily married to her white corporate boss, pregnant with their baby, and celebrating their blended/biracial family in their newly acquired countryside mansion. Both the beginning and end are accompanied by an upbeat track performed by Gunter Carr, "We're Gonna Rock," suggesting that the utopian ending was possible from the start. The neat fantasy of *Romuald et Juliette* inspired my students and me while the mundane details of our former lives, like going to the supermarket for essentials or handling mail responsibly, had become potentially dangerous. *La Haine* shows a society on the brink of one inhumane act of violence after another while systems of justice fail: a grim voiceover bookends the film with the story of a man falling from a skyscraper and telling himself "so far, so good" as he plummets through the air. Through the intensely amplified sonic motifs of clocks ticking, sounds of gunfire, and an onscreen DJ's mash-up of Edith Piaf's "Je ne regrette rien" with N.W.A.'s "Fuck the Police" that rings out across a housing estate of the *banlieue*, the film foregrounds volatile social divisions determined by race and class. With the pandemic, I felt duty-bound to make my students more aware of the abuses of power that perpetuate extreme racial and class-based inequities, especially as the effects of COVID-19 hurt minority populations disproportionately. *La haine*'s resonance beyond its own time was most obvious to my students because the Black Lives Matter movement was rising through 2020.[5] *Nobody Knows* is about cherishing the value of human lives, no matter how poor or confined, and the beauty of children who find joy in simple pleasures like using crayons, watching plants grow, and feeling fresh air. The original, sweetly melodious music by the guitar duo Gontiti honors the suffering of the children and the beauty of their existence with compassion. The film made my students and me talk about the reality of widespread child poverty in Japan and the importance of engaging with such faraway problems. In keeping with our conversation about *Nobody Knows*, the first months of the global pandemic prompted us to be more conscious of our small treasures at home, more compassionate with each other, and more cognizant of ourselves as part of a global population that could only prevail with the biggest collective effort. *Secrets and Lies* stresses the importance of telling the truth to loved ones and trusting that they will hear it. As I discussed with my class, living through a disaster requires that we be nothing less than honest with the people we hold dearest. Moreover,

living in perpetually close quarters with our families can mean having to reassess everything, redefine relationships, make things clearer, and say the things that need to be said to release the pressure within. As the main male character, Maurice, cries out, "We're all in pain! Why can't we share our pain?" Talking about all these wildly different films with my students during the first pandemic lockdown had a leveling effect: along with our being mindful of their individual contexts and resonances, we could perceive them all as pain-acknowledging *and* life-sustaining gifts.

Brown argues that "art has the power to render sorrow beautiful, make loneliness a shared experience, and transform despair into hope ... Music, like all art, gives pain and our most wrenching emotions voice, language, and form, so it can be recognized and shared ... the magic of all art [is] the ability to both capture our pain and deliver us from it at the same time."[6] This book, *Life 24× a Second*, focuses on how some films give voice, language, and form to pain. I explain how they uplift me even when they dwell on sadness. They deliver me from pain because they remind me of what connects me to other human beings. I connect with the films themselves as active beings too. I have developed attachments to them that deepen because I replay and teach them: as Danijela Kulezic-Wilson puts it, films can be much more than "one-night-stands." After the spark of meeting a film, the audioviewer can decide to stay with that film to form a loving relationship with it: "Intimacy is won through investing time, patience, and genuine interest in the other (or, in this case, something)."[7]

I am most inspired by my students—having taught university courses for twenty years, I know that they embrace films with which they can form immediate *and* lasting emotional attachments. I encourage my students to talk about what they bring *in* to each film experience, before asking them to explore what each film is bringing *to them* that they could not know ahead of time. Echoing Ann-Marie Dunbar's approach to teaching multiethnic American literatures, I teach cinema to inspire a particular "ethics of knowledge" that entails making my students "more self-conscious, ethical readers, with a much clearer sense of their own positionality in relation to textual others."[8] Without wanting to homogenize "important racial, ethnic, cultural, and historical differences,"[9] I stress that my students can and should explore why films speak to them on their own unique situational and experiential terms. At the start of class discussions, I often invite my students' individualized responses as jumping-off points, which then leads to their being more willing to meet a given film within its own specific cultural and

historical contexts of production. In other words, the individual gains lead to greater social curiosity and consciousness.

My belief that each one of us fuses our reading of a film with our individual subjectivity is hardly a new one—nearly fifty years ago, Christian Metz wrote of the diegetic world as "a reality that comes only from within us, from the projections and identifications that are mixed in with our perception of the film."[10] That said, the personal position of the scholar is still rarely given more than passing acknowledgment in most film criticism, even though it drives so much of pedagogical practice. I believe that a professor must frequently meet the students *where they are* before those students will become truly invested in the discussion of a film's significance beyond themselves. In addition, I suspect that many professors besides me find that students respond most fully and wholeheartedly when they themselves make their personal investment in the films they select for courses absolutely clear. I introduce every film to my students like a person I have formed an attachment to, harkening back to Kulezic-Wilson's observation that some films invite us to have relationships with them. "I don't expect you to necessarily *like* every film I've chosen for you," I tell my students, "but I ask you to keep an open mind about each encounter, as if you were meeting a friend-of-a-friend for the first time."

This book takes shape from my combination of personal investment, teaching practice, and scholarly research. I believe the extreme times we are living in demand such an integrated approach. Just as I have needed to reassess and redefine why I continue to love, teach, and write about cinema while "America is on fire,"[11] I owe it to my students to communicate the profoundly positive impact that many forms of cinema can have in the midst of so much social turbulence requiring our most urgent attention. In her book of teachings, *The Places That Scare You*, the Buddhist nun Pema Chödrön repeatedly encourages us to break from "habitual reactions" so that we may recognize our own struggles and the struggles of others with greater compassion. Here, I am breaking from my own "habitual reactions" that are borne of scholarly tradition.

The writings of Brown, Chödrön, and Kulezic-Wilson encourage me to take new risks in my own work, and to celebrate the enlivening emotional impact that films have on my students and me. This is after my having consulted affect theory for a scholarly way to write about such impact without being too informal or "touchy-feely." I assumed that this theory would bring me closer to explaining the power of those film moments that have stayed with me most

movingly and lastingly. More personally, I wanted better tools for explaining the significance of films that "speak" to me in relation to how I define myself: a mother, a daughter whose parents have died, and a professor who wants to inspire others to combine their personal and pedagogical knowledge in boldly direct ways. However, I have discovered that many writings of affect theory (or perhaps more accurately, approaches to defining affect theory) move me further and further away from the cinematic moments of emotional impact that mean the most to me, in the service of pinpointing generalized audiences' responses in complex philosophical and scientific terms, and often in terms of what bodies involuntarily *or unthinkingly* do. Donovan O. Schaefer's *The Evolution of Affect Theory* is a good representative example in that he stresses how human "bodies are impelled by forces other than language or reason."[12] In other recent affect theory, I notice a prevalent distrust about focusing on audience's emotional responses to works of art for fear of seeming undisciplined or biased at the expense of broader contextual specificities and pregiven potentialities within cultural frameworks that bear upon every individual. For example, in their introduction to the anthology titled *How to do things with affects: affective triggers in aesthetic forms and cultural practices*, Ernst van Alphen and Tomáš Jirsa criticize the looseness with which the term "affect" is commonly applied, with the goal of restoring rigor to its usage. Their collection of essays explores how specific affects "operate" and "trigger" audiences, through intersecting "aesthetic forms, media strategies, and social arrangements." More specifically, they place emphasis on "shifting the focus from individual experiences and the human interiority of personal emotions and feelings towards the agency of cultural objects."[13] To take another recent example, in *The Forms of the Affects*, Eugenie Brinkema argues for the "autonomous potentiality" of films with inherent affects irrespective of an audience's individual "kinesthetic strivings and pleasures."[14] She pays uncommonly exacting attention to the formal properties of films to challenge the "subjective, vague accounts of a reader's or critic's feelings."[15] Though I share her zest for close analysis, our approaches diverge when it comes to encountering the same cinematic information. I use her discussion of a scene from *Funny Games* (1997) after the young son is murdered as an instructive example. Brinkema describes the scene's stylistic elements that show "the bending of cinematic form to the heavy shape of grief."[16] She demonstrates painstaking care for the "painterly and theatrical" composition of the scene, and the power of Haneke's long take that allows ample time for the attentive audience to perceive every detail, including: the bent corpse

and splayed limbs of the dead son, the lines of the mother's body bent forward in grief, the "gauzily muted" palette of the *mise-en-scène* offset by the bright light of a knocked-over lamp in parallel to the mother's bent body, the tight framing of the living room without showing its doorways leading out, the "minutes-long poses" of the parents, and the windows bracketing "rectangles of darkness" along the main wall.[17] Brinkema sees no representation of interiority here. The human body is turned from a living thing to "a plastic form, made to exhibit the force of grief as a representational problem of line and curve for the arrangement of elements in the tableau."[18] Though I accept her emphasis on how *Funny Games* represents grief through external representation, as opposed to pulling us close to its characters on visual, psychological, or cathartic levels during their worst living nightmare, I still honor my interior and subjectively lived response to it. I embrace that which she does not: the metaphysical, physical, personal, and pedagogical significance of this scene for myself as a self-aware individual forming a relationship with the film, even while knowing that it resists my urge to engage with the characters as fully fleshed-out beings. I use the same details she provides to reflect on what the scene represents to me as a mother who cannot imagine losing her children, how the heavy silence enters my body and folds me into the mother's shock, how my students have responded to being held captive in the parents' grief, and how Haneke himself makes me think on the death of a single child, which has radical significance within the genre of the family-in-peril horror that rarely shows something so unthinkable. I have positioned the film carefully in my undergraduate course about film genres and in terms of real-world ethical stakes.[19] My goal here is not to generalize about or disparage the important and wide-ranging scope of affect theory, but I do find it curious that recent affect theorists show great caution about seeming too overtly caught up in ways that films move individual audioviewers (*including* themselves), as if personal revelations were inherently untrustworthy or flimsy.

By honoring my personal revelations about a film, I hopefully inspire my students and other scholars to honor their own. When I love a film, I want to get closer to it in every way and I feel no shame in disclosing this desire. While I do not read my relationship with that film as necessarily representative, I recognize the integrity of my relationship with it as a distinctly meaningful event. That initial spark I feel upon a first audioviewing turns into an evolving relationship that can only belong to the film and me, even if it parallels the relationships that many others form with that same film.

Hirokazu Kore-eda, the director of *Nobody Knows*, says, "The movies I hope to make start to grow inside you after the closing credits. In a way, they start the minute the movie is over."[20] I devote a chapter to *Nobody Knows* because it has indeed grown inside me over the last few years, but this statement applies to *every other* film I dwell on through this book, including (in order of my analyses): *Imitation of Life* (1959), *BlacKkKlansman* (2018), *Dancer in the Dark* (2000), *Life of Pi* (2012), *Ikiru* (1952), *A Star Is Born* (2018), *Call Me By Your Name* (2017), and *Portrait of a Lady on Fire* (2019). The protagonists in all of these films suffer through extreme circumstances: the Black woman rejected by her daughter who passes as white (*Imitation of Life*), the African American detective who infiltrates the Ku Klux Klan (*BlacKkKlansman*), the family of children living in extreme poverty (*Nobody Knows*), the woman on death row (*Dancer in the Dark*), the sole survivor of a shipwreck (*Life of Pi*), the old man living for others after being diagnosed with terminal cancer (*Ikiru*), the alcoholic who commits suicide and the widow who survives him (*A Star Is Born*), and the young adults learning to keep living after their first and deepest lover affairs are over (*Call Me By Your Name* and *Portrait of a Lady on Fire*). Despite the extremity of these characters' stories, I do not find the films exploitative because they move me with a purpose: each one trusts that I will be *listening* to it, and that I will be then inspired toward effecting compassionate change for myself and for others. I write of listening to these films as a literal and symbolically meaningful action. Each sound track enters my body and also makes me absorb the construction of its world and all the implications within its sonic dimensionality by extension. Each film presents despair along with the anticipatory hope that I am listening on literal and metaphysically transformative levels. This is the life-affirming pattern that I hear, internalize, and share with my students.

I have chosen to teach every one of the films I analyze in this book, while knowing they are all designed to provoke extremely heightened emotional responses. Every film has therefore presented me with the challenge of making sure my students feel safe enough to fully engage with them. Sometimes I have been nervous about playing these films for fear of the impact they might have, but I have always introduced them as forms of life that just might change my students' lives. Several of the films are manifest tearjerkers: from the melodramas of *Imitation of Life*, *Dancer in the Dark*, and *A Star Is Born*, to the love stories of *Call Me By Your Name* and *Portrait of a Lady on Fire*, to the gut-wrenching dramas of *Ikiru* and *Nobody Knows*. I embrace how these films move me without embarrassment, and I teach

them with open-hearted devotion, but I also know that many other scholars might view their poignancy more critically. After all, there is a longstanding tradition of scholars who routinely undermine those films that are designed to be extremely moving. Robyn R. Warhol explains that "the common names for genres that typically invoke crying carry connotations so negative as to require no comment": "tearjerkers" are also known as "sentimental drivel," "five-handkerchief movies," and "women's weepies." After establishing "the prevailing prejudice" against "effeminate crying," Warhol argues that "feminist film theory—with its psychoanalytically inspired tendency to read women's crying over films as a masochistic pleasure and films' manipulation of women's sentiments as a form of textual/sexual violence—has not done much to ameliorate the negative associations of crying over stories."[21] Other scholars go so far as to prejudge the audiences who enjoy tearjerkers. For example, Wyatt Moss-Wellington argues that tearjerking films provide "a safe place to exercise and explore one's affective extremities." He writes of "our" self-indulgent and self-flattering enjoyment of such films as follows: "Emotions elicited by fiction can . . . reinforce a sense of identity: if we identify as a 'deep feeling' person, we might enjoy rehearsing these responses by watching tearjerker films, as the emotion itself reinscribes a grander autobiographical narrative about our own appropriate responses to the world's ills."[22] In the absence of real threat in many people's everyday existences, Moss-Wellington argues that tearjerkers have additional inherent appeal because they provide scope for injecting drama into our own lives: we can get "pleasure, gratification and enjoyment" from "having our buttons pushed."[23] His terms of argument suggest that audioviewers readily give themselves over to deliberate self-indulgence over and above nobler goals of engaging with the lives of others and/or knowingly improving themselves through engagement with others' representations of the world. By contrast with Moss-Wellington, Warhol argues that "we don't have to be embarrassed when our tears remind us that we are living in bodies," and she "envision[s] a community empowered by a relationship to sentimental texts that is both visceral and self-aware, fully conscious of how strategies 'get to us,' and free to enjoy the physical act of crying. If we can dispel that sense of embarrassment and isolation associated with textually induced tears, our potential for participating in the transformation of culture and society will be that much more powerful."[24]

Following from Warhol, I believe in the transformative power of all those films I analyze, and I also create a classroom space where my students can

respond freely to them without fear of judgment from me. Equally, I do not regard our collective emotional responses as endpoints but experiences that just might "rejig our encounter with life," as Daniel Frampton puts it. The emotions my students and I share through films hopefully lead us to new understandings of ourselves and others, including the values and possibilities we want to embody in the world at large. As Florian Cova, Julien Deonna, and David Sander put it, moving narratives frequently provide occasion to "reflect on our condition as human beings and to reflect on what makes our life meaningful."[25] Based on their study of audience responses to extracts from select films (ranging from 2009's *Up* to an unidentified documentary showing the birth of a baby) Cova et al. have found that being moved by a film typically leads an audience to perceive it as "deep," which in turn prompts their further reflection. Therefore, they argue that being moved plays a major role in the "eudaimonic gratification" of sad narratives.[26] This is a useful counternarrative to the dominant writing on tearjerkers that dismisses their value.

Talking Back to Death

I focus on films that have transformatively intense value for me, prompt my deep reflection long after they finish, resonate with my own life and the lives of others, sustain me through adversity, help me make sense of real-life and emergent realities as well as the histories I know, and move me toward different socially awakened futures that are more hopeful, informed, compassionate, and humane. Therefore, why would I ever equate cinema with death? Ironically, for sixteen years, Laura Mulvey's landmark book that defines cinema as a form of inescapable and relentless death—*Death 24× a Second*—has been uncontested.[27] Her book is my first inspiration for creating this one: *Life 24× a Second*.

With her title *Death 24× a Second*, Mulvey references Jean-Luc Godard's *Le Petit Soldat* (1960), in which the protagonist, a photojournalist named Bruno Forestier, declares "photography is truth and cinema is truth 24 times a second." Bruno makes this statement to his love interest, Veronica, while photographing her with the camera that he believes can capture her soul. In speaking of "truth 24 times a second," Bruno alludes to the material reality of celluloid cinema that is static images projected at the rate of 24 frames per second. For Mulvey, the consequent illusion of movement makes cinema

a disturbingly deceptive impression of life and every cinematic 24th of a second presents the latent threat of a return to deathly stillness. Therefore, Mulvey argues that the answer to the question "what is cinema?" should be "death 24 times a second."[28] She places cinema on a time-bound continuum with the death photograph that replaced the death mask as a way of embalming time.[29] For Mulvey, even the most famous movie stars, people whose onscreen presences seem larger than life, are part of the loss that is latent within all cinema: Marlon Brando and Katherine Hepburn are not so much made immortal as existing "in perfect fossil form."[30]

Moving beyond the era of celluloid, Mulvey writes about cinema of the digital age and DVDs of old films that transform "the ways in which [they] are consumed."[31] She focuses on the spectator's power to make new discoveries within a film by simply pressing pause. Despite the new possibilities of any cinematic life that are unleashed through a spectator's frame-to-frame analysis, the idea of pressing pause leads Mulvey back to death. She suggests there is something frightening, haunting, and even life-negating in pausing a film: "the still, inanimate image is drained of movement, the commonly accepted sign of life";[32] and "digital technology enables a spectator to still a film in a way that evokes the ghostly presence of the individual celluloid frame."[33] Mulvey ultimately implies that the spectator violates a film and robs it of its natural life when breaking it into pieces for analysis. A film watched at the correct speed of 24 frames per second in the darkness is beautifully elusive, like "running water, fire, or the movement of trees in the wind," but the spectator's pressing pause returns them to "the heavy presence of passing time" and "the mortality" associated with a still photograph.[34] Moreover, if a spectator can play over parts of a film at will and under new circumstances (that is, not "in the dark, at 24 frames a second, in narrative order and without exterior intrusions"), the "cohesion of narrative comes under pressure" and the "horizontal structure mutates."[35] Therefore, for Mulvey, "the possessive spectator commits an act of violence against the cohesion of the story."[36]

Even when a spectator plays a film with uninterrupted speed and flow, Mulvey stresses that it "cannot *but* come to an end."[37] Despite the multiple forms of visual motion within a film—such as crane shots, tracking shots, and pans—a film always returns us to a blank screen that signifies erasure and "the nothing that lies beyond it."[38] Sometimes, the shift from motion in life to the reassertion of death is quite literally and visually played out—as in *The Red Shoes* (1948), for instance, where the narrative is propelled by the ballerina's movements up until her tragic fall into the stillness of death.[39] For Mulvey, this

fall signifies the threat that is *ever-present through that film and every other*. No matter what life in motion the spectator witnesses, the film is still hurtling toward the death that reasserts itself time and time again with the power of the inevitable, "as though the beautiful automation was to wind down into its inanimate, uncanny, form."[40] Whether the last moments of a film show a final Hollywood kiss, that "the time-honored convention of cinematic narrative closure," or the end of a road in a film about journeying, or the words "The End," or a blank screen, or a freeze-frame, it closes with a "return of the repressed stillness on which the cinema's illusion of movement depends."[41]

If Mulvey's writing on cinema is about unavoidable dead ends, my own emphasis is on films as lifeforms that I extend through absorbing them. Where she generalizes about cinema does for *us*, I maintain focus on my direct experiences with students and on my individual reactions without presumption. Though every film records moments that have certainly passed, as Mulvey writes, it is also filled with those moments that are waiting to be found and *lived by me* as an audience bearing witness. Though cinematic moments are as ever-changing as life, I can still grab those that matter most to me, much as I hold on to life's most precious memories. By remembering, replaying, and/or rehearsing these moments, I extend their living power because they become a lasting part of my self.

Echoing Kulezic-Wilson again, I return to the understanding of films as existences with which I can have evolving relationships. Moreover, I accept that films exist in flux as we all do, and that they make sense and we make sense to ourselves differently over time. How can the object that is ever-changing to us as ever-changing beings possibly die? What about all the films that, as Kore-eda puts it, "grow inside you after the closing credits"? Instead of fixing a film in death, treating it as an object that can always be stopped with the pause button, I respect every film as something that is *made to move me while it is moving*. Any film can be unfixed from stable meanings within the unique context of a classroom, through repeat screenings, in relation to the world at large, and in the way it matters on unique terms to each one of us at any given moment.

In summary, *Death 24× a Second* communicates a sense of loss that is the always-*pastness* of cinema: films represent moments that cannot be recaptured, events that have already happened, objects unmoored from their unrepeatable contexts of inception and production, and human presences that have already gone.[42] All this leads Mulvey back to the inevitability of endings and the very last word of her book is "death."[43] By contrast, I start

and finish with ideas of life. I focus on cinema as an artform that is always dynamic because my life is enlarged by it and I *choose to perceive it accordingly*. Though cinema is undeniably created through the illusion of movement, this does not undo its vital energy—indeed, it is the transitoriness, the fleeting impressions, and the changeable rhythm of cinema that makes it often feel as precious as actual life to me.

Along with fixing on the threat of endings within every cinematic image, Mulvey ignores the energizing power of *sonic* elements of cinema that work on literal and figurative levels. Where she writes of the spectator, I write of the *audioviewer*. On a literal level, the aural components of cinema enter the audioviewer's body through sound waves. Its life thereby moves far beyond the immediate present or the material circumstances of its being originally made. A character's voice can always be renewed through being reheard by an audioviewer, even long after the visual and bodily life of the actor has passed. In addition, every sound track registers differently within a room of variable acoustic properties. On a figurative level, each audioviewer "houses" a film's sounds uniquely in relation to their own subjectivity. Therefore, sound waves travel into audioviewers' living *and* metaphysically changing bodies. Like innumerable others, I sometimes extend cinematic experiences by playing their music in new places too.[44]

The idea that soundtracks can intensify the living impact of films, both within the broader world and within ourselves, is not new. For example, Jeff Smith takes an industrial angle on the outreach of popular film music in his landmark book, *The Sounds of Commerce*.[45] He focuses on movie themes that hook audiences in and remain memorable long after films have finished running. More recently, Juan Chattah takes a scientific approach to the physical and cognitive impact of cinema that audiences often sense subliminally, whether or not they are musicologically trained.[46] My own approach foregrounds personal subjectivity, pedagogy, and emotion in relation to absorbing films as audiovisual experiences. I dwell on the wisdom I hear within films, particularly when it comes to coping with life's biggest challenges, or "lifeshocks."

Cinema as Lifeshocks

I believe that cinema is most energizing in the lifeshocks that it explores and teaches me to handle. Here, I use a term defined by Sophie Sabbage, referring

to moments in time that "surprise us, blindside us, soften and stir us. Sometimes they slap us hard in the face. Some scratch the surface of our lives while others strike deep into our being."[47] A lifeshock is an opportunity to confront something new, and to choose a response in turn. Sabbage stresses that a person always has a choice about how to respond to a lifeshocking event, no matter how disturbing it might be—this is a *relational* comprehension of one's "interaction with someone or something outside of [one's self]."[48] A person must rise to meet a lifeshock, and sometimes this means scrutinizing what hurts them. For example, Sabbage recalls the lifeshock of being at her father's deathbed. She writes of letting him go with words of love, cherishing, and acceptance: after a considerable struggle within herself, she developed the ability to calmly tell him, "You made the world a better place. You can go now."[49] She thus aligned herself with life as it *is* instead of how she thought it should be. In doing so, she avoided the "unnecessary suffering" that comes with fighting reality.[50]

Sabbage says that a big lifeshock can change the course of a person's life in profound and lasting ways. While any lifeshock can be unpleasant, along with being unexpected, shocking, and confrontational, it can also be a moment of possibility, realignment, and new understanding. Being diagnosed with advanced cancer was a big lifeshock for Sabbage, but so too was the moment when her daughter called her "beautiful" after a chemotherapy drug left her face temporarily deformed with blisters. The surprise of her daughter's reaction caused her to step back from judging her own appearance too harshly and unlovingly. Along with taking various extreme forms, Sabbage says that the lifeshock take place within temporal extremes. Whether it happens over the course of a day or lifetime, the relative duration or frequency of the lifeshock matters little next to its lasting significance. Whatever its context, Sabbage compares the lifeshock to that moment when a doctor restarts a heart, reestablishing a rhythm with electronic defibrillation that can "shock it back to life."[51] The lifeshock calls a person to love themself and others anew, and this includes their becoming more awake and attuned to the pain that others feel.[52] A person's embracement of a lifeshock can lead to radical levels of gratitude, creativity, and ways "out of personal hell."[53]

Reframing Sabbage's words, I find that cinema gives me lifeshocks through "external moments in time that grab [my] attention and invite [me] to turn that attention inwards."[54] The films that matter most to me, on personal, pedagogical, and emotional levels, are those that contain lifeshocks that become part of who I am, extending themselves within me. Obviously, cinematic

lifeshocks need not (and cannot) affect every person similarly. Indeed, they are best described as unique *moments of impact* between a film and an audioviewer. Moreover, a given film need not hold up a direct reflection of an audioviewer's life in order to create lifeshocks for them, and I do not assume that the films that give me lifeshocks will work similarly for others. Still, I celebrate those cinematic moments of impact that ignite me in lifeshocking ways with the hope that my reader will recognize them in relation to their own equivalent moments. To give one example, when I watched Billi (Awkwafina) watch her grandmother become smaller through the back window of a taxi driving her away near the end of *The Farewell* (2019), I had the lifeshock of returning to the last time I saw my own mother. Without projecting myself onto Billi's Chinese American life, I felt a sense of surprising kinship with her.

The Farewell tells the true story of a fantastic lie: Billi is the granddaughter who returns to China after her Nai Nai (a Mandarin term for paternal grandmother) is diagnosed with stage 4 lung cancer, and her family decides to stage a wedding of her cousins so that everyone can gather together without telling Nai Nai the truth of her sickness. The film is an uncommonly personal act of revelation that invites a personal response in turn: director/writer, Lulu Wang says that Awkwafina as Billi "is a *version* of me," the film includes a framed photograph of Wang's own grandparents hanging above Nai Nai's bed, Wang cast her great-aunt, Nai-Nai's sister Hong Lu (who goes by "Lil Nai Nai") to play herself in the film, Wang's parents helped her with Chinese translations on an early draft of the script, and Wang aligns herself with the film in terms of identifying as both American and Chinese.[55] The film incorporates many specifically Chinese details, including Nai Nai calling Billi a "stupid child," which is a term of endearment to Chinese families,[56] and an emphasis on the color blue, which has entrenched Chinese associations with "conserving, healing, relaxation, exploration, trust, calmness, immortality."[57] The color blue also carries more "taboo" associations with death and funerals, making its usage complex, ironic, and poignant given its dominance in the film's wedding party scenes.[58] Writing for *The Atlantic*, Shirley Li observes such cultural specificities along with the film's focus on "one particular family" that becomes "magical" through its surprising cross-cultural "recognizability." She holds up *The Farewell*'s "universally messy" themes of "generational differences, unbreakable bonds, and singular issues." Audiences across America have responded to the film's relatability by sharing their uncommonly intimate responses with Wang and telling "her how much her Nai Nai reminds them of their own, or how much her family resembles theirs."[59]

Near the end of *The Farewell*, Billi's watches Nai Nai through the back window of a taxi, She is sitting next to her mother in silence. They are on their way to the airport and they know this is likely their last time seeing Nai Nai alive. A nondiegetic song fills the sound track: "Come Healing," cowritten by Leonard Cohen and Patrick Leonard, and performed by Elayna Boynton. Its lyrics have ritualistic weight through a repeated phrase, "Come healing of the," that ends in different ways—including, "body," "mind," "spirit," "limb," "reason," "heart." This song is originally inseparable from Cohen's gravelly male voice and the film self-consciously features this female-dominated cover in honor of Billi and her mother. While they sit in their shared silence of barely concealed feeling, the lyrics communicate their mutual wish for Nai Nai's healing, which is too precious or difficult to be spoken aloud onscreen. This scene of departure reminds me of when my mother walked slowly into her own driveway to observe my eldest child and me leaving her home for the last time, waving her little hand and smiling as if to will us away so she could cry in private. This makes me appreciate Billi's grandmother in a particular way, as the benevolent matriarchal figure who knows exactly how to say goodbye with grace. My mother did not know it would be our last time seeing each other, much as Nai Nai does not know it could be her last sight of her daughter and granddaughter, but something in Nai Nai's fallen face reminds me of the agony my mother must have felt knowing that her grandchild and I would soon be thousands of miles away. After witnessing Billi and her mother's shared silence, as well as hearing Boynton's performance of Cohen's song, I am more accepting of what I could not say and what I needed to hear in that final farewell of my own.

A spoiler at the end of *The Farewell* reveals that Nai Nai is still alive and oblivious to her own sickness, but the final moments of the film still suggest a loving goodbye in keeping with the promise of its title: Billi walks outside her New York apartment and suddenly shouts "ha!" much as her grandmother did while when they were exercising together in China. The first "ha!" in *The Farewell* is Nai Nai's projection of core strength and her emphatic exuberance in qigong practice. Nai Nai's repeated "ha!" is connected to her selfcare as well as her teaching Billi: she explains to her granddaughter that she is clearing "all the bad toxins" so she can breathe "fresh oxygen," and she encourages Billi to move and exclaim "ha!" with her. Qigong is about achieving a "mindbody-spirit" integration that involves "posture, movement, breathing technique, self-massage, sound, and focused intent." It opens "the flow of energy in meridians used in acupuncture and Chinese medicine." This "enhances

our ability to feel the Life Force underlying the physical world and deepen our communication with it."[60] Wang's own grandmother taught her to "ha!" with qigong movements, which requires so much core strength that it takes a lot of practice.[61] Wang celebrates this memory with the concerted focus of a long take in the qigong scene of *The Farwell*. Knowing this backstory compels me to absorb every "ha!" of the film with special appreciation.

When I hear Billi's last "ha!" in the final moment of the film, I understand that Nai Nai's presence remains within her body. The core strength of this "ha!" signifies the union of Billi's Chinese and American self too, since "ha!" makes sense in cross-cultural terms: in the Chinese context, it is the projection of air and expelling of energy that is equated with healing though qigong, but in the American context it sounds like a defiant near-laugh. Whichever way I hear it, the exclamation is a joyful representation of the granddaughter continuing the life of the grandmother by making the same sound she did (see Figures I.1 and I.2). On Billi's final "ha!" the film suddenly cuts to show a flight of birds take off from a roof in China, and her voice reverberates across the cut. Because this sound sutures the scenes of Billi's two countries, I assume that she is feeling the Life Force that connects her to Nai Nai and all things across the world.[62] The birds taking flight might symbolize how Nai Nai's spirit will soon ascend, but also how much new power Billi feels within herself. If I can gather this much from a monosyllabic exclamation, just imagine the lifeshocking possibilities of an entire sound track. *The Farewell* is sonically rich with abundant and eclectic music, meaningful and subtextually loaded dialogue, and many pointed silences, all of which deserve further analysis.

With regard to the bigger cross-cultural vision of *The Farewell*, I can never know what it is to be a Chinese American young woman living the lifeshock of anticipating my grandmother's death while living so far from my homeland. I must acknowledge the limits of my own experience for my students as well as myself, opening the door to an honest exploration of profound cultural differences. But the dominant academic writings that have taught me the danger of universalist assertions should not be allowed to create artificial barriers between me, my students, and the films that make us laugh and cry together in recognition of those moments that stir us on such human and humane levels. If I am prohibited from overcoming such barriers, I risk losing the power of lifeshocking cinematic experiences that can change my students and me at the same time, and I forfeit the possibility of affirming deep connections to other human beings while also respecting the

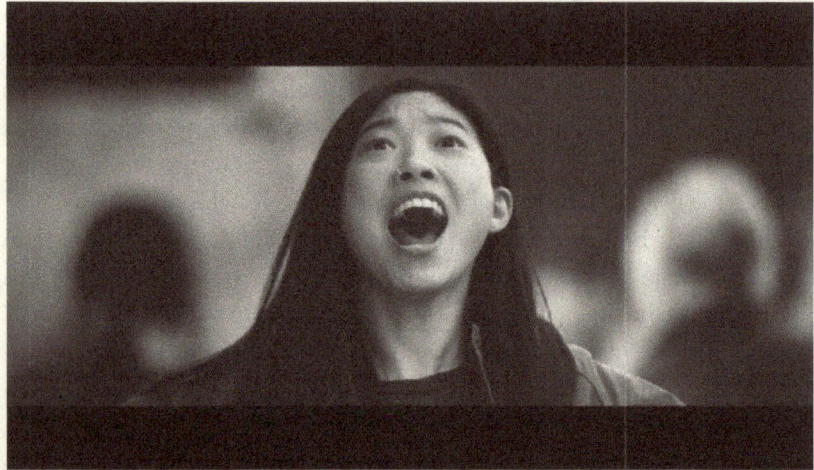

Figure I.1 On a New York street, Billi lets out her "ha!" in tribute to her grandmother. Pedestrians around her drop out of focus because they are oblivious to the significance of this moment, but her position before us is the film's act of confidence that *we* will absorb the sound *and* recognize its transcendent meaning.

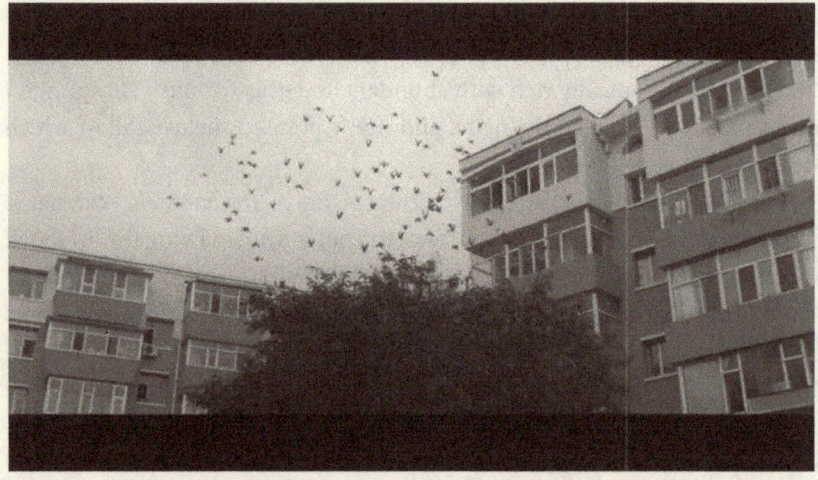

Figure I.2 Billi's "ha" carries over the cut a tree in China where a flock of birds suddenly rise into the sky. This shows Billi's tangible and transcendent sonic connection to her Grandmother's place as well as her spirit.

differences among us. When I first heard that final "ha!" in *The Farewell*, I did not imagine I could fully understand Billi, but I did think of all the words and phrases of my mother that I myself echo and then catch myself doing so: it was a jolt of lifeshocking energy that brought personal revelations to me, as uplifting as a shot of birds taking sudden flight.

With every chapter of this book, I draw directly from my own lifeshocking encounters with films as well as the ways I have taught them. I have always shaped my courses in terms of building toward films that will offer potentially lifeshocking experiences for my students, while also knowing that they might not be able to vocalize it when this happens. I respect that not every student will be willing or able to disclose a lifeshock that happens to them, though I cherish those moments when a student is willing to explore their own lifeshock in the context of a class discussion after the fact. A student's lifeshock can lead to my own in turn: their revelation might force me to re-understand a film that was already meaningful to me, and to comprehend its life reverberating in ways I could not anticipate. For example, I think of a surprise after my most recent class screening of *Secrets and Lies*. I thought the film might be a relatively hard sell—it is ponderously paced by today's mainstream American cinema standards and features thickly accented, class-conscious British actors living more than two decades ago. The film represents many major rites of passage: a daughter attending her adopted mother's funeral, a biological mother reunited with the daughter she never knew, a couple's struggle to conceive, and several characters forming a newly united family. The narrative ends with a hugely cathartic scene in which all the major toxic family secrets and disturbances are spoken about with a new level of honesty, and the characters allow themselves to cry. The speeches and the shot durations are long: the montage is respectful of how much the characters need to say, allowing time for an audience to take in every word in the absence of much editing. At the end of this scene, two women who have been "at war" with each other embrace for the first time. I chose this film before the semester began, and by the time I screened it I had come to know my class quite well: I knew that one particular student had been suffering from clinical depression, partly due to feeling alienated from his own family. After the screening of *Secrets and Lies*, this student lingered with me for the closing credits. He looked relieved, as if lifted by the final moments of the film. After the screen went black, he connected his life to what had happened. Before I had a chance to put the full auditorium lights back on, he was speaking excitedly: "That was powerful. My arms went numb because I was so moved."

Then he said, "My family is coming together again, and it's a good time." In these few words, he communicated his full-bodied, heartfelt investment in the film because it surprised him with its personal resonance. He used this as an opportunity to remind himself, and let me know, what was most precious in his life at that moment. In response to this, I was more conscious of the film's will, or of the "filmind" as Frampton defines it: that is, the film's *being* and intentionality that is in excess of any or all of its characters or its narrative components, and which has a level of "transsubjective" dynamic agency that might change how a person makes sense of their own life in response.[63] I sensed that the filmind of *Secrets and Lies* was prompting this student to speak more hopefully about his own life: in short, the filmind was changing his mindtalk, or, the characters' combined lifeshocks led him to confront his own anew. This led me to comprehend the film's life beyond its own ending, in direct conflict with Mulvey's insistence on films as finite things.

This was a film-to-person encounter that I was lucky to witness. My student's lifeshocking reaction to the film prompted my own—I was newly humbled by the significance of *Secrets and Lies* beyond countries, cultures, times, peoples, ways of speaking English, and cinematic style. I felt the thrill of recognition in what he told me, more than sensing anything was completely resolved for him by the film experience. To quote Sabbage again: lifeshocks "reveal us to ourselves. And this is what love does. It listens and sees and remembers who we are . . . It doesn't try to fix things that are broken. It holds our brokenness to the sun so that light might find its way through the tissues."[64] In the dimness of our postscreening auditorium, there was this kind of hopeful light.

The Shape of This Book

This book is a more individually idiosyncratic journey than most academic writing and all my work to date. I ask the reader to accept this redirection. My first book was a study of various approaches to hearing cinema. In *Understanding Sound Tracks Through Film Theory* (2015), I present key works of feminism, queer theory, postcolonial theory, and genre studies to show how they can be meaningfully applied to specific film sound tracks. I not only challenge the dominance of visual emphases across cinema studies, but demonstrate how some of the most influential works of theoretical analysis can become newly meaningful in relation those sound tracks that

resonate with them. My second book is a close study of one auteur's sonic approach: *Hearing Haneke: The Sound Tracks of a Radical Auteur* (2017). Above all, Haneke makes me confront how humanity can hurt itself through his characters' violent sounds, their silences, and their failures to speak. He is frequently perceived by audiences as cold or even cruel, but I hear humane care in Haneke's strategies for making his audiences actively listen to the ways that people do damage to themselves and each other. I am invested in the uncompromising morality behind Haneke's willingness to show the hurts that people are capable of committing, which makes the kindness of his *Amour* (2012) most beautifully surprising to me. I have positioned my arguments for his work in relation to the great noise of many other scholars, along with honoring the tenderness of his only love story.

With this book, I make no intricately sustained effort to situate my work in relation to well-established theoretical works or other scholars. I approach every film in a self-consciously unorthodox way because I consistently privilege personal, pedagogical, and emotional experiences where many other scholars do not. I want to do justice to the lifeshocking energy of each film as it uniquely inspires me within a certain context of audioviewing. Therefore, instead of being led by theory or any well-established scholarly lines of argument, I am led by the lives of the films themselves and I adopt a different interpretive approach for every chapter. To make the most of my chosen films, I pull ideas from a range of authors across fields of literature, business, psychology, biological science, autobiography, history, and cultural studies, many of whom present broad arguments about what we perceive or go through in life. I quote these authors' general arguments directly in the hope they will resonate for the reader, but without assuming that they automatically will. Along with quoting and paraphrasing the work of other authors who explain how anyone might respond to life (and cinema by extension), I use four ways of describing what happens within each given film: first, I refer to what is manifestly in the film, by describing details with as much precision as I can and without overt subjectivity; second, I occasionally refer to what the audioviewer might perceive in the given film or what it might do for us by making reasonable assumptions about the possibilities of the film that extend beyond my perceptions and experiences alone; third, I refer to my students' responses to films and what we discover in the classroom; and fourth, I use the first person for communicating the reactions that I have to each film without presuming my reader will read it the same way as I do. As I explain in every chapter, the cinematic lifeshocks that matter most to

me are inextricably intertwined with my first-person knowledge—from my participating in the current Black Lives Matter movement, to facilitating pedagogical breakthroughs with my students, to growing into motherhood, to grieving for my parents and for my best friend. Like the ever-transient medium of cinema, and like all audioviewers, I accept that I am in a constant state of change, but I hope the reader will connect with the possibilities of the films that I wish to hold in time through this writing.

As I acknowledge the personal experiences that inevitably bear upon my reading of every film, I treat each film as distinctively as a person. That said, the chapters of this book still relate to each other: overall, I am making a multifaceted case for cinema as an artform of never-ending life. Where other scholars still write of the "spectator" and of film as a visual medium, I stress what sound tracks do as indispensable parts of entire audiovisual experiences with lifeshocking value. In chapter 1, I hear cinema in relation to the contemporary Black Lives Matter movement, with a special focus on the sound tracks of Douglas Sirk's remake of *Imitation of Life* and Spike Lee's *BlacKkKlansman*. I examine how the films resonate with the racial politics of America today, along with knowingly "talking back" to white-centric, canonized American cinema. *Imitation of Life* features an original score by Franz Waxman that celebrates the uncommon stature of its lead Black female character's life. Parallel to this, the subversive agency of *BlacKkKlansman* is sonically driven: I stress John David Washington's unusual vocal prowess as the Black police officer who investigates the Ku Klux Klan by passing as white in his telephone conversations with David Duke, and the orchestral strength of Terence Blanchard's score that communicates Stallworth's remarkable multidimensionality. Chapter 2 is about my understanding of cinema in relation to one of my most transformative lifeshocks while urging my readers to hear the resonances of cinema anew on their own terms. More specifically, I explain how becoming a mother has changed the way I hear and teach the film *Nobody Knows*. The film depicts a family of representative Japanese children in need, gently amplifying the sounds they make and the things they say, along with stressing that they matter from the humane perspective of Gontiti's original score. From a motherly perspective, I apply Otto Scharmer's business-based model of multilevel listening to explain the instructive, empathic, and generative possibilities of listening to the film with my students. In chapter 3, I apply the scientifically documented findings of HeartMath to *Dancer in the Dark*. I use HeartMath to explain the film's musically driven pull on my students and myself in particular. Since I have taught the film for

a decade, I draw from my many conversations with students about Björk's extraordinary original score. Björk's character (Selma) dies tragically before the film's end, but her music has repeatedly shown my students and me how to live and breathe with Selma in heartening ways. Like a strong pendulum clock pulls other clocks into rhythm alignment with itself, Selma's music has entrained the rhythms of our hearts into alignment with it, giving us overwhelming access to her spirit that can outlive the film. Chapter 4 is my analysis of three films about confronting grief and teaching me to live through it. I draw from a range of contemporary psychological studies to analyze how *Life of Pi*, *Ikiru*, and *A Star Is Born* teach me to cope with actual loss. All three films deal with pain through surprisingly beautiful musical forms. With this chapter, I move from macrocosmic to microcosmic examples: from Mychael Danna's entire score for *Life of Pi*, to the repetition of a Japanese popular song ("Gondola no Uta") in *Ikiru*, to the performance of just one song in *A Star Is Born*. Through these increasingly concentrated case studies, I explain the therapeutic, healing, and restorative significance of each film's music in relation to contemporary psychological writings about confronting mortality and handling grief. This chapter is a direct appeal to my readers to embrace how cinema might intersect with their most painful losses because I break down the usual boundary between psychology and cinema studies. In chapter 5, I turn my imaginary microphone around to hear from my former film students. I report on the surveys I sent to forty-six alumni who answered my questions about how films have resonated with their lives and helped them cope with lifeshocks. Many of these students wrote of the films that continue to reverberate even years after studying them, often through lines of dialogue and music that gather new meanings over time. Chapter 6 is my most personal analysis, inspired by my former students' willingness to relay their own unique experiences of understanding what cinema has done for them. I reflect on how two films—*Call Me By Your Name* and *Portrait of a Lady on Fire*—have helped me cope with the death of my best friend while writing this book. I zero in on two parallel scenes that show the protagonists grieving while listening to the music that connects them to their former lovers. This culminating chapter is my most concentrated application of this book's priorities: embracing emotionality without fear, using cinema to make sense of lifeshocking experiences, actively listening to films along with seeing them, and dissolving the divide between cinema and life.

1

Black Lives Matter, Talking Back, and the Life of *BlacKkKlansman*

> Floyd's life is the awful price we have paid for a momentarily common tongue, a language that precisely conveys what we are speaking of when we say "American."
>
> —Jelani Cobb[1]

> Healing does not cover over, but exposes the wound to others: the recovery is a form of exposure ... The work of exposure is not over in the moment of hearing: often such testimonies have to be repeated, again and again.
>
> —Sarah Ahmed[2]

This chapter revolves around the concept of talking back. "Talking back" is a form of sonic insubordination that signifies the refusal to capitulate to authority. "Don't talk back!" is a commonly condescending instruction for children who disrespect the words of elders or caregivers. Here, I reclaim the idea of talking back as a subversive and necessary ideal. I examine life-affirming examples of African American cinema and African American characters that talk back to canonized cinema, institutionalized racism, white-centered nostalgia, and racist perceptions of truth. In addition, I continue talking back to Mulvey's revered *Death 24× a Second* before parting ways with that book.

In focusing on why African American films and characters *must* talk back, I am inspired by the Black Lives Matter (BLM) protests of 2020. These protests were among the biggest in history, and they taught me about hearing others (especially Black and white voices) differently.[3] The urgency that thousands of protestors felt was encapsulated by their chanting George Floyd's last words: "I can't breathe." Floyd gasped these words shortly before he stopped breathing, after having had Officer Derek Chauvin's knee on his neck for nine

minutes and twenty-nine seconds.[4] The cellphone footage of Floyd's murder went viral within one day, and it echoed the viral cellphone footage of Eric Garner's death in 2014: Garner gasped "I can't breathe" eleven times before he died in police officer Daniel Panteleo's chokehold.[5] The shock of Floyd's death was most acute for people who have not lived in the Black America he inhabited. As Jelani Cobb explains, "the shock of revelation that attended the video of Floyd's death is itself a kind of inequality, a barometer of the extent to which one group of Americans have moved through life largely free from the burden of such terrible knowledge." However, the massive demonstrations in white-dominated Salt Lake City alone, where the Black population is only 2 percent, is testimony to a national sea change.

In 2020, thousands of BLM protestors were chanting "I can't breathe" while wearing face masks, thus mediating their potential exposure to COVID-19. Many people took this health risk because the "health" of America demanded it. The phrase "I can't breathe" has become shorthand for talking back to institutionalized racism and is now permanently "embedded in the national conscience."[6] The BLM protestors' chants of "I can't breathe" represents a widespread and newly charged engagement with the truth of racial discrimination. I hear hopefulness in these chants that mediates the tragic origins of the phrase. Along with remembering Garner and Floyd, I hear humanity, compassion, social conscience, historical awareness, and commitment to immediate progressive change.

Since the BLM protests of 2020, I find evidence that many Americans have been hearing the dying words of Black citizens *and* the entitled speech of white privilege differently. When Amy Cooper used her white female voice to call 911 on a Black man (Christian Cooper) who was bird-watching in Central Park on May 25, 2020, she sparked widespread outrage that prompted numerous other people to share footage of white people calling in law enforcement to control African American strangers.[7] Ms. Cooper's phone call was a deliberate, conscious choice to enact white privilege solely through using her voice a certain way: she told Mr. Cooper, "I'm going to tell them [the emergency dispatcher] there's an African American man threatening my life." He responded with "please call the cops, please call the cops," audibly encouraging her to provide the example that would make her an infamously representative embodiment of prejudice. She then called 911 and told the dispatcher, "there's a man, African American, he has a bicycle helmet," and "he is recording me and threatening me and my dog." Mr. Cooper (offscreen) was silent and unmoving during this call, offsetting her

performance of jittery victimization. She finished the phone call in tones of increasing hysteria and breathy urgency: "I'm being threatened by a man in the ramble. Please send the cops immediately!" Mr. Cooper simply but emphatically said, "Thank you," giving himself the last words of his video. His vocal control over himself in contrast with Ms. Cooper's irrational vocal performance had seismic impact. Mr. Cooper shared his video footage of the incident on the same day and it went viral within hours. When millions of white BLM protestors took to the streets in the summer of 2020, they were determined to make their voices heard differently from the "Amy Coopers."

I am retraining myself to hear other people *and* cinema better in relation to the current BLM movement. In this chapter, I focus most on one film: *BlacKkKlansman* (2018), directed by Spike Lee. While I make no assumption that the reader will hear this film or any other precisely as I do, I make a general case for listening to representations of African American life more attentively in this historical moment. I pave the way for analyzing *BlacKkKlansman* by examining some other cinematic landmarks first. I take this approach because, like all Lee's films, *BlacKkKlansman* positions itself in conversation with a network of other films and forms of reality. For example, during the summer of 2020, and at the height of nationwide protests against police brutality, Lee created a short film titled *Three Brothers*. It is his most succinctly haunting statement about cinema as a reflection of the past *and* the present. The short includes pieces of cellphone footage showing Garner and then Floyd attacked by police, and part of the climactic sequence from Lee's *Do the Right Thing* (1989) when Radio Raheem is killed by a police officer.

Before analyzing *Three Brothers*, I must give the extract from *Do the Right Thing* some narrative and sonic context. Radio Raheem is the main character of *Do The Right Thing* who stands for the ultimate tension between good and evil, as signified by the gold rings he extends toward the camera. He obsessively plays N. W. A.'s "Fight the Power" on his beatbox in multiple scenes, an "anthem" that Lee commissioned for the film.[8] The song boldly talks back to institutionalized oppression, though its lyrics are grave in relation to the film narrative: "Our freedom of speech is freedom or death/We got to fight the powers that be." Radio Raheem is murdered by police after he refuses to turn off "Fight the Power" in an Italian American pizza shop. The shop owner, Sal, denies him service unless he turns "that shit off," and their argument escalates into a climactic shouting match involving everyone at the restaurant. Sal beats Radio Raheem's beatbox with a baseball bat, stopping

the music and shocking everyone into stunned silence before a brutal collective fight spills out into the streets. While Radio Raheem is strangling Sal, some white police officers intervene with all-too-familiar brutality. Radio Raheem dies when one officer strangles him with a baton and other officers restrain him, and in the presence of his Black neighbors who vocally protest but cannot intervene.

In the next sequence of *Do the Right Thing*, a riot breaks out around Sal's pizza restaurant. One especially vulnerable, doubly marginalized character (the mentally disabled African American, Smiley) sets the place on fire and the rioters chant "Radio, Radio, Radio." This is an eerie foreshadowing of how BLM protestors would repeatedly shout "say their names" for the victims of police brutality thirty years later, raising their voices because they saw that America was "on fire."[9] By including Radio Raheem's death within *Three Brothers*, Lee reasserts his longstanding, earnest commitment to participating in a massive ongoing conversation that transcends any storylines, film release dates, or headlines.

Three Brothers begins with red-lettered words "Will History Stop Repeating Itself?" along with a sonic advance of Garner's death footage. Garner says, "I'm minding my business officer," followed by a cut that shows him standing on the sidewalk moments before several police officers wrestle him to the ground for no apparent reason. Lee dismantles the truth/fiction dichotomy by then cutting to Radio Raheem and Sal's fight bursting onto the street in *Do the Right Thing*. I understand Radio Raheem's death anew in this context: what *might* seem like the extremity of action necessitated by the narrative obligation to build toward a climax in the original *Do the Right Thing* now registers for me as a haunting anticipation of *real* murders happening decades later. Lee shows me that understanding *Do the Right Thing* properly means perceiving its resonance across time and in the world at large. In juxtaposition with the real footage of Floyd and Garner dying, Radio Raheem's death takes on the weight of a prophecy. This is how Lee talks back to the police officers who took the law into their own hands, as if to say, "I saw this coming, and you had no power to surprise me." *Three Brothers* does not downplay the individual tragedies of Garner and Floyd, but Lee uses their death footage to show a pattern, making a point of righteous anger that folds the past and present together.

I give the sonic components of Garner's and Floyd's death footage, as replayed in *Three Brothers*, special attention.[10] Both men were filmed by bystanders at a medium to long-shot distance, with their faces frequently

turned away or blocked from the camera's viewpoint. What BLM protestors have recalled most are the weakened voices and panicked last words of both men: they echo Garner and Floyd in order to *keep hearing them*. "I can't breathe" is the phrase that haunts me most, along with reminding me of the perishability that connects us all through a pandemic, and which defines the perilousness of being Black in America today most especially. While I know that many prominent monuments to Confederate soldiers are currently being dismantled or destroyed across America, I bear witness to the new *sonic monuments* being built: the chants of "I can't breathe," "Black Lives Matter," and "say their names" will resound in perpetuity.[11]

Films to Rehear

I argue that the sound tracks of *all* films featuring African American characters warrant more attention because the voices, music, and sounds of racial representation have not been weighed heavily enough in cinema studies. I open up a new soundscape of possibilities by revisiting many landmark films. Just a few influential examples make the case. I replay scenes featuring jazz performed by Johnny Ingram (Harry Belafonte) as a form of resistance to mainstream, white-dominated music in *Odds Against Tomorrow* (1959), a *noir* that dwells on segregation within American society only to show the two main characters (Black Belafonte, and white Robert Ryan as Earl Slater) burned to death in a *loud* explosion that makes their charred bodies ironically indistinguishable from each other. To give another example, I think of how often Noah Cullen (Sidney Poitier) refuses to be called "boy" by his fellow escaped prisoner, John "Joker" Jackson, the white man (Tony Curtis) he saves in *The Defiant Ones* (1958). Noah speaks with certainty about who he is, even when he is literally shackled to a man who speaks the language of oppression without self-awareness. When a police officer menacingly approaches them both in the film's final moments, Noah maintains sonic control of the scene, ironizing his own defeat by stridently singing his favorite song ("Long Gone"). I remember Poitier as another oppressed but self-assured character on the other side of the law: Detective Tibbs. I rehear that scene from *In the Heat of the Night* (1967) when he hits a white plantation owner (Mr. Endicott). This slap is Tibbs's reflexive response to Endicott's slapping him, after Tibbs's investigative questioning implies his guilt, but it reverberates far beyond this immediate narrative context. Right before this

scene, the film shows several African American plantation workers toiling in the hot sun outside Endicott's mansion: they work in silence, while Tibbs is able to speak confidently and defiantly as needed. Throughout *In the Heat of the Night*, he is repeatedly harassed and humiliated by white characters despite his unmatched professional skills for investigating the murder of a white man. Tibbs embodies the hope of his people who need him to talk (and slap) back, as well as the justice that both white and Black Americans need. To give yet another example, I think of the compilation soundtrack for Charles Burnett's *Killer of Sheep* (1978). In one scene, an African American married couple slow-dance to their record of Dinah Washington singing "This Bitter Earth." Washington's pained lyrics match the couple's near-despair: "And if my life is like the dust/Ooh, that hides the glow of a rose/What good am I?/ Heaven only knows." This heartbreakingly coherent combination of music and onscreen action contrasts with the film's quicker-paced montages showing the husband's relentlessly horrible job at a slaughterhouse with music that does not match his grisly work. While he sprays away the blood and other remnants of the animals from the floor and the sinks at the slaughterhouse, his work is ironically underscored by part of William Grant Still's "Afro-American Symphony,"[12] a grand, optimistic, and celebrated orchestral work that draws from Blues harmonies and rhythms in a progressively affirming way.[13] The disjunct between images and music matters. The film makes me yearn for a world where such brokenness can be healed.

These films I have mentioned are generally well-known, but their sound tracks are still given relatively short shrift by film scholars.[14] Since the current BLM protests have been so much directed toward making us hear last words, chants, and voices of Black oppression as well as voices of white privilege more attentively, I think we should revisit all relevant sound tracks to rehear what they tell us. I argue we should weigh the sonic dimensions of newer releases more heavily too: consider, for example, the uncanny power in the tiny sound of a teaspoon stirring inside a porcelain cup in *Get Out* (2017), evoking the colonial history attached to the tea industry, and narratively attached to a white woman controlling a Black man by hypnotizing him into the "sunken place" of his complete subjugation; or the vocal interchanges that are not visually matched by the moving mouths of the Black couple on the run from police in *Queen & Slim* (2019), signifying that their unity in subversive action is bigger than anything that can be attached to their bodies; or the musically saturated entire experience of *Black Panther* (2018), featuring an original score by Ludwig Göransson and original songs performed by Kendrick

Lamar, the prominence of which reflect director Ryan Coogler's belief that most audiences connect their favorite cinematic moments to music, and that "a song can do in three minutes what it takes a great film several hours to do."[15]

Cinema that portrays race relations gives me the opportunity to confront some histories of prejudice that I cannot separate myself from. This is a crucial gift for my life now, and a challenge to the fossilizing impulses of film criticism exemplified by Mulvey's death-driven approach to cinema. *Three Brothers* gave me the most intense defibrillating jolt that I needed to take professional action in relation to the BLM movement. As devastated as I felt by my first audioviewing of the film, it reminded me of the lifeshocking power that cinema can have for me. This led me to teach a full course on African American cinema for the first time, not because I suddenly felt more equipped to understand it: As a white, middle-class New Zealander, how could I? Still, I felt a moral imperative to try. Harkening back to Frampton, I heard the filmind of *Three Brothers* telling me that I needed to rehear the African American cinema and characters I already knew to reunderstand them, not only *Do the Right Thing* but every film that represents African American life. Referring back to my first point of departure for this book—*Death 24× a Second*—Mulvey provides just one example of racially loaded analysis. She demonstrates a common failure to listen fully to the racial politics of a film: Douglas Sirk's *Imitation of Life* (1959). Before I leave *Death 24× a Second* behind, I focus on the representative peculiarity of what Mulvey does with this film.

Imitation of Life: Rehearing Sonic Subversiveness

Mulvey zeroes in on the presence of African American extras in the opening beach scene of *Imitation of Life*. They are unobtrusive but important presences that could easily go unnoticed were it not for a pause button. Mulvey's finding these extras reminds her of how often minority peoples are placed at the margins of mainstream cinema and society. Though Mulvey says the remote control can therefore be a progressive weapon because a pause button can help the viewer uncover subversive truths, this is nullified by her emphasis on the *pastness* of the cinematic moment. Moreover, her work sidesteps the much more obvious significance of *Imitation of Life* as a story about intergenerational Black

trauma: after the exposition, the narrative is increasingly preoccupied with an African American woman (Annie) whose own daughter (Mary-Jane) rejects her with the goal of passing as white. In writing only of those moments that might be easily missed were it not for the keen film critic empowered by a pause button, Mulvey leaves out the most salient racially charged elements of the film.

Mulvey's analysis of *Imitation of Life* is a particularly curious example given that the film *foregrounds* the moving performance by Juanita Moore as Annie. She begins as a familiar Mammy figure but emerges by the film's end as its most hallowed presence. Indeed, Annie transcends all the belittling limits of her stereotypically subservient role because a massive crowd gathers to grieve for her. Mulvey's insistence on foregrounding visual details that are fleeting and missable while entirely leaving out any sonic dimensions of the film is troublingly representative of the visual bias in cinema studies too. She stresses the *silent* onscreen presence of African American extras, but she does not analyze the scene of Annie's funeral in which Franz Waxman's score reaches an orchestral climax along with the excruciating cries of Sarah-Jane who finally begs for her mother's forgiveness. The child who once rejected her mother is now in sincere mourning for her. She throws herself against Annie's coffin in a desperate, too-late expression of attachment. This is the film's emotional highpoint, and its most gut-wrenching development of a character. Therefore, I find Mulvey's analysis not only incomplete but counterintuitive.

Mulvey's visual analysis revolves around the film's much better-known star, Lana Turner, who plays the white female lead (Lora Meredith). With emphasis on the film's opening beach scene, Mulvey stresses the camera's sexualization of Lora versus its emphasis on Annie's maternal care for their daughters. She describes the topography of the opening scene that places Lora above Annie, and which associates the freedom of camera movement with the white woman over and above the Black woman, prefiguring Lora's rise in star status through the film after Annie becomes her selfless maid.[16] Though I find Mulvey's visually-driven logic indisputable for this one scene, her analysis negates the trajectory of the film's development toward a climax that does *not* privilege Turner's star power at Moore's expense. Before the end, Annie takes the central role of martyr, a position traditionally reserved for the white female lead (as with all Sirk's films featuring Jane Wyman). The last scene places uncommon emphasis on her significance: having shown Annie mostly relegated to a private life of service to Lora and her daughter

behind the scenes, *Imitation of Life* eventually shows a surprisingly large crowd lining the street for her very public funeral procession.

Imitation of Life places extreme sonic emphasis on Annie's death through the large crowd of silent mourners, Sarah-Jane's cries, Waxman's music, *and* an intensely personal diegetic performance by "the Queen of Gospel," Mahalia Jackson. She sings "Trouble of the World" at the funeral church service, in an unusually lengthy scene of diegetic music for a melodrama. Jackson's voice dominates the aural hierarchy. The film shows her face in tight close-ups, with just a few cutaways to show the congregation attentively listening to her.[17] Through this performance, Annie's voice is virtually reheard after her death. Jackson musically articulates Annie's feelings about death, even if she takes sonic command as Annie never did. "Trouble of the World" expresses that which lies beyond what Annie is able to tell Lora before her last breath. On her deathbed, Annie simply and kindly relays her last wishes as a quiet response to Lora's trembling, tearful protestations that she cannot die. Finally, she says, "I'm just tired, Miss Lora, awfully tired." Moore's quiet, soft delivery is consolingly underscored by Waxman's heavenly sounding chorus of female voices harmonizing with strings. Her transition to heaven is then signaled by a sudden series of pedaled, accented, and descending low piano notes, and Lora screaming "Annie! Annie!" By contrast with Annie's mild and weary voice in relation to Lora's anguished, loud screaming, Jackson sings with the robust force of a woman propelled by faith that overrides her pain. Her lyrics place newly comforting emphasis on Annie's way of dying: "Soon I will be done/With the trouble of the world/I am goin' home to live with my Lord."

The lasting legacy of *Imitation Life* is not in the initial seen-but-unheard extras who easily escape our attention during that first beach scene, notwithstanding the symbolism of this marginality, but in this final emphatic emphasis on the multidimensional life of a Black woman who is mourned by one aurally dominant Black woman and many *very visible* Black people. By choosing to focus on the ingenuity of her finding Black visual presences that might be too easily missed, Mulvey fails to hear the most subversive, life-affirming, and hopeful energy of the film. She places herself in a position of an "armchair conquistador," traversing the film to make a claim for some of its undiscovered meaning.[18] When Mulvey uses the pause button to "freeze the flow of action" in the beach scene most particularly, she turns the film into an object to be dissected: this ironically parallels her own seminal writing on the fetishization of the cinematic female body as a frozen object to be consumed

by the spectator, reducing what that presence can be.[19] Given her emphasis on the political prescience of *Imitation of Life*, especially as it was released during the civil rights movement of the mid-1950s, this is an odd position for her to take: she omits the film's most obvious political dynamism and in so doing denies her reader the life that comes from that. *Imitation of Life* does not simply change the way we view Annie as more than a supporting, minority character: its last sequence "talks back" to all the preceding scenes by insisting on her being the film's most beloved and larger-than-life presence. Moreover, in the act of freezing frames for her close analysis, Mulvey inevitably cuts *all* the film's sound: whatever latent meaning she consequently unleashes, this is another form of death.

I do not study, teach, or write about Sirk's *Imitation of Life* because I want to indulge a fetishistic urge to pick it apart as a curated object of the past. More to the point, I have not included the film within my course titled "Film Politics" because it relies on my pausing frame by frame to perceive the subversive meanings that might be otherwise hidden. I teach *Imitation of Life* because I think it still speaks overtly, urgently, and directly to what is happening *now* in America, even though it revolves around the extraordinary story of an imagined past. In writing about such films and teaching students for a different time than Mulvey's, and in the wake of our BLM uprising as well as our pandemic crisis, I am duty-bound to explain why my work matters as *part of life more than death*. I talk back to Mulvey's analysis of *Imitation of Life* because it demonstrates a great danger: performing an intellectual pirouette around the artistic object of fascination that can be locked in time, as something to look at like a museum artifact behind glass. She does not think of how that creation can literally enter an audience's breathing bodies through sound, becoming part of *that audience's present, embodied moment*, nor does she consider how every individual life is extended by such an encounter and how the object itself gains innumerable afterlives through that.

Let Us Rehear, So We Can Re-see

Though I celebrate the progressive energy of *Imitation of Life*, I recognize the overwhelming number of films that are racially offensive. Before zeroing in on Lee's *BlacKkKlansman* as another progressive exception to the rule, I must restate the importance of hearing the racial politics of all cinema better. Lee's films positively demand that his audiences perceive and engage with racial

politics, but I believe we should rehear the other voices, music, sounds, and silences of *all* our cinematic past so that we can understand its hurts and omissions better. The documentary *I Am Not Your Negro* (2016) is an indispensable primer on the racism that dominates American cinema and a terrific starting point for confronting this history. *I Am Not Your Negro* features extracts from James Baldwin's unfinished novel *Remember This House* that are spoken in voiceover by Samuel L. Jackson. This voiceover reminds me just how reality-shaping an authoritatively recognizable vocal delivery can be. Jackson's voice is closely miked, and even when certain film quotations gain aural prominence, the sound mix repeatedly returns to making his voiceover prominent. Baldwin's words *and* Jackson's vocal delivery make for a doubly impactful experience of literally and figuratively "talking back" to white-dominated cinema, undoing its seeming immutability. Along with an extract from *Stagecoach* (1939) showing John Wayne as the Ringo Kid shooting at Native Americans, Jackson (speaking "as" Baldwin) simply says, "heroes as far as I could see were white." Then he says that for Wayne there was simply "no necessity to grow up," thus complicating the potent visual image of Wayne as a fresh-faced "hero" of John Ford's first western feature with a sound track, a revered cinematic monument now defaced by Baldwin's words.

Later, *I Am Not Your Negro* juxtaposes a vibrant and pristine display of white characters' exuberant musical joy in a scene from *The Pajama Game* (1957) with a montage of real and grainy footage showing white police attacking African Americans. The scene from *The Pajama Game* is a saccharine-sweet example of choreographed exuberance, with an entirely white cast prancing across a Technicolor park of bright green grass. The characters perform "Once-a-Year Day," a song of frivolity, letting go, self-indulgence, and being entirely free from the need to behave. The lyrics include, "I feel like hoppin' up and down/Like a kangaroo/Jumpin' fences, climbin' trees,/What pleases me is what I'll do" and "Everyone's entitled to be wild/ Be a child, be a goof, raise the roof" (1.14.50–1.15.26). After "Once-a-Year-Day," *I Am Not Your Negro* makes a hard cut to handheld footage of white American police in militia Black combat gear, followed by sounds of gunfire and screaming as African American citizens run from them. The shock of this juxtaposition with *The Pajama Game* is extended through a montage of six more examples of African American civilians being attacked by police. This audiovisual disturbance makes the constant sound of resiliency and steadiness within Jackson's bass-toned delivery of Baldwin's words

all the more impactful: "This is the formula for a nation or a kingdom in decline, for no kingdom can maintain itself by force alone."

The very next clip of *I Am Not Your Negro* is an excerpt from *Soldier Blue* (1970), showing a Native American woman scrambling on the ground while her clothing is savagely torn by white soldiers and she screeches in panicked agony. The documentary juxtaposes this with actual photographs of the Wounded Knee Massacre. Baldwin/Jackson says that "not everything that is faced can be changed. But nothing can be changed until it is faced." Through such juxtapositions, *I Am Not Your Negro* reminds me that facing history—whether cinematic or not—is a crucial part of being alive and morally engaged with the world.

Near the end of *I Am Not Your Negro*, after a montage of Black people hanging dead in the distant past, and a sequence of Black people looking into the camera in the present, there is some archival footage of Baldwin in a television interview saying, "I can't be a pessimist because I am *alive*. To be a pessimist means that you have agreed that human life is an academic matter. So, I'm forced to be an optimist, I am forced to believe that we can survive whatever we are forced to survive." The way that Baldwin uses the term "academic" here is all too redolent of a commonly negative pattern in everyday speech: the academic approach is frequently equated with what is practically inefficient, or theoretically removed from real life. I argue scholarship on cinema can be and *should* be directly connected to developing strategies for living in the world in wholly embodied, real, *and* optimistic ways. I now turn to a more extended example of a film that offers lifeshocking hope.

BlacKkKlansman

I hear Lee's *BlacKkKlansman* as an open invitation to rehear and re-see intersections of history, life, and cinema. It therefore parallels Baldwin/Jackson's words and the montage logic of *I Am Not Your Negro*, along with anticipating the compressed form of *Three Brothers*. Despite how these films confront rampant racism and the consequent "Trouble of the World," I perceive them all as affirming forms of life because they care enough to engage in the possibility of positive change. Ironically, *BlacKkKlansman* includes many features that Mulvey might connect with a propulsion toward the death: a narrative based on the documented past, the incorporation of static photographs, an historically authentic-looking *mise-en-scène*, archival

footage, and the static image of the American flag at the end. That said, every moment of the film serves the purposes of the American present in pressing and immediate ways. The past/present barrier collapses, much as it does within *Three Brothers*. This is most obvious in the film's final montage when the historical narrative cuts abruptly into television footage from 2018, including President Trump's problematic response to the 2017 Charlottesville tragedy. But even when recounting events from the 1970s, *BlacKkKlansman* is not a relic: to me, it as *rescue action*.[20]

The story of *BlacKkKlansman* comes from Ron Stallworth, the first Black detective in the Colorado Springs Police Department as of 1978.[21] Stallworth infiltrated and investigated the Ku Klux Klan by passing for white in his conversations with its leaders over the phone. By gaining insider's information, Stallworth prevented many KKK acts of domestic terrorism along with bringing down several key Klan members who held offices at the highest levels of US security. Despite his success, Stallworth's story was buried for decades because his police chief was worried it could result in a PR disaster for their department.[22] Though his police chief consequently told him to destroy all the evidence of his investigation, Stallworth took many of his own records and documents home for the basis of his memoir. He published that book in 2014, and it became the primary sourcetext for Spike Lee's film adaptation just four years later. Stallworth went against orders because he wanted something stronger than "word of mouth recollections that erode with time."[23] Lee's film gives that memoir a new kind of embodied reality, especially as it self-consciously uses a sound track to move its audiences for the *now*.

BlacKkKlansman features John David Washington in the lead role, and his very presence fuses the cinematic past and present because, as many reviewers have noted, his voice is similar to his father Denzel Washington's: he speaks with a low, warm, full timbre, along with a precise style of enunciation and well-managed modulations. His voice that sounds familiar while also new parallels the film's retelling a story of the past for the purposes of the present. This resonates with Stallworth's claim that being a Black man in America is not so very different today then it was when he first joined the police force, especially given the election of an "avowed racist" for POTUS.[24] President Trump has been repeatedly supported by David Duke, Grand Wizard of the Klan, the white supremacist leader who trusted Stallworth over the phone.[25]

In *BlacKkKlansman* Washington replays Stallworth's conversations with Duke as if they are happening on the spur of the moment, not as an obvious

reenactment of the past that has died, but as dialogue bringing the past *into the present*. As Washington reveals in many interviews about the film, Lee encouraged him to improvise much of the dialogue, especially when he was using the language of hate to deceive Duke.[26] Echoing Stallworth, Washington argues that the language of hate does not seem to have changed much since the 1970s. While the film is a period piece, Lee and Washington wanted it to have immediate meaning for a contemporary audience.[27] *BlacKkKlansman* represents life unfolding as it has and as it still does—not death 24× a second, but the past reimagined, rescripted, and improvised for the most urgent purposes of today.

BlacKkKlansman was released in the context of high-profile racially motivated attacks, including the 2015 Charleston church massacre by the white supremacist Dylann Roof, and the 2017 murder of Heather Heyer, who was killed in Charlottesville by James Fields ramming his car into a crowd of counterprotestors against white supremacists marching. For me, the film is like a chord struck in an acoustic space that feels endless because of these recent incidents and so much else since. Every piece of hate speech in *BlacKkKlansman* reverberates with the force of hurtful truth. In particular, the word "nigger" is like a note struck a hundred different ways throughout the film because it registers anew every time. Lee never lets the word get lost or swallowed. Any time a character says "nigger," I feel he aims a dart directly at me or any audience member and I/we cannot help absorbing it. There is no stopping this kind of motion—pause button or not. The word unleashed cannot be unheard, and its unquestionable potency energizes the film. Every time I hear "nigger" in *BlacKkKlansman*, the film pulses with the life of all those real and reel moments that it draws upon *and* anticipates.[28]

BlacKkKlansman opens with percussion (cymbals, timpani, and militaristic snare drums): it is a call to arms that leads into the first scene from *Gone with the Wind*. The scene is an iconically familiar one, showing Scarlett O'Hara (Vivien Leigh) moving through a field of dead soldiers who have fought for the Confederacy during the American Civil War. This scene is underscored by Blanchard's original score that alludes to Max Steiner's original Classical Hollywood scoring for the film. Blanchard echoes Steiner's techniques of adapting well-established folk music associated with the Civil War, the Old South, and the Confederacy.[29] Steiner's original score for this scene combines "Maryland, My Maryland" (1861) with "Taps" (1862). The melody of "Maryland, My Maryland is the same as "O Tannenbaum" (or "O Christmas Tree"), which might cause confusion on its own, but the

combination with "Taps" clearly signifies the death of the Old South: "Taps" was first written by General Butterfield (a Union Commander) as a final bugle call for solders to go to sleep, but quickly became a mainstay of military funerals and memorials services.[30] "Maryland, My Maryland" was the official state song of Maryland from 1939 (the year of *GWTW*'s release) but it has a much longer history as "an anthem of the Confederacy" from 1861. The song infamously includes lyrics about Abraham Lincoln as a "tyrant" and a "despot" and about the Union as "Northern scum!" Since the lyrics are obviously absent through Steiner's orchestration, their nastiness is suppressed, but that makes his scoring insidious rather than innocent.[31]

Echoing Steiner, Blanchard's score blends together quotations from two well-known, traditional pieces of music, but both of these choices have unusually complicated histories. First, Blanchard quotes from Stephen Foster's "Old Folks at Home" (1851), a song sold to C. P. Christy, a businessman who ran minstrel shows. The song has lyrics from the perspective of a Black man who is "a-longin' for the old plantation." Ironically, "Foster was a Northern supporter and a strong advocate for the abolition of slavery."[32] Second, Blanchard quotes the "Look Away" part of Daniel Decatur Emmett's "Dixie," which was originally written for Jerry Bryant's traveling minstrel show in 1859:[33] Despite Emmett's "Northern origin and his stance against slavery," his song became "the battle cry of the Confederacy and a staple of Southern pride."[34]

The effect of Blanchard's score is peculiar: though the music is not for *GWTW*, it *sounds like it could be*. At the same time, while Steiner incorporated fragments of songs for their unironic value to eulogize about the Old South, Blanchard's use of similar songs is ironically inseparable from an historical reality of racist musical appropriations. Blanchard's allusive score immediately complicates the nostalgic possibilities of including the *GWTW* scene within *BlacKkKlansman,* just as the first percussive call to arms over that scene lamenting the death of the Old South is ironized by the film having been directed by Lee. The director has been as outspoken as James Baldwin on the dangerous deceitfulness of movies that sentimentalize the era of slavery and that perpetuate racist stereotypes. The climactic montages of *Bamboozled* (2000) makes this breathtakingly clear: a compilation of scenes showing laughable, contemptible, caricatured, and Blackface African American characters before the closing-credit close-ups on various racist ornaments and museum pieces. Through this juxtaposition of two montages, shifting from the living/breathing examples to the curated items, Lee talks

back to those films that marginalize African American people by turning them into objects for consumption. *BlacKkKlansman* holds the past in its hands in a similarly playful-but-serious way.

As a scholar of sound tracks, I am fascinated by the way *BlacKkKlansman* begins. While I cannot expect that every audioviewer will hear it as I do, I hope to make its sonic strategies more audible and symbolically meaningful to the reader. The *GWTW* scene enlists my alertness through an unusually curious sonic technique: the inclusion of a new female vocal track, through which an unseen and anonymous woman speaks for Scarlett O'Hara. Along with the familiar sight of Scarlett's panicky movements through a field of fallen soldiers, gasping and crying out to men carrying the wounded, this new voice speaks Scarlett's lines anew: "Have you seen Doctor Meade? Doctor Meade! Oh, can you help me find Doctor Meade, God help us." This familiar/unfamiliar audiovisual combination creates a sort of accordion effect for me—the film stretches back into history and then sonically closes my feeling of separation from it. As opposed to the original scene of *GWTW*, in which Leigh's voice is virtually drowned out by Steiner's score within seconds, the anonymous woman's voice for Scarlett at the start of *BlacKkKlansman* is closely miked and clear. The new voice attached to Scarlett therefore brings me closer to the dangers that extend from her time to ours. The fact that the film never reveals who is speaking for Scarlett matters as well: I imagine she could be any and all women who want to embody the character, from 1939 right up until today.

Retrospective screenings of *GWTW* mean that Scarlett's voice is reheard in contemporary cinemas as part of her fetishistic value, and in contexts that sidestep the problematic aspects of the film. Not long after the tragedy in Charlottesville, the Tennessee Theatre in Knoxville prompted a public outcry when fans believed they would stop showing the film. The Theatre's executive director Becky Hancock was then at pains to stress "we'll show it as a piece of cinematic history and not war history."[35] *GWTW* was screening in Memphis' Orpheum Theatre *the same night* that white supremacists marched in Charlottesville. Though *BlacKkKlansman* does not mention this, the footage from Charlottesville toward the end of the film makes me think about where nostalgia for the Old South can lead.

From the outset, *BlacKkKlansman* is an echo chamber of reverberations across histories of cinema and racial representation. The first scene injects new life into some familiar visuals, along with reminding me that *GWTW*'s white-dominated representation of the Old South retains some powerful

sway. *BlacKkKlansman* closes with a moment that visually echoes this opening scene, driving home its fusion of the past and the present. The Confederate flag that ends the opening scene from *GWTW* is ultimately answered with an upside-down American flag that fades to Black and white at the end of the film. The inversion and removal of color is a powerfully nonverbal statement on the negative consequences of Black/white logic—whether racially based or morally simplistic. Further, this vision of a distorted flag implies that Lee sees America as a nation undoing itself. As the flag changes, the final silence of the sound track makes me attend to such symbolic possibilities.

A flag can change in aspect, just as the significance of a film can be re-understood. The opening scene from *GWTW* cuts into a scene featuring Alec Baldwin as Dr. Kennebrew Beauregard, a fictional white supremacist of the 1970s. He is using the scene from *GWTW* as a segue into his speech behind a bogus news desk backed by a prominent Confederate flag. This is the superficially and ironically authoritative visual context for his conspiratorial declarations about minorities seizing control from white people in order to create "a mongrel nation." "We had a great way of life," he insists three times, "until the Martin Luther Coons of this world and their army of Commies started their Civil Rights Assault against our holy white Protestant values." Beauregard's emphasis on a "great way of life" obviously resonates with President Trump's campaign slogan "Make America Great Again," suggesting that his time of the 1970s anticipates the time of the film's release. Beauregard's delivery soon crescendos as he speaks of minority peoples who are "racists, murderers," and "super predators." Here, his propaganda film-within-the-film features extracts from *The Birth of a Nation* (1915), including the infamous footage of a Blackfaced villain (Gus) attempting to rape a young white woman (Flora). Since the white virgin would rather die than be defiled by a Black man, she jumps off a cliff before he can catch her.[36] Her screaming presence is made new by the anonymous female dubbing within *BlacKkKlansman*. Beauregard uses his film quotations (from both *GWTW* and *The Birth of a Nation*) as "evidence" of threats to white lives in support of his claims.

Despite his forceful dogmatism, Beauregard messes up his own delivery. At times, he even sounds like a man at war with himself, though without Baldwin breaking role. Beauregard stumbles on the words that make his speech particularly nasty: "miscegenation," "Brown decision," "coffin," "we had a great way of life," "virgin white," and "Northern Black beasts." He

further undermines his own power by interrupting himself to check his lines or shout "God, watch this, God!" By breaking his own rhythm, he disrupts the flow of his own familiarly modulated newscaster performance. All his vocal stumbling makes Beauregard visibly angry and increasingly frustrated. In the absence of flattering edits that would cut out his failures to deliver his own speech fluidly, the film undermines him as much as he undermines himself. As Beauregard finishes speaking, some progressively distorted and blood-red-tinted scenes from *The Birth of a Nation* play over his face, further disrupting his performance. The superimposition makes his features appear increasingly strange, and his shifting visage clashes with the unyielding prejudice of his script (see Figure 1.1). Beauregard's broken vitriol is compounded by a further, metacinematic point: Baldwin has repeatedly expressed revulsion with playing President Trump because of the limitations of his speech as well as the hatefulness of his ideology.[37] Baldwin does not imitate President Trump's uneven intonations as he has for *SNL* here, but his performance in *BlacKkKlansman* is a viciously ironic extension of the way he parodies President Trump's dogmatic extremism. Beauregard's entire propaganda film is a new representation of fake news and broken logic, a way of talking back to Trump by turning the man best known for parodying him into an unusually and mesmerizingly *unstable* audiovisual presence.

While Beauregard speaks, Terence Blanchard's most lyrical and sonorous cue (the playfully titled track, "Hatred at its Best") argues against his poisonous words. This music features soft timbres: gently played piano chords,

Figure 1.1 *Birth of a Nation* plays over Beauregard's face, distorting his visage in a subversive way, and detracting from his speech.

legato strings, muted clarinet, and light flutes. The melody is held by violins above the slowly thickening harmonies, and each melodic shift is so consistently matched by harmonic changes that the whole cue evokes the steady grace of a hymn. The meandering through-line of the melody communicates expansive hope, freedom, and ease that echoes the music of Aaron Copland (reminiscent of the very opening of Lee's *He Got Game* (1998), which features Copland's "John Henry").[38] Blanchard's music is a most extreme form of counterpoint in relation to Beauregard's hate speech.

BlacKkKlansman acknowledges the lasting power of *GWTW* and *The Birth of a Nation*, but it also undermines them through the ironies within Blanchard's music, the newly recorded speech for white female characters, and Beauregard's disrupted vocal delivery. Much later, the film revisits *The Birth of a Nation* when Klan members watch it with great enthusiasm. For me, this scene is even more searing. The onscreen Klan audience provide a new aural accompaniment to the film, almost as if they are attending an interactive pantomime: they jeer at the Black characters, cheer for the Klansmen, shout racial slurs, and chant "white power!" The film intercuts medium shots of them with close-ups of Stallworth looking on from an observational distance as "security detail," his face fallen in silent disgust.[39] I find it hard to stomach this scene, even though the Klan is satirically represented and the camera brings me closer to Ron. I read the onscreen crowd's jubilant reaction to *The Birth of a Nation* as an invitation for me to give my own vocal response, to speak out because people like Stallworth have had to remain silent.

Music for Hearing (and Honoring) Difference

In Blanchard's score for *BlacKkKlansman*, I hear the film's most direct appeal to my conscience. It is a strident, albeit wordless, form of commentary. His scoring talks back to countless other films with music that privileges the presences and voices of white characters only. Ron has the most developed theme, with the clearest signifying logic and the most instrumental and textural variety. The first iteration of Ron's theme is unusually late and relatively subdued for a protagonist of a major film. It does not come until his first undercover mission attending a Student Union rally for Kwame Ture to witness what his police chief argues is "the greatest threat to national security": Black Power. Ron's theme is a full-bodied, arching melody for electric guitar, one that begins in a languid tempo but which gathers in complexity and intensity,

including harmonies by flute, strings, and brass, and then a piano picking up the melody while the guitar riffs above it (13.55–15.40). This first iteration is a fluid, free and effortless, playful counterpoint with excitable Black voices outside the rally venue. It is a relatively subtle "backdrop" cue while Ron first meets and talks to Patrice, president of the Black Student Union in charge of the event. Ron's theme ends before Patrice introduces Kwame, leading into his speech beginning, "I'm here tonight to tell you that it is time for you to *stop running away from being Black*" (his emphasis). Kwame then speaks of Black people reclaiming their beauty, and Ron appears as caught up in his words as the civilians around him. This scene works ironically in relation to an earlier scene where Ron offers to shave back his Afro for the police chief: he fears not being taken seriously enough with his natural Black hair. Therefore, the first iteration of Ron's theme positively anticipates his joining a crowd reclaiming both Black Power and Black Beauty. His theme is immediately connected to the work he has longed to do, the new purpose he lives as a Black man straddling two worlds, and his claiming himself back through a new professional standing. This music is about reintroducing him as a man with latent power, quiet determination, and self-regulation. It is the antithesis of that initial, prominent music for the opening *Gone with the Wind* scene that knowingly amplifies a spectacular, bombastic, unselfconscious white claim to righteousness.

The most poignant variation on Ron's theme comes with his silently entering a space once occupied by Klansman doing target practice. In an earlier scene, Ron's partner, Flip (Adam Driver), the white officer who pretends to be Stallworth when in person with the Klan, shoots with the Klansmen. They fire their rifles at a row of wooden, Black, human-shaped targets. The film does not show what they are shooting at immediately, so Ron's moment of visual confrontation with the Black targets is the audience's own in alignment with him. Before Ron enters this confrontational scene, the camera is positioned in the long grass before him and then it slowly tilts to show Ron arrive and pick up a shell casing. His music precedes his appearance (1.01.20–1.02.45), as if laying out a sonic carpet for him to tread. With this cue, Ron's theme is played at a slower pace than its original iteration in the film and maintained at forte without any other sounds competing with it. The theme gains special prominence through a full orchestral texture that builds around the guitar line and becomes increasingly percussive. The strength of this cue communicates Ron's reaching new heights of unwavering focus. He walks right up to a Black wooden target and stares at it. Then he touches the

44 LIFE 24× A SECOND

Figure 1.2 Ron Stallworth approaches the Black target on the firing range.

Figure 1.3 After pausing to take in the line of Black figures, Stallworth walks away, making himself another figure in the line.

target in a gesture of sad recognition before walking away. The film shows Ron's body in the crook of the target's arm as he approaches it (see Figure 1.2), then as one in a line-up as he walks away (see Figure 1.3). The visual logic is clear: he could possibly become yet another target for the Klan. The variation of his theme, here titled "Firing Range," is about his *resolve* in the face of this reality: with the introduction of strong snare drums near the end of the cue, the music says he is reaching a new level of assertion. The strong presence of snare drums links this scene to the start of *BlacKkKlansman*, as if talking back to *GWTW*'s vision with its own emphasis on Ron's quest. The cue relays his willingness to confront the truth that is as strong as his ability to walk away from what hurts him too. Minutes later, Ron's theme returns in part, as he is checking mail and opening up his new Klan membership

card, this time in a softer variation dominated by flute and pizzicato strings (1.07.05–1.07.30). These two examples are representative: Ron's theme repeatedly recurs when he *could* be feeling oppressed and disempowered but when he chooses to own his own power in investigating the Klan: without falling apart, he goes where they have been to expend racist energy and sees his name attached to a signifier of their standing as "the organization."

BlacKkKlansman self-consciously stresses Ron's struggle in straddling the two worlds of the white-dominated police force and the struggles of African Americans as victims of institutionalized bigotry. Patrice and Ron openly discuss W. E. B. Dubois's related concept of "double-consciousness," which she defines as "two warring ideals inside of one dark body." Later, in a moment of atypical cruelty, she accuses Ron of being a kind of "house nigger" because he is a "pig." Yet as *BlacKkKlansman* progresses, Blanchard's music repeatedly stresses Ron's certainty about who he is, using his variable theme to underline his adaptability. By contrast, Blanchard's cues for the Klan (including tracked titled "Connie and the Bomb," "Guarding David Duke," "Klan Cavalry," and "White Power") are not memorable or repeated enough to become recognizably flexible.

Blanchard makes me feel as if I have a direct line to Ron through his music, even in his silent moments. While the camera frequently rests on his unmoving and stoic face, his changing theme reveals his dynamic inner life that consistently demands my attention. This uncompromising focus on a Black man's distinct and multidimensional interiority is still relatively unusual for mainstream cinema: to quote Trea Andrea M. Russworm, such "psychological recognition, even if obtained momentarily, can never hold."[40] This is the reason for the provocative title of her book, *Blackness Is Burning*, a reference to the 1960s refrain "Burn, Baby! Burn!" popularized by R&B and soul music radio DJ Magnificent Montague.[41] Ironically, there is a literal fire in *BlacKkKlansman* at the narrative climax, but this is the result of an explosion that Ron has successfully prevented from killing innocent Black civil rights activists. In that scene, Ron is temporarily on the ground at the mercy of white police officers, but the burning still signifies his triumph that is underscored by Blanchard's most extended variation on his theme. Even when he is down on the ground, Ron's music rises with the flames, representing his resilience instead of his destruction.

Ron's music works against the muteness that his police superiors attempt to impose on him: in his initial interview for the Colorado Springs Police Department, they state an explicit expectation that he will respond to overt

racism with the silence of a "Jackie Brown." The camera frequently shows Ron absorbing the lifeshocks of unforeseen levels of hidden dangers, hate, and bigoted ambition: for example, when his white police mentor warns him of the possibility that a Duke-sympathizer might take residence in the White House (47.10–48.30), and when an FBI agent tells him that two Klan members have been privileged with the highest levels of security in the interest of national "safety" but then quickly insists "we never had this conversation" (1.22.35–1.24.23). In these scenes, Ron is imaged as a solitary figure taking in newly appalling information and who cannot speak or must remain silent, but Blanchard's music *never abandons him*. During both scenes, Ron's theme underscores the dialogue.

The film's climax comes after Ron interrupts a Connie (Klansman Felix's wife) planting a bomb in Patrice's mailbox, and many key characters converge after the big explosion in her car: representatives of the Klan (Felix driving with David Duke's voice on his radio, Connie), representatives of the Black Student's Union (Patrice and her friend arriving home), white police officers who wrestle Ron to the ground, and Flip, the officer who intervenes for Ron. This scene shows the scale of action broadened far beyond Ron's one-to-one conversations with David Duke, bringing all the ultimate tensions together in the presence of a massive explosion, which makes the music's emphasis on Ron's theme all the more significant. The cue that leads into and dominates the climax is titled "Blut und Boden" ("Blood and Soil") (1.51.30–1.56.05). As Jonathan Broxton explains, the "blood and soil" chant was commonly "used in nineteenth-century Germany to espouse Nazi ideology." Near the end of the film, there is real-life footage of white supremacists chanting "blood and soil" at Charlottesville. The cue "Blut und Boden" begins with wavering flutes before the texture soon thickens with strings and brass. Then, Ron's theme emerges through an expressively dominant electric guitar line. It is an important elongation of Ron's theme as first presented, with the guitar maintaining its clarity even after militaristic snare drums come in.

The snare drum section of "Blut und Boden" is first associated with the Klan in *BlacKkKlansman*, when an abbreviated iteration of the cue underscores Klan members arriving at their initiation ceremony (1.29.39–1.31.23). Snare drums also link us back to Blanchard's first "Gone with the Wind" cue with all its ideologically heaviness. That said, in the climactic iteration of "Blut und Boden," Ron's theme plays at higher pitches when the snare drums enter, symbolically suggestive of his transcending those who

oppress him. His theme continues long after the drums have dropped out too, signaling his lasting victory. At that point, the guitar line becomes a freewheeling, improvised-sounding, virtuoso performance of unpredictable rhythms and jazz-inspired funk, an unbroken line of music even as Connie and white police scream and yell at Ron above it, almost as if they are arguing with the nondiegetic authority of Blanchard's score that speaks for Ron when he cannot. The music anticipates Ron's resounding triumph over the Klan well before Flip arrives to rescue him from arrest. Its orchestral scale communicates an audacious belief in something bigger than Ron too: the good that must prevail over evil.

The Unending Story

After its narrative climax, *BlacKkKlansman* follows Ron's hard-won triumph with his wish-fulfilling final conversation with Duke. He finally gets to throw Duke's hate speech back at him, letting go of the extreme restraint he has embodied up to that point. Where before he silently gave the middle figure to Duke over the phone, now he identifies himself explicitly using Duke's racist terminology against him: he says, "this nigga, coon, gater bait, spade, spook, Sambo, spear-chucking jungle bunny, Mississippi wind-chime Detective is Ron Stallworth you racist, peckerwood, red neck, inch worm, needle-dick motherfucker!" Duke can only respond with silence while Stallworth revels in his pointed emphasis on every single racial slur, like a series of unbroken musical downbeats. His words are punctuated with the laughter of his colleagues listening in. The film tips the balance of a split screen toward Ron, at Duke's expense (see Figure 1.4).[42]

BlacKkKlansman does not rest on this triumphant release, however: the film maintains tensions between opposing sensibilities until the very end. After Ron's final telephone conversation with Duke, a scene shows him privately arguing with Patrice about his continuance in the police force. As this scene ends, the last music before the final credits begins. The cue is "Photo Opps," a track Blanchard adapted from his own score for Lee's *Inside Man* (2006). Here, the sinister reality of the present is underscored by the pre-existing music that suggests history repeating itself. This last cue (2.05.09–2.08.43) starts by underscoring the very last images of Ron and Patrice with their guns raised against an unseen and unidentified person knocking at their apartment door. This scene transitions into images of an imagined Klan cross

Figure 1.4 Stallworth's final moment of talking back to David Duke. The split-screen not only pays homage to the popularity of that technique in the 1970s when the action is set, but also underlines that Stallworth has disrupted Duke's "image" with the support of several white men.

burning and then actual media footage of Charlottesville. Lee thus withholds a feeling of safety that might come with keeping the *mise-en-scène* in the past.

"Photo Opps" is a slow-moving, minor key, orchestral piece built around a repetitive theme shared by full-sounding brass and strings. This cue underscores the disturbing voices and sounds from August 11, 2017 with eulogizing weight: white supremacists are shouting "blood and soil," "Jews will not replace us," and "white lives matter," before a cut to counterprotestors shouting "Black Lives Matter." The film shows members of these opposing groups fighting on the streets. Then comes a cut to President Trump speaking from Trump Tower on the very next day (August 12), insisting with a tone of emphatic condescension, "you had a group on one side that was bad and you had a group on the other side that was also very violent. Not all of those people were Nazis, believe me." *BlacKkKlansman* undermines him with a cut to people shouting, "Nazis go home," and men with swastika flags, followed by Trump's continuing speech: "Not all of those people were white supremacists. You also had people that were very fine people." The sequence then cuts from Trump to some footage of the real David Duke speaking to an audience about Trump "taking America back" (also on August 12).

"Photo Opps" communicates a grim understanding of the ideological threat embodied by both Trump and Duke through its low pitches, minor tonality, sinister chromaticism, and incrementally emphatic percussion (featuring timpani, cymbals, and snare drums toward the end). The

ponderous pacing and sustained notes of this cue suggest waiting for change too. When asked how he feels about having his music playing underneath the hateful speech of both men, Blanchard responds by stressing the moral subtext of his work: "I'm 56 years old and being from the South, I've been hearing [that kind of speech] all my life. I didn't want to glorify it but the music to me, in those scenes, is that intangible thing that speaks to the humanity within all of us."[43] He thus connects his composition with Lee's "humanitarian" outlook in "constantly trying to allow people to deal with the fact that we know what's right and what's wrong."[44] Blanchard's music is a benign way of talking back to racist leadership without forgetting deep-seated hurt.

The clip of Duke's speech cuts suddenly into footage of James Fields driving his car into the Charlottesville crowd, and people screaming in shock. "Photo Opps" continues still, providing a consistent sense of compassionate musical logic pitted against the chaotic agony of people screaming and shouting. The footage from Charlottesville was not in Lee's original script, nor in Barry Alexander Brown's first cut of the film, but Brown explains that the idea was "stewing" in Lee's mind for months leading up to its screening at Cannes Film Festival.[45] This parallels how Lee decided to add footage from the Rodney King beating in his film of *Malcolm X* (1992) because the uprising occurred during his rough cut screening for Warner Bros. studio executives on April 29, 1992.[46] As Brown argues, Lee's work is constantly evolving, with the present feeding into the past so much that Lee never draws a hard line between them.[47] Indeed, Lee's emphasis on allowing the present and the past to feed into each other is like a continuous movement along a Mobius strip. This is part of his films' vitality, for they consistently evolve in keeping with the realities around their own making.

The last held cadence of "Photo Opps" plays over Heather Heyer's face filling the screen, followed by two images in silence: a gathering of flowers by her picture along with a handmade sign that reads "no place for hate," and then the American flag (first in color, upside-down, then turning to Black and white). With this silence, the film provides the audioviewer with a merciful break from competing sonic messages, jarring cuts, and the sounds of violence and distress. Here, *BlacKkKlansmen* gives breathing space for a different voice to rise. After a few moments, the music for the final credits begins: Prince's heartbreakingly beautiful performance of "No Mary Don't You Weep." This music parallels Blanchard's in that it offers the hope of a humane and compassionate perspective; it is a comforting balm after the film's agonizing final sequence. The song is about a loss that is incalculable,

both religiously loaded and grounded in the reality of how people make the world cold (as relayed in the lyrics "Mary, Mary, don't you mourn, yeah/I got that bad, bad feeling your man ain't coming home, yeah/Home" and "I don't like no snow/No Winter"). Despite the lyrics that communicate inconsolable grief and cycles of mourning, the piano's rhapsodic and rubato accompaniment refuses to capitulate to pain, matching the elasticity of Prince's voice that communicates range, buoyancy, and exuberance that cannot be contained in traditional measures. This is music that bends time to its own unique logic, an unconventional lullaby for grown-ups who acknowledge suffering but can still make something beautiful out of it. Hearing Prince's singing the extremities of pitch from the depths of his own body gives me a wonderous feeling of posthumous communion with his unmistakable voice. Lee's choice to position Prince's recording after the most painful footage within *BlacKkKlansman* is a tribute to the enduring power of his music, and it honors countless other Black lives by extension. In listening to this music and absorbing it wholeheartedly, I pull the film's most poignant truths inside myself.

Conclusion

I teach *BlacKkKlansman* because it knowingly resonates with current racial politics. I teach it to share the speech of a Black man who challenged extreme racism from within one of the most racially conservative institutions. I teach *BlacKkKlansman* because I feel the progressive vitality of its soundtrack that I willingly absorb into my body and that I want my students to absorb with me. I recognize the significance of how the film sonically changes the space around us in the classroom, even while we look at its characters from an historicized distance. *BlacKkKlansman* is a movie more about the Black Lives Matter movement for today than what has passed, and more about hope for the future than what has already been decided—all this is obvious in the voice of the lead character Ron Stallworth when he uses the language of hate against some of the people who made it. The film has the life-giving energy of resistance that is greater than the echoings of Klan gunfire or white supremacist speeches. This energy is in Blanchard's leitmotif-driven music that sonically represents the power of Stallworth's adaptable and certain self too.

I teach *BlacKkKlansman* because the film makes me listen carefully to all its details from the start, calling me to re-understand cinema as a form of

intervention for contemporary America. Ironically, it starts by confronting racism within the hallowed cinematic past. The film tells me to hear racist a film like *GWTW* differently, instead of allowing it to be encased as a fossil of life already over. *BlacKkKlansman* talks back to such canonized cinema by making it sound different. The film is *life* because it reanimates history, speaks urgently to the present, and trusts me to hear what it does.

2

Levels of Listening to *Nobody Knows*

Uniting Personal Experience, Pedagogical Practice, and Social Purpose

> One of the ways you can be written off quickly as a professor by colleagues who are suspicious of progressive pedagogy is to allow your students, or yourself, to talk about experience; sharing personal narratives yet linking that knowledge with academic information really enhances our capacity to know.
>
> —bell hooks[1]

> Conducting is communication. And what I communicate at the moment is what I feel and what my musicians need.
>
> —Zubin Mehta[2]

> I am hopeful that films can connect people who are in conflict in a separated world.
>
> —Hirokazu Kore-eda[3]

In this chapter, I continue to affirm the power of sound tracks that help me feel surer of what matters in life. In relation to the last chapter about hearing cinema that resonates with the current Black Lives Matter movement, I write from a more personal angle here. I start with the fact that motherhood has given me a newly heightened experience of cinema that entails my hearing children, parents, and the spaces they inhabit differently. I focus on *Nobody Knows* (2004), a film that revolves around the lives of children, while in the next chapter I focus on *Dancer in the Dark* (2000), a film that revolves around a mother and the way she loves her child. I combine bell hooks's interpersonal approach to pedagogy with Otto Scharmer's theory of multiple of levels of listening, both of which lead me to hear and teach cinema more hopefully,

and both of which empower me to apply my personal experience to pedagogy with conviction.

Although bell hooks wrote *Teaching to Transgress* almost thirty years ago, her book still reads like a timely manifesto for current progressive pedagogical practice: few academics honor students' voices as much as she does. She positions herself in a place of humility so that she can absorb their perspectives in classroom conversations that are always open to change. hooks sometimes gives her students direct instructions for sharing their experiences that relate to the texts they study. For instance, when she teaches Toni Morrison's *The Bluest Eye*, hooks has every student write an autobiographical reflection on a racial memory, which she then has them read aloud in class. She says that the reading aloud helps students generate a collective understanding of diverse points of view within a class, and "our collective listening to one another affirms the values and uniqueness of each voice."[4] Along with such preplanned assignments, hooks stresses those times when students' self-revelations generate extraordinary energy. For example, after students return from breaks from college, she typically asks about how they have applied what they learned in the classroom in the outside world. She writes that her students thereby "practice interrogating habits of being as well as ideas," and "through this process we build community."[5] She says, they "want knowledge that is meaningful. They rightfully expect that my colleagues and I will not offer them information without addressing the connection between what they are learning and their overall life experiences."[6] hooks shares her own personal stories of praxis with her students, which she says inspires them to share in kind.

hooks keeps her students on track, in terms of encouraging them to always relate their personal stories back to the academic subjects under class discussion, but she allows for a teacher-student reciprocal relationship of wholehearted engagement. As hooks writes, many other professors are wary of, or even hostile toward, including personal experiences within a classroom: for example, in *Essentially Speaking: Feminism, Nature and Difference*, Diana Fuss argues that personal reflections easily "dead-end the discussion."[7] Fuss finds students' attachment to their direct experience limiting, and says that this potentially leads to a "struggle for authority" with the professor. Conversely, hooks argues that students engage more when they feel directly connected to a text by virtue of their own experience, and that their sharing personal stories can be a humbling and "great gift" without disrupting her pedagogical purpose. Moreover, hooks is invested in a collaboration with her students as opposed to maintaining top-down authority.[8]

hooks drops the "banking system" idea of the teacher with the one who possesses the knowledge that students buy into and to which they must always attend.[9] Along with breaking away from the teacher-knows-best assumption, hooks says we must "teach students *how to listen, how to hear one another.*"[10] *Teaching to Transgress* consistently stresses listening as a proactive, necessary, progressive, powerful, life-changing, humanitarian, and pedagogically vital action. Along with foregrounding listening as a positive action, hooks speaks out strongly against silencing certain kinds of speech in the classroom, especially self-disclosures in relation to a text and admissions of not understanding. She also challenges those unspoken rules of institutional engagement that perpetuate marginalization as another form of silencing. In the context of recognizing that universities are still "not accustomed" to her own Black presence,[11] hooks emphasizes the hurts that minority students feel when "neither heard nor welcomed," so she pointedly affirms their "presence, their right to speak."[12] This is not about her creating a pedagogical substitute for therapy, but about her acknowledging that students often enter the classroom with wounded psyches.[13]

I argue from a different feminist position than hooks writes from, as a white middle-class mother working in American academia. I make no presumption to understand what a woman of any other race, or of any other historically marginalized group, experiences. While acknowledging the reality of my relatively protected racial position in a white-dominated profession, I have been stunned by the extent to which motherhood has led to my feeling disempowered before I knew how to apply that experience meaningfully in the classroom. I make no problematic assertion of what all academic mothers live along the lines of mothering theory that, as Judith Grant explains, "posits a universal female experience through which one can begin to explain the oppression of all women."[14] That said, my claiming motherhood as an experience that *positively* affects my professional practice is a significant political act that goes far beyond myself. While this chapter is my individual story of how I have applied the lessons of motherhood to becoming a more holistically engaged professor, I hope it resonates for all those academic feminists, parents, and caregivers who have struggled to find a work/life balance as I have and then found meaning in the struggle.

The birth of my first daughter was traumatic, potentially fatal, and I inhabited my body differently as a consequence. I was both critical of my postpartum shape, and intensely grateful that my body had survived. This immediately changed the way I taught feminism to my students: I was more

sensitive to the idealization of impossibly sculptured female bodies onscreen, which I greeted with a sense of personal failure *and* refreshed righteous anger. I was also suddenly more sympathetic to the voices of all mothers who are imperfect: I recognized I could never be the ideal of a mother who only sings sweetly to her children, like the one that Wendy imagines through a song in Disney's *Peter Pan* (1953). I saw myself possibly becoming the mess of a mother embodied by Laurie Metcalf in *Lady Bird* (2017), the overly controlling parent who says terrible things to her daughter despite loving her. As my frames of reference were changing, I wanted new conversations at work with my colleagues too. However, I realized that broaching such conversations was risky, and I learned that I was far from the first (nor last) to know this frustration. When I returned to teaching after maternity leave, some colleagues asked me if I had enjoyed my "time off," and expected me to demonstrate I was ready to return to work with as little mention of my child as possible.

In this context of becoming a mother, I became a new feminist to myself. As Sara Ahmed argues, "feminism can begin with a body, a body in touch with a world, a body that is not at ease in a world; a body that fidgets and moves around. Things don't seem right."[15] For me, this process began when I was pregnant and couldn't easily squeeze into the all-in-one desk chairs to do small group work with my students, nor behind the lectern podiums. In Ahmed's words (with reference to queer and disabled bodies who do not "fit"), "a *cannot* is how some bodies meet an environment."[16] I had the sense that the university institution was not built to accommodate my presence anymore, both literally *and* figuratively. After my baby was born, my heightened sense of physical vulnerability combined with my greater sentience (especially my hearing) made me more cognizant of the pressure that all parent-colleagues (and especially mothers) were absorbing every day without freely speaking about it. I noticed that nonparent colleagues I had considered friends were initially excited to see me return after maternity leave but that they were still wordlessly yet perceptibly resistant to moments when I steered the conversation toward my new experiences of having a child. I sensed they rejected such conversation because it derailed us from the "more important" subjects of work or dragged them down into my postpartum vulnerability. I therefore had the lifeshocking sense of being suddenly disconnected from a lot of the people around me. I saw academic life from a new vantage point: not as the domain that had allowed me to grow my own mind in the pursuit of knowledge, but as the place where conversations now might exclude me if

I participated as my whole self. In response, I became one of those people Ahmed calls "willful tongues":[17] I decided to keep talking about my work in relation to my home life, against the "rules" of the institutional culture. In Ahmed's words, I became a "space invader in the academy,"[18] principally by applying my personal experience to theorizing my pedagogy in an unorthodox way.[19] In my desire to bring motherhood into my professional work, I knew I was "not in compliance with the order of things."[20]

Ahmed's writing, like hooks before hers, unites her personal experiences with her theoretical arguments to define the best embodied, moral, and life-affirming pedagogical practice. Throughout *Living a Feminist Life*, Ahmed gives her readers a strong model of praxis, and she encapsulates this as follows:

> Theoretical work that is in touch with a world is the kind of theoretical work I wanted to do. Even when I have written texts organized around the history of ideas, I have tried to write from my own experiences: the everyday as animation. In writing this book, I wanted to stay even closer to the everyday than I had before. This book is personal. The personal is theoretical. Theory itself is often assumed to be abstract: something is more theoretical the more abstract it is, the more it is abstracted from everyday life. To abstract is to drag away, detach, pull away, or divert. We might then have to drag theory back, to bring theory back to life.[21]

Much of *Living a Feminist Life* is focused on Ahmed's direct encounters with institutionalized sexist behavior, which inspires her manifesto within it. This manifesto is a guide to being an effective "killjoy feminist" at work, one who refuses to be silenced even when that makes others uncomfortable. In speaking aloud and writing about how I hear and teach cinema from a mother's perspective, I am knowingly being a killjoy: my action is unusual and even distasteful to many of my colleagues.

Like Ahmed, I know that the language of hetero-patriarchal sexism is prevalent within academia, especially at the upper levels of administrative decision-making.[22] Moreover, as Loren Marquez (professor of rhetoric and composition) explains, the duties of motherhood often "*collide* with the expectations of the academy."[23] She explains that "making it" as a female academic is typically defined in three stages: becoming professional, thriving as a professional, and *then* developing a life "too."[24] Marquez calls for a more holistic idea of "making it" as a female professor/mother who tells and writes

her stories at home as well as work, and who consequently creates "an alternate rhetorical history of women professionals" that will "complicate and deconstruct the often patriarchal construction of professionalization."[25] More specifically, she explains that "the myth of the work-home divide needs to be re-imagined in our narratives and scholarship, not as a dichotomy, but as a system of reciprocal relationships that create both complexity and value in the lives of women professionals ... and subtly subvert the patriarchal structure of the academy."[26] Similarly, Michelle Schlehofer (psychology professor and former department chair) interrogates the dominant assumption that "women who become mothers are often seen as less-than-ideal workers and are subsequently penalized professionally."[27] She explores how and why gender inequality in the academy exists for many reasons, especially since "the tenure track timeline is not congruent biologically with a woman's reproductive timeline."[28] In a mentoring session on balancing life and work, Schlehofer was advised by a senior colleague: "Get tenure first, then have your children. And, time it so that they are born in early June."[29] She points out that such advice is problematic in making work a priority at the expense of family, and in implying that a woman has complete control over her reproductive capabilities. I would add a third problem here—her senior colleague's implicit assumption that having a child can take away from a professor's productivity and success if not tightly controlled. Both Marquez and Schlehofer have taught where I work, in the same building, and along the corridor from me at Salisbury University in Maryland. I only happened to find their work by chance because it was not widely circulated or publicized on campus. They have reminded me of a quiet sisterhood that becomes possible and more tangible when I seek it out.

 I talk back to that dominant belief within academic culture that having a child can materially *compromise* a mother's professional capabilities. My counternarrative is that having children has *increased* my abilities to teach my main area of expertise: film sound tracks. I do not operate with a scattered "mommy brain," but with a sharper ability for educating my students on how to listen. I do not imply for one second that *only* motherhood can enable a person to deepen their pedagogical practice through an integrated approach. Indeed, this counternarrative is broadly transferable to *any* person's lifeshocking experiences that can feed into their better teaching. Further, I argue that the synergy between our personal and professional lives is inherently unavoidable, meaningful, *and* desirable. Just as hooks argues that teachers and students should "move together" in "mutual engagement."[30]

I argue that I can only teach well if I stand before the class as my entire self, as the person changed by motherhood as well as the scholarly practitioner who wants to keep learning through teaching. The wonderfully sustained surprise is that my students have welcomed this for fourteen years. Though the institutionalized realities around me have not materially changed since the birth of my first child, within the contexts of my classes I have felt a freedom that I hope can and will extend to other working parents, and especially to those mothers who have felt alienated as I have.

Despite several book-length studies of films that revolve around children (including Karen Lury's *The Child in Film: Tears, Fears and Fairy Tales* and Ian Wojik-Andrews's *Children's Films: History, Ideology, Pedagogy, Theory*), and the first global documentary on the subject (*A Story of Children on Film*, directed by Mark Cousins in 2013), there is little sustained analysis of how parenthood affects the pedagogical practice of teaching cinema.[31] Given that having a child can change a person's perceptions of the entire world, this gap in scholarship is strange. In the movie *Whip It* (2009), a mother named Maggie Mayhem (Kristen Wiig) voices the truth of becoming a parent by simply saying, "*everything* changes." This transformative level of change includes all the senses. There are well-documented studies of how a new mother hears more acutely, for example, which is linked to the rise in oxytocin that make her sensitive to the sound of babies' crying.[32] I know that my maternal sense of sound is heightened beyond such basic biological imperatives too. Indeed, I find that my sonic perceptions are *entirely* altered: I think about what I say and who is listening more carefully, about the sounds I do or do not contribute to the world's noise more consciously, and about how every sound can be new (especially in the presence of my children). I have heard a tiny piece of Lego fall as if it was closely miked and amplified, even on the second floor of my home when I'm downstairs, and several rooms away—after all, I know that that piece of Lego might be picked up and swallowed by my youngest child. More tenderly and less alarmingly, I can perceive the sound of a tiny breath from across a room. Considering that a newborn's trachea is about the size of a drinking straw, such perceptiveness is a significant protective ability. On a different, medium-specific level, I hear all films anew. I now use this heightened level of perception in classroom contexts, to pass on what I have learned in a wholly embodied way. Contrary to the institutional norm "that we are not supposed to speak of our bodies," I therefore draw from my own emotionally charged, personal, *and* physical experiences, as hooks and Ahmed would have me do.[33]

Teaching Cinema to Transgress

This chapter is a train moving on the tracks already laid down by Ahmed as a cultural theorist and by hooks as a professor of literature, but I redirect their arguments to my holistically engaged and compassionate teaching about cinema in particular.[34] Empowered by Ahmed's writing on the value of praxis, I connect my personal and embodied experience to feminist theory *and* pedagogical practice. Inspired by hooks's confrontation with the missed opportunities of traditional pedagogical approaches that she claims can and must be addressed, my journey shifts from remembering my postpartum aloneness to celebrating the connections I feel with my students' through listening to them and the cinema we study together more attentively. I pay special attention to the ways that films *ask us to hear them*, taking to heart hooks's emphasis on the moral, humanitarian, and progressive significance of listening well. My students teach me to listen better, just as I give them tools for listening that I have been sharpening myself. I hear as a mother, while most of my students are closer to the world of childhood, so they lead me to places I would not have found myself. Over this chapter and the next, I dwell on the parent/child duality in our combined perspectives on two films: with *Nobody Knows*, I dwell on my conversations with students about the sounds of children that dominate the film, and with *Dancer in the Dark*, I dwell on our conversations on the central musical presence of the mother.

I follow hooks's example of owning my individual identity before my students without shame or apology. Over the last twenty years, and since long before I had children, I have referenced stories of my own life as it felt right and as the classroom environment made it both possible, organic, and constructive. In hooks's words, "In my classrooms I do not expect students to take any risks that I would not take, to share in any way that I would not share. When professors bring narratives of their experiences into classroom discussions it eliminates the possibility that we can function as all-knowing, silent interrogators."[35] I find my students more than capable of absorbing the correlations I make between films and my personal experiences. Without dramatic self-indulgence, I have told them about how the father in *Shine* (1996) reminds me of my own father's extraordinary control over my (lack of) self-esteem, or how the scene of a man's dying in *Ten Canoes* (2006) reminds me of being in the presence of my mother's dead body, or how the movie *Babies* (2010) takes me back to the intense joy of holding my newborn babies while the rest of the world revolved around that. My students

have responded in kind without embarrassment, changing the course of our dialogues, and igniting their peers and me through volunteering their self-possessed and sincere self-disclosures in relation to the films we discuss. Such self-disclosures never need to feel forced or strange, and can bring us closer together while making the lives of the films bigger to us all.

I remember the student who told me he was overwhelmed by *Room* (2015) because he "never cried" at movies. He said, "I had this feeling in my throat, and I didn't know what it was, and then I realized I was crying." As the son of a single mother, he connected with the film so strongly that it was a major lifeshock, enlarging his comprehension of what art could do for him on a personal level. It was as if *Room* had taken over his body and he had become one with its trauma: the result was both painful and relieving to him. I think of the student who came up to me in tears after our in-class screening of *Life Is Beautiful* (1997): he was crying because he wished he had had "a father like that." This feeling made him love and write about Roberto Benigni's character with special intensity: he understood the father as the great "gift" that the son describes in the closing voiceover, and their resilient relationship as being a rare (though hard-won) triumph against Holocaust trauma. Writing on *The Pursuit of Happyness* (2006) in her very first paper for my introductory film course, another student surprised me with her willingness to share her personal connection to the film: "The very last scene shows Chris Gardner and his son walking down one of the famous elevated streets of San Francisco and I felt like it symbolized the highs and lows that they went through in their life. This scene stood out to me the most because I come from a single parent, low-income household, and I remember as a child I had to grow up at an early age." Another student shared her personal experience of domestic violence when writing about *Code Unknown* (2000), with reference to the scene in where a main character (Anne) hears a child being abused by her parents next door yet fails to intervene. This student wrote with compassion for the people who fail abused children like herself, which allowed her to understand the profound humanitarian angle that many critics often miss in Michael Haneke's work: the director, she wrote, "wants us to feel exactly what Anne is feeling in this scene and he wants us to think 'what would you do if you were in this scene?' From personal experience in dealing with abusive parents, it's often a lot to put on to one individual. . . . We don't know what happens behind closed doors, and we still choose to look the other way and go about our lives." When I recently taught *Paris Is Burning* (1990) for the fifteenth time, I thought I could anticipate anything my students might

say, but I was newly humbled by a student coming out to the class in direct connection with our film analysis. We had been talking about the families that the people of the film create for themselves when their original or by-birth families reject them. The student then shared that she repeatedly tells her grandmother that she is gay but her grandmother refuses to believe her, so they have to have the same conversation every year. I was grateful that this student felt able to speak differently with the class than she could with a blood relative.

Sometimes a sense of personal connection arises from the tiniest detail of a film, instead of a major theme. One such tiny detail led me to rethink my entire approach to teaching *Nobody Knows*: a student in my class noticed that the lead child protagonist (Akira) is wearing an Ocean City, Maryland boardwalk t-shirt as he roams the streets of Japan in need of food and water. My student said he used to have a t-shirt like the one he saw, and it made him feel connected to this person he did not know. This ordinary, tacky t-shirt thus took on enormous significance in our classroom located just thirty miles from Ocean City. This strange coincidence made me consider how we might connect with the film more deeply as a group, most especially through the sounds that reach our bodies and which bring us physically into its Japanese characters' lives. I wanted to facilitate a discussion that would build upon our attention to visual detail, with more attention to different levels of listening to the film. Without my implying we could collapse geographical or cultural distance, I wanted my students to feel the completely involving impact of the film's unique sonic logic.

Generative Listening

My compulsion to explore the sound track of *Nobody Knows* further is a direct result of my heightened, motherly perceptions of sound, and I have found a surprising source of inspiration that is well outside my comfort zone: the business world of methods for enlightened leadership. In this terrain as unnervingly new to me as first parenthood, the work of Otto Scharmer (senior lecturer at MIT) is especially helpful. Scharmer specializes in leading people to develop skills of renewal within corporate and institutional contexts. In this professional capacity, he emphasizes that listening is "not only a core skill for leadership, but for *all* domains of professional mastery."[36] He describes four levels of listening. When combined, these levels of listening draw in the

mind, heart, and will of the auditor. All of the levels can apply to teaching film, and the fourth one relates most directly to the skills I have developed as a mother in the field. Scharmer's multi-leveled approach to listening deserves some more extended introduction before I explain how I have applied it to teaching *Nobody Knows*.

Along with stressing that we are all listening for sixteen hours per day, and that we should therefore pay much closer attention to *how* we listen, Scharmer argues that there are four distinct levels on which we process sonic information. First, there is listening as "downloading." This is habitual listening to what we have already known, as if we are in a room with all the windows closed and curtains drawn. This is not listening to what is happening outside. This baseline level of listening draws from our personal past rather than requiring that we fully engage with the present moment. The outcome of such listening is to reconfirm what we already believe, like projecting our own slides onto the walls of our enclosed space. Second, there is "factual listening," which is about taking in different information from what we already know. At this level, we access our open mind through hearing what we did not necessarily expect, looking for contradictions, noticing what does not fit with our preconceived theories, and disconfirming data. This kind of listening allows for innovation. It is like opening the curtains and windows of the room we inhabit to deliberately look out. Such listening is therefore necessary for groundbreaking scientific enquiry. The third level is "empathic listening," which means perceiving what we hear with an open heart. This is about listening to a situation as another person does, enabling us to connect with them deeply. Our listening happens from the place the other person is speaking from, as if we have left our own room. The fourth level is "generative listening," which "requires us to connect with our open will." Scharmer says this kind of listening leads to our imaginatively perceiving an emerging future, both in terms of ourselves and the person we are listening to. This is the most aspirational level that transports us to a potentially new space, somewhere we could not have anticipated before the listening act. Generative listening helps us understand who we are *and* who we want to be more fully. It also helps us answer what the person talking to us needs from us. For example, an effective coach listens to a player talking of their current struggles in terms of perceiving that player's highest future abilities. The coach can only hear the player's emerging future self by paying close attention to what they say. Similarly, Scharmer argues that a strong educator hears students in terms of their highest potential and directs class conversations accordingly.[37]

Adrienne Shoch, a specialist in neuro-centric behaviors, and the unconscious biases that hinder effective leadership, explains this fourth level of listening from a professional *and* parental point of view. She says that generative listening is the point at which we hear "an emerging future that is driven by our need to create a new/better possibility for ourselves, our children and the world. We tap into this level of listening at a deeper, more connected level because what we listen for as a mother is different than pre-children, not only from the perspective of preserving the species, but from a different level of love and responsibility."[38] Ultimately, as management consultant Matthieu Daum explains, generative listening is much more than straightforwardly active listening: it is a "powerful transformational behavior" because it means "entering a disposition" that leads to our perceiving new possibilities by hearing that which does not originate from within ourselves, and with an open, generous will.[39]

While generative listening can be hard to understand as an abstraction, Scharmer provides a detailed and inspiring example in his demonstration video about the conductor Zubin Mehta leading two orchestras and the soloist Placido Domingo.[40] The two orchestras are playing together for the first time in this performance, so Mehta has to deal with an instantaneously evolving relationship between them and with the superstar Domingo, all working together for the benefit of a live audience. Along with urging his audience to revel in this elevated collaboration, Scharmer argues that the conductor demonstrates generative listening at its best. We witness the conductor's highly skilled interaction as he "leads by listening," even to the extent that he "merges with" the other performers. Early on, he engages with the emotion of Domingo's part by churning his arms around, paralleling the expressive turbulence of the vocal line, physically propelled by his own open will. Shortly before Domingo begins his climactic part without orchestral accompaniment, the conductor opens his arms out widely, giving all his attention to Domingo as the music builds toward his solo. Then, the conductor lets his arms fall slowly by his sides, dropping the baton, and holding one palm down to keep the orchestra quiet for the singer's voice to rise alone. For Scharmer, this is "a radical statement that says, it's not about me, it's about something else . . . that is about to come into the world and I am in service of." Scharmer then translates this into pedagogical terms: "When you put yourself in the center and talk everyone to death, there's no way you will ever bring a group to the fourth level." Conversely, Mehta very visibly and deliberately pulls himself out of the center: he "holds the space for something that

isn't quite there yet to come into reality." Since "the creative breakthrough arrives at its own schedule," nothing can be forced into being. The conductor must pay *patient* attention, holding the space for the build-up of musical energy, waiting with confidence until the climax of the performance happens. Eventually, Mehta brings his baton back up, pulling the orchestra back in to support the pinnacle of Domingo's virtuoso performance, thus turning himself "into an instrument for something that is coming into being": this is the triumphant-sounding end, a sort of "landing" through collective action.

Scharmer's work on listening resonates with how I choose to register, talk about, learn, and teach cinematic sound tracks. I explore whether any sound track presents me with the world I know (through downloading), provides me with new sonic information (through factual listening), asks me to hear as others do (through empathic listening), and invites me to re-understand myself and others with a greater level of consciousness that just might change how I live my life, positioning me as part of a greater movement toward future possibility (through generative listening). Equally, as a teacher, I position myself like the conductor who holds everything together with a baton, ready to lead the conversation, but also being ready to let that baton fall to my side when my students can (and should) take over the "music." If I raise my baton again, it is to bring my students and me into elevated moments that can only happen as a result of our combined effort building toward them, and which arise from the uniqueness of our different subjectivities working together.

Teaching and Hearing *Nobody Knows*, On Multiple Levels

I have repeatedly taught *Nobody Knows* in my undergraduate course titled "International Cinema" at Salisbury University. As a parent, I feel a particular attachment to this film because it invites its audience to live life alongside its child protagonists with relative intimacy and genuine care. Before delving into the patterns and stakes of its sonic design further, I will explain how I have taught the film using Scharmer's four levels of listening. I relay my most recent experience of teaching the film, and my pedagogical approach follows the pattern of the concert performance described above: laying the groundwork through establishing concepts in relation to a film screening (like the conductor leading), giving my students control over the consequent conversation (like the conductor letting their baton fall), and bringing us all

together with final remarks to fuse what my students have said with my own synthesizing interpretation (like the conductor bringing all musicians back into a uniquely collaborative finish). I make no presumption to have been as remarkable as Mehta in all this, but I believe that the heightened level of consciousness with which my class and I have applied all four levels of listening is rare and precious.

Nobody Knows is one of Hirokazu Kore-eda's most celebrated films. It is a key example of his consistent attention to ordinary people whose quotidian lives are underrepresented in Japanese cinema.[41] The film provides a nontouristic experience of Japan, and one that draws from Kore-eda's background in documentary film production. The plot is loosely based on a true story of several young children who were abandoned by their single mother to fend for themselves in Tokyo.[42] The mother does not allow her children to attend school because she cannot afford it, so they have little interaction with other people. Given her limited means, she houses her children in a small apartment with a lease disallowing more than one child, and all but one of them (Akira) lives there in secret. She is strict about the children having to be quiet and out of public sight, largely for fear they will be discovered and lose their place to live. The children lack the verbal skills to fully express their distress within this confined existence. The nonverbal elements of the sound track are important in "speaking for" what the children cannot say, and for defining the cultural context that defines their disempowerment. For example, on those few occasions when the children venture cautiously outside their apartment, the traffic of the city is often loudly oppressive, signifying the city's harsh obliviousness to their existence.

Nobody Knows is designed to *open* its audioviewers up to the lives of others that too often escape notice, while the story fixates on how much the world *closes in* around the child protagonists. The mother within *Nobody Knows* explicitly states the "rules" of her children's constriction. That role is played by You, a Japanese singer, model, and actress who adopts an especially childish (high-pitched, soft, playful, and petulant) voice. This makes her dogmatic speech on what her children can or cannot do a startling example of aural dissonance—that is, the youthful timbre of her voice clashes with the austerity of her parenting. The first rule is that her children must refrain from "loud noises or screaming," which she announces on their first night together in the new apartment that only legally allows for one child. She scolds her younger son (Shigeru) for having had tantrums that led to their having to leave a former apartment. Shigeru scoffs and laughs as she reminds him of

this. In response to his insubordination, her speech becomes nastier though her childish intonation stays the same: she commands him, "next time you're up for a tantrum, get in the suitcase." Then she tells the other children to put him in there if he's "noisy." This threat is immediately ironic given that she has smuggled several of the children into the new apartment within suitcases. She therefore places her children in claustrophobic spaces that are meant for objects rather than people, and in which any sound they make will be muffled. This underlines the unnaturalness of how she treats them. Aside from Akira, who is legally allowed to live in the apartment, only the older daughter Kyoko is permitted to "step out quietly" onto the veranda to use the washing machine there. In a couple of scenes, Kyoko stands silently in front of the machine and its functioning, rhythmic hum is a strange comfort.

Have taught classes about *Nobody Knows* for over a decade, I find that it demands and rewards all four levels of listening. In the next several paragraphs, I distill what we (my students and I) have heard in the film over the years. In terms of downloading the film's sonic information, my students and I have noticed that *Nobody Knows* incorporates many archetypal sounds of childhood—lightly running footsteps, mechanical toys, soft snores, delicate sleep breathing, cartoons, video games, giggling, and squeaks of excitement. There is also an aural motif of children's drawing sounds (with crayons, pencils, or markers) as they attempt to create and mold small pieces of their world. All these aural details resonate with common experiences of childhood, and they help make the film an example of global cinema that does not rely on our preknowledge of Japanese culture. The film also follows familiar rules of sonic (and visual) continuity that draw from innumerable other films without requiring that we re-understand the language of cinema to follow its logic. In terms of factual listening, the film educates my students and me by making us hear the reality of many underprivileged children living in Tokyo. The film's main characters stand for millions of Japanese children living in poverty over the last two decades. Many moments of the film silently or wordlessly stress that the children are left to fend for themselves in a generally hostile city. This reinforces our understanding that while their situation is extreme, it is entirely possible, rather than a melodramatic anomaly. The film's sonic details are deceptively straightforward and usually connected to common everyday objects and environments, communicating the ordinary but nonetheless heartbreaking despair that the children represent on behalf of many like themselves. There are repeated, silent shots of clothes that Kyoko has washed, subtly stressing the lack of a parental figure to take care of

the family in basic domestic ways. A more pointed aural motif of one-sided phone conversations suggests how often adults fail the children. The oldest and most responsible child, Akira, attempts to reach his mother by phone several times after she has abandoned him and his siblings. He calls her place of employment from a payphone, and a coworker bluntly reports that she has resigned weeks ago. Moments later, a plane flies over Akira as he walks away from the phone booth. This is the first of several moments featuring the sound of a plane taking off, sonically signifying the release that never comes for Akira or his siblings. As a relatively expensive mode of transportation, the plane represents a standard of living that will always be well beyond their reach, and an entire class of people who move above and away from them.

In a later scene, Akira attempts to reach his mother from home by calling her at an unknown residence, and she answers the call as if part of another family. In his stunned state, Akira is reduced to silence. He makes a third attempt to call his mother, this time from a payphone after his landline has been disconnected, and because his youngest sibling (Yuki) is suddenly, critically, ill. The man answering the phone fails to have Akira's mother come to the phone before he runs out of change to keep the line open. Akira bangs his head against the payphone booth, a startling sound in the absence of his speech, and one that is unusually amplified in the urban context. The film places this sound at the top of the aural hierarchy to symbolically stress what is usually drowned out within the life of that city. Akira's ability to make this sound rings true against his inability to speak of his distress. Through all this sonic detail, the filmind of *Nobody Knows* communicates clearly to my students and me, as if to say, "this is what can happen to children in Tokyo, and this *has* happened, but there are no words adequate to it." I interpret the title of the film as a challenge for us to know better than others, to be more conscious of the children who are often seen but not heard, not matter how far away they are.

Child poverty has been a major issue in Japanese life for decades, which nevertheless tends to be "hidden from the global view."[43] In an article for *The Guardian* newspaper, Justin McCurry writes about the soup kitchens that have sprung up around Japan in response to the needs of an estimated 3.5 million children living in poverty, and he explains that this poverty has risen in Japan over many years. McCurry quotes Yasushi Aoto, chairman of the Japan Association of Child Poverty and Education Support Organizations (JACPESO), who says that "Japan's rising child poverty exposes true cost of two decades of economic decline."[44] Nicolette Schneiderman summarizes

the reality as follows: "Rates of child poverty have been rising continuously since the 1980s. In 1985, the percentage stood at 10.9%. By 2015, this number had risen to 13.9%, meaning that approximately one in seven Japanese children was living in poverty. Among single-parent households, this average shot up to 50.8%."[45] Still, the Japanese government did not directly address child poverty until 2009 due to it "lack of visibility." This is the reality that *Nobody Knows* tapped into upon its release in 2004, years ahead of governmental intervention.

When it comes to empathic listening, *Nobody Knows* frequently makes one or more children the point of audition. It also frequently provides extension—that is, an expansion of the story space—by including sounds of life outside the children's apartment. The extension repeatedly makes us hear the reality of freer existences beyond the children's limited apartment space, which we can reasonably assume the children perceive.[46] In addition to such sonic emphasis on the isolation of the main characters, the film features music by Gontiti (a Japanese acoustic guitar duo) that sensitively underscores several scenes of their restricted movements beyond the apartment. Without lyrics, this music plaintively "asks" us to notice what the children go through while others around them fail to take notice. It suggests a mature understanding that is beyond the children's collective consciousness, implying the perspective of the director as an engaged person of greater awareness, and enlisting us to respond in kind. Because this score appeals to our comprehension of more than the children can actually hear or understand, it asks us to listen at the fourth, generative level. This music appeals to my students and me as we can grow through the film, not only by witnessing what the children endure but also by considering what *we* can be and do in relation to that.

All of Gontiti's cues are light and accessible, especially the repetitive main theme in easy triple-time. The main theme sounds like a lullaby, almost as if the film wants to soothe us while showing the truth. We first hear this theme when Akira goes to meet his sister Kyoko at the station after they have their new apartment, and it communicates a sense of hope through that initial narrative association (5.20–6.40). Whenever this theme enters the film, it provides a buffer for us lest the reality become too much to bear, but its repetitions also position us to notice the children's gradually dwindling hope after the exposition. The music not only affirms that the children and their losses matter: it primes us to imagine what action we would take for them *if only we could*. Throughout *Nobody Knows*, silences and ambient sounds are also unusually impactful on this generative level. Where the music directs us

to feel the children's vulnerability and beauty, the frequent silences and ambient sounds of the city give ample scope for us to reflect on what we witness very consciously and in a full urban context. The four child protagonists—Akira, Kyoko, Shigeru, and Yuki—are unusually quiet: they are consistently set apart from the children on the streets and at school who are louder because they are under no pressure to make themselves inaudible as well as invisible.

The most poignant silence, ambient sound, and music come with a montage after the youngest child, Yuki, has died. The film makes a hard cut from a playground where we hear happy, faraway children playing offscreen to a series of images within her family's apartment. The light sounds of children playing offscreen continue over the montage as follows: first, Yuki's crayon sketch of her mother in a red dress, a reminder of her unquestioning love for the prominently absent parent; second, Kyoko's miniature red piano, a toy that both Yuki and she liked to play but which we now see silent and knocked off-kilter with a broken leg, symbolic of Yuki's broken body; third, Akira sitting sleepily still with exhaustion; fourth, Kyoko's hand checking Yuki's pulse; and fifth, Akira bowing his head in grief. No one is saying anything, but the montage speaks strongly in relation to the offscreen sounds of children playing. Those sounds remind us of a world that is oblivious to what the main characters lose, as well as stressing that it could and should have been different for them. This heartbreaking, ambient sonic information is then interrupted by some unusual music of extraordinarily painful urgency. We hear Akira singing nondiegetically, along with a few strangely canted and overexposed images of the streets near his home, suggestive of his entering a transportive space. Akira is repeating the song he heard children singing at a baseball match. In that earlier scene, Akira enjoys a rare experience of play and frivolity, simply because an adult mistakenly believes he is attending school and able to join a team. After Akira bats the ball surprisingly well, a chorus of children sing "a big, big homerun, homerun, in heaven, grandpa and grandma . . ." Now, after Yuki has stopped moving, we hear Akira singing "a big, big homerun, in heaven, grandpa and grandma, so surprised." Akira's voice is soft and steady, but its impact is *piercing* because of the phrase "so surprised" that euphemistically relays his shock at Yuki's death. He stops singing suddenly as someone calls out "Akira" on the street, but we never see this person. It is as if Akira is calling himself back into the world he cannot escape. The film enforces our empathic listening by making us hear Akira's musical effort to manage his grief as well

as the shock of his sonic re-entry to the world. However, the time the film takes over this process allows for another, more complex, *generative* level of response. We must feel the despair, outrage, shock, and resolve that goes along with being older than Akira is, registering the injustice and needlessness of Yuki's death, and being all too aware that we are powerless to intervene. By extension, the film invites us to consider those times in our own lives when we might have power to pay attention *and* to intervene. We must feel the hurt, but we must also get past that since this film is not about us: it is about what tends to escape our notice and what we fail to hear if we are living only for ourselves.

Before playing *Nobody Knows* in class, and in order to help my students perceive all the above, I prime them to listen at all the levels defined by Scharmer. I ask them to consider how the film confirms what they would expect to hear, and what they have already heard through the course (level 1 listening, or downloading). I ask them to take in what the film makes them hear about Japanese society, and how its sound track aligns them with the characters (levels 2 and 3, factual and empathic listening). I do not anticipate the fourth level of generative listening for them, but I hope that the first three kinds of listening might lead to it. A couple of days after the screening, I present my students with a list of sonic signifiers through the film, all of which I have heard most acutely as a mother of two children. I ask them to latch on to one of these signifiers and explore its meaning. I give them a few minutes to select one and note down some ideas before reporting back. My list includes the following:

- Mother's voice
- Yuki's squeaky toy
- Kyoko's toy piano
- Yuki's squeaky shoes
- Sounds of drawing
- Noises of automated machines (ATM, vending, cash register)
- One-sided phone calls
- Sounds of children running
- Airplanes taking off
- Nonverbal communication (crying, laughing, breathing etc.)
- Traffic around children—pedestrians, cars, bicycles, planes, the monorail
- Children's expressive silences

LEVELS OF LISTENING TO *NOBODY KNOWS* 71

Every one of these sonic details relates to the children's disempowerment *as well as* the importance of their presences in *Nobody Knows*: in other words, though the children are socially disadvantaged within the film's social world, they are privileged by the film's sonic structure. To underline the eloquence of the nonverbal sounds in particular, I dwell on just one example that my students have repeatedly chosen for analysis: the squeaky shoes. These shoes are worn in only one scene by the most vulnerable child, Yuki (aged five), but my students frequently emphasize the sound with good reason. At the beginning of the scene, Yuki declares that she's going to the train station to meet her mother. When her older sister, Kyoko, flatly tells her "she's not coming home today," Yuki insists, "I'm sure she's coming home." She is looking out the window as she says this, but the film restricts our access to her view of the world outside. While Yuki vocalizes a hopeful certainty, the film maintains a visual limit though a two-shot angled toward the wall outside, subtly underlining her inability to see past her own desire (see Figure 2.1). Akira, the de facto parent to his siblings as the eldest, confidently declares that their mother will be back next week, but Yuki does not respond or move, signaling her willful refusal to let go of her desire. My students and I understand that Akira wants to reassure his sister, even though he has *no evidence* of their

Figure 2.1 Yuki looks out the window, determinedly anticipating her mother's arrival home while Kyoko looks skeptical at her side. The shallow depth-of-field subtly represents that Yuki cannot see the awful truth beyond her own hope.

mother's imminent return. In a later scene, he tells his new friend (Saki) that he believes their mother will never come back. Later still, after their mother does not return by Christmas as she promised, Akira gives his siblings gifts for the new year as if they are from her. To make the gesture seem authentic, he has an older acquaintance write accompanying cards out for his siblings with imitations of their mother's handwriting. As a mother, and as I explain to my students, I hear and see Akira's lies in light of all those times I've spoken to my children with absolute assuredness about how Santa Claus will find his way into our house despite our lacking a chimney.[47] A loving parent wants to make the world of wonderful fantasies real so long as a child needs it. *Nobody Knows* shows us Akira's instinctive grasp of this for Yuki's benefit. After his benevolent lie about their mother coming home next week, the film shows a silent close-up of Yuki's fingers on the windowsill and her toy pink rabbit peeking out. I encourage my students to read deeply into this quiet. In such moments without any sonic stress (whether music, words, or a sound effect), the film appeals to our fourth level of listening, to that sense of love and responsibility that we must embody if we are to make the world better for children like Yuki. The sedate rhythm of such scenes in *Nobody Knows* is crucial on a generative level too: the film frequently builds in time for us to not only contemplate what we are witnessing as it is happening, but to reflect on what it means and how it might change us.

Kyoko says that it is Yuki's birthday. The film then cuts to show Akira's hand on the door, showing that he therefore honors Yuki's wish to leave for the train station to meet their mother. There is no sonic punctuation of this moment beyond the sound effect of his turning the knob. The *absence* of much noise or music makes his quiet decision most moving. This relative quiet also offsets the sound of the squeaky shoes that Yuki chooses for her walk to the station, in eager anticipation of meeting the mother who will never come. The shoes are red slip-ons with small brown bear faces over the toes. They are too small for her feet, as shown in a close-up of her putting them on (see Figure 2.2), which subtly reminds us that her basic needs are not being met while she grows. The shoes squeak one by one as Yuki squeezes into them, like a tiny form of protest. After the film cuts to outside the apartment door, we hear the shoes squeaking while Yuki descends the outside steps and walks on to the street. Akira holds her hand as they pass a market, and she lists off the ordinary things she sees: "tomato, daikon, broccoli, squash, carrot mushrooms, plates, cups, the butcher's . . ." Along with her closely miked voice, we can still hear her squeaking shoes, despite the foot traffic around them and the

Figure 2.2 Yuki's too-small, squeaky shoes are eloquent objects. They stress we should hear her in the absence of her mother.

long-shot distance. "We won't lose these children," the filmind seems to say. In the next moment, *Nobody Knows* shows Yuki and Akira sitting quietly still at the train station. Akira says nothing, and other passengers walk by them without paying any attention. The filmind is speaking more strongly here, as if to say, "these children are invisible and inaudible to others," leading us back to its title "Nobody Knows." We can guess Akira and Yuki have been sitting for some time because Yuki is finishing her personal supply of candy. "Last one," says Yuki, simply, and it feels like she is giving away her last hope. Mother does not come. The film cuts to show the children walking home in the darkness. Now Yuki's shoes are noticeably squeaking with her steps again. What words could these representatively eloquent objects be saying as Yuki goes "squeak-squeak" down the road? Along with my students, I hear them say "hear this child, hear this child," "she's so young, she's so young," "her life matters, her life matters."

Akira says nothing while they walk, but his speechless care for his sister implies how much he knows beyond her comprehension. He is that figure within the diegesis who listens with most compassion, along with being honored by the most close-ups. These strong audiovisual patterns prompt my students and me to empathetically *and* generatively attend to him, as if with him *and* with a broader worldview. Suddenly, Akira and Yuki see the

monorail pass above them, a reminder of the city that keeps moving irrespective of them. At this point, music by Gontiti punctuates the scene along with overlapping exposures of Akira's face (1.06.38–1.07.35). The music features a precisely plucked yet delicate sounding tune. The accessibility and simplicity of this tune amplifies the bittersweetness of this scene as it shows the children's ability to keep going despite their vulnerability. The theme plays first on one guitar, then again with the second guitar providing a full harmony, musically emphasizing the scene's primary focus on the relationship between two siblings as they sustain each other. Akira says that the monorail goes to the airport, and suggests they go see the airplanes one day. Much earlier in the film, the children's mother tells Kyoko that Akira's father used to work at Haneda Airport. This may or may not be true (as the film never confirms it), but Haneda Airport signifies the inaccessibility of his father, the early life that neither Akira nor his siblings can be sure about, and the impossibility of leaving where they now live far behind. Akira's mentioning the airplanes also harkens back to that scene when his attempt to reach their mother by payphone is punctuated by a plane flying away and above him. All these narrative details that signify disempowerment and dwindling hope give weight to Akira's suggestion of going to see the airplanes, but Yuki agrees to it without needing more than the chance for an adventure with her big brother: "Yeah," she says, "let's do that." At the precise moment after Yuki speaks, the musical theme ends, marking the moment that their mutual plan is made.

What a first-time audience cannot yet know is that Yuki *will* go back to the airport, but not alive. After she dies from an un-medicated illness, and in the absence of any adult assistance, Akira lovingly packs her in a pink suitcase and takes her to the airport on the monorail.[48] He carefully places her squeaky shoes back on her still feet, and they make one more little sound, as if in weakened protestation. Gontiti's touching music for the monorail scene anticipates this tragedy of the film, which is the devastating cost of what "nobody knows." That music extends each moment so that we have a chance to reflect and focus on Akira and Yuki being together without feeling the need for anything else.[49] This scene represents the whole film as it begs us to notice so much more than the passengers who walk past Akira and Yuki. The scene and film want us to pay attention to the children like the music does, and to not move away from them with the unbroken speed of the monorail.[50]

I held my most recent class on *Nobody Knows* two days after the film screening. My students talked about the sound of the squeaky shoes in

connection with themes of innocence, youth, loss, resistance to reality, childish optimism, and grown-up understandings of what children need. We also discussed how the film sounded different when we returned to select scenes in class. We agreed that with the first time we watched *Nobody Knows*, we could hear everything like the children do, especially as they playfully enjoy the few objects of their lives without foreseeing Yuki's tragedy. Returning to the film with an awareness of how the narrative unfolds positioned us more like adults anticipating a terrible outcome. We recognized that the children are not properly heard within the film, especially since several scenes show adults failing to respond when the children try to communicate their desperation. Therefore, we perceived some objects (like the squeaky shoes) as having more humane presences than the adults in the film. This led us to a broader theme of the importance of *our* bearing witness to the children's suffering, and our hearing better than the onscreen adults. My students mentioned sounds that represent childhood generally (level 1 listening), that relay specifically Japanese realities (level 2), and that take us into the world of the characters as they experience it (level 3). To my surprise, our main emphasis was on the fourth level of listening, that level of awareness that exceeds anything in the diegetic realm. For example, one student dwelt on the silent monorail at the end of the film, which communicates more than any of the onscreen characters can fully comprehend. He argued that the silent monorail is a statement about the travelers who are invisible and unheard by many people around them. The same student said the silent monorail reminded him of the final moments of *Bicycle Thieves*, a film we had studied a few weeks earlier. *Bicycle Thieves* ends by showing its protagonists (an impoverished father and son) walking silently away from the camera and becoming lost within a crowd of people who pay no attention to them at their lowest point. He said that both films demand we notice what others rush past. Therefore, this student's poignant observations reminded us that other people might live tragedies like Akira does and that we want them to be noticed too. His imaginative comprehension led to our confronting this big cross-cultural truth together.

Two students chose to give their presentation on *Nobody Knows* in the week following the screening and subsequent class discussion. The material they presented demonstrated their willingness to listen on multiple levels and on their own terms. They anchored their presentation in a close analysis of a scene that could be easily skipped over due to its being relatively low-key. This allowed them to showcase their ability to read into the details

that anybody could miss, and this had great significance in relation to how *Nobody Knows* notices realities of poverty that many people in real life manage to ignore. The scene shows Akira with a man who may or may not be his biological father, and Akira is asking for money so he and his siblings can survive. The presenters noticed Akira's quiet, broken, hesitant, and heartbreakingly simple speech in contrast with the man's casual, dismissive, and monotonous tone. The man taps on his cellphone and chews gum, both sounds being closely miked while he grunts his responses. One presenter argued that the gum-chewing was "deafening as it might symbolize wealth [and the man's] access to material wants, not necessities." He said, "the act of chewing is something that Akira struggles with, in the sense that he's always hungry." Both presenters pointed out that the film demands we listen and take action in the ways this man does not, partly through its special attention to the sounds that signify his willful negligence. They spoke of the scene's sonic details in relation to the film's main themes of acknowledging extreme poverty, the powerlessness of children, and the obliviousness of adults to children's suffering. They reflected on Kore-eda's greatest pride in how audiences have received *Nobody Knows*: the director says, "it's not a movie that posits, 'Oh, let's revise some specific child-welfare law.' What I'm getting instead are letters and e-mails from people who have seen the film saying, 'Kids that I used to ignore in my neighborhood, now I talk to them.' That means more than a change in the law."[51] The presenters ended with a plea to the class to notice poverty around them more, and to take action for the world starting with their own neighborhoods. This was the climactic point of our work together on *Nobody Knows*. Following the presentation, I thanked the students for attending to a short but crucial scene and then brought other students' back into the conversation by summarizing their comments on the significant sounds of objects, poignant silences, different voices, and the vocal powerlessness of children in relation to adults. This was my way of ending our collaborative and unique performance, bringing the whole class and the presenter soloists together for a final flourishing moment.

An Open-Ended Conclusion

The impact of studying *Nobody Knows* lasted after the class I have described, as I hoped it would. Weeks later, a very shy student who always had trouble

speaking aloud wrote me the following close analysis of Yuki's shoes, as part of her midterm exam:

> When Yuki and Akira leave the apartment so Yuki can wait for their mom at the station, she picks out a pair of squeaky red shoes. For her, these shoes are associated with excitement, and they mirror the squeakiness in her voice as she speaks with certainty that their mother will be waiting for them. It is almost as if her joyful expectation of seeing her mother again cannot be contained within her body. But just as we are encouraged to hear this sound through Yuki's ears, we hear it from Akira's perspective. In this way, the sound is tinged with sadness. Akira knows that their mother will not be at the station. The squeak is representative of hopes that will inevitably be dashed. As they walk along, her shoes become smothered by the sounds of the city—crowds that pay them no attention and remind us of how isolated these children truly are. Eventually, that sound is replaced by the sound of the train Yuki hopes their mother is on, and the one Akira knows she isn't. When we hear her shoes again on the walk back home, it is entirely different. Small and insignificant, mixed with the scuff of her feet, her footsteps are blown about by the sound of the wind.

Echoing our conversation in class, this student showed me a level of awareness that exceeds the film's diegesis *and* her own direct experiences. She reminded me that childbearing and rearing are not necessary prerequisites for such mature and imaginative comprehension. But I also know that I helped her and the other students reach such a level of expressivity by the conversation I created for them as a professor *and* a mother. I, in turn, appreciate the richness of their responses, both as a specialist in cinema *and* as a mother hearing the world with her children.

3

HeartMath

Listening to the Organ of Fire and *Dancer in the Dark*

> One of the most essential ways of saying "I love you" is by being a receptive listener.
>
> —Fred Rogers[1]

> Smooth, soft, red, velvety lungs
> Are pushing a network of oxygen joyfully
> Through a nose, through a mouth but all enjoys, all enjoys
> The triumph of a heart that gives all, that gives all
>
> —Björk[2]

The last chapter is about my commitment to hearing *Nobody Knows* as a parent as well as a professor. Inspired by the work of bell hooks and Sara Ahmed, I present an example of praxis that involves my entire self. More specifically, I explain how my heightened capacity to hear as a mother leads me to teach sound tracks with great and multi-leveled aspiration. I teach my students about hearing the children of *Nobody Knows* and the world they inhabit in expansively factual, empathic, and generative ways. Through such teaching inspired by my motherly experience, I talk back to many professionals who perceive parenthood or caregiving of any kind as a distraction from more important work. With this chapter, I maintain an unorthodox and personal approach, but I rehear cinema with a different physical and emotional emphasis: its impact on my students' hearts and my own. Along with alluding to the life-affirming and life-giving power of films in a conceptual sense, I literalize the idea that films can better our lives. I start this analysis by exploring the life-determining work that our functioning hearts do. I then argue for the physiological and metaphysically sustaining ways that cinema can help our hearts work better. As an example of profound possibility, I focus on teaching

Dancer in the Dark: a fearful but ultimately kind film about what the heart can withstand.

Heart-based feelings are very real, vital, life-affirming and life-enhancing, crucial for longevity, and sustaining to the body as well as the mind. They are both anchoring and elevating. In short, these feelings have "muscle."[3] Without my always being conscious of it, cinema has influenced the work of my heart for a long time. Until recently, I did not recognize that I was using cinema to help my students acknowledge their own heart-based feelings and to develop heart-based, restorative, and regenerative skills along with me. I now know that I teach movies in parallel to the methods of "HeartMath," as explained by Doc Childre and Howard Martin in *The HeartMath Solution*.[4] Childre and Martin begin their book by establishing the significance of a human heart as it has a consciousness that is separate from the brain and that affects every part of a person's being. They provide specific techniques for tapping into the heart's intelligence. I have applied their teachings in the classroom, especially the so-called freeze-frame technique. By showing my application of *The HeartMath Solution*, I present my pedagogical practice as a revitalizing act of hope for the body as well as the mind.

Many film scholars pay attention to the physicality of audience's experiences. Consider Linda Williams's seminal work on so-called body genres, just for openers.[5] She examines audiences' reflexive physical responses to porn, melodrama, and horror, therefore running the gamut from biological signs of arousal, to shedding tears, to shaking with fear. My own focus is both narrower and more all-encompassing: I consider the heart as a specific locus of power, feeling, and activity, and I explore the repercussions of a heart-focused approach to teaching/learning that can influence all that I am and all that my students are. I acknowledge the sentimental suggestiveness of saying that I teach "from the heart," with "heartfelt conviction," and with my "heart on the line." Nevertheless, I embrace such clichés because I acknowledge my heart's hold over myself with humility. To access the full power of my (or any other) heart is to be in tune with "forty thousand neurons (nerve cells)" and 100,000 beats a day.[6] A heart is not a soft, mushy place but a source of commanding energy: as Count Almásy of *The English Patient* (1996) writes inside a firecracker paper, it is "an organ of fire."

As peculiar as it may seem, neuroscientists write of the "brain in the heart."[7] Heartbeats are more than mechanical throbs: they are an "intelligent language that significantly influences how we perceive and react to the world."[8] Following from this, Childre and Martin define heart intelligence

as a "flow of awareness and insight that we experience once the mind and emotions are brought into balance and coherence through a self-initiated process." This coherence "manifests in thoughts and emotions that are beneficial for ourselves and others."[9] Childre and Martin stress the value of heart intelligence because of the organ's incredible jurisdiction over who we are and how we make our presences felt to others. Such intelligence is *not* "sentimental or overly sweet"—it can even have a "businesslike quality; it's balanced, it's efficient, and it takes all possibilities into consideration."[10] Listening and decision-making in line with the heart's intelligence leads to a life that is more "*educated*" as well as "balanced and coherent."[11]

Childre and Martin explain the heart's impact on all brain activity. The amygdala inside the brain is "responsible for assigning emotional significance to everything we hear, smell, touch, and see."[12] While the amygdala is influenced by information from our cerebral cortex, its "cells exhibit electrical activity that's synchronized to the heartbeat."[13] There is a direct connection between the heart's electromagnetic field and that which is produced by the whole brain, so the heart's activity influences our perceptions and mental processes *along with* our feeling states."[14] Moreover, since the heart is "the strongest biological oscillator in the human system, the rest of the body's systems are pulled into entrainment with the heart's rhythms."[15] Childre and Martin use an audiovisual example of motion in time to explain this concept of entrainment: the phenomenon whereby multiple pendulum clocks that might be ever so slightly out of rhythm with each other will eventually swing together because the strongest one brings the others to move in time with it.[16]

A heart has controlling influence over everything happening within the body *and measurably beyond it*. The heart produces the strongest electromagnetic field generated by the body, and this can be measured 8 to 10 feet away "with sensitive detectors called magnetometers."[17] If I am in the same limited space as another person, their body is impacted by my heart's electromagnetic energy. The beating of my heart affects the other person's heart, whether or not our two bodies are touching.[18] The way our hearts are functioning in relation to each other can be detected by others around us and impact how theirs function in turn.[19] In short, we are "*broadcasting* our emotional states all the time (and receiving others')."[20] This is reason enough for me to cherish any opportunity to live through a compassionately moving film with my students. I have often intuited that all our hearts will begin to beat differently in response to emotionally loaded films that we see/hear together, but now I realize that our hearts' overlapping electromagnetic fields have

made this *inevitable*. In this chapter, I dwell on cinematic music as a force that can foster heart connections among my students and between them and me, leading us all toward greater heart intelligence as a consequence. Though I focus primarily the soundtrack of one film example—*Dancer in the Dark*—my arguments are transferable to other films that take shape according to heart-led principles.

In keeping with the aural emphases of this book, Childre and Martin repeatedly use sonic language to explain the great potential gains of heart intelligence. They say we must "listen to and follow the wisdom of the heart" because there are constant "two-way conversations between the heart and the brain."[21] We must address how our "inner dialogue" hurts us. Positive emotions of love, care, and appreciation bring "harmony, order, and coherence in the heart's rhythms."[22] The great freedom of accessing the heart's core means "less static,"[23] and a way out of "discord."[24] We can bring about the coherence of "mental and emotional energy," so that "virtually no energy is wasted" and every part of us is "operating in *harmony*."[25] Conversely, when we are in the midst of tension or feeling out of balance and incoherent, we long for the "ability and the poise to smooth out [our] feelings. That longing is the voice of the heart telling [us] that something needs to be balanced," but despite hearing it, we "may remain stuck in emotional dissonance."[26] Childre and Martin appeal directly to the reader to prioritize attending to this "voice": "As your heart gives you insight into what to do differently, it's important to listen and obey. You build your emotional capabilities by actualizing what your heart tells you. Intuitive listening must be followed by intuitive doing. Your happiness depends on it."[27] All these sonic ways of conceptualizing the heart's power within *The HeartMath Solution* lead me to new ways of explaining how hearing cinema can sustain my life and the lives of my students.

Perhaps everyone has, as Childre and Martin suggest, "heard the voice of the heart before,"[28] but I argue that this might be a question of necessary practice. I have consciously encouraged my students to listen well to a film with an attitude of open-heartedness, always with a view to helping them turn that experience into the actions of engaging with the film on multiple levels, expressing new thoughts in writing, and sharing what happens to them with their peers. This frequently leads my students to connect their personal reflections and experiences with what happens in a film in ambitious and risk-taking ways. They absorb a film into themselves as an object that can validate what they have already lived *and* hopefully expand their

greater knowledge of the world through hearing what the film says. Such pedagogical ambitions can be too much for a class within the opening weeks of a given course, but I find them achievable by the end of a semester. In this chapter, I dwell on *Dancer in the Dark* as a film that rewards my advanced pedagogical ambitions because I place it in the penultimate week of my survey course titled "Film Genre."

My students and I must work up to experiencing *Dancer in the Dark* because it subjects us to severe distress, trauma, and shock. It also demands our utmost willingness to develop heart intelligence through conscious effort. As such, it offers an extraordinary opportunity for teaching and learning how to process extremely difficult content within the relatively safe perimeters of a classroom conversation. Before delving into this teaching experience, I must first elaborate on the fundamental teaching of *The HeartMath Solution* that practically informs my approach: the "freeze-frame technique."

Developing Heart Intelligence Through the Freeze-Frame Technique

Childre and Martin explain how the freeze-frame technique can help any of us gain a "clearer perspective." This perspective comes from the practitioner aligning their heart and head to efficiently access heart intelligence.[29] The ultimate goal of the freeze-frame technique is a shift from self-poisoning to poise, after which the practitioner is ready to encounter and "edit" the next "frame" of their life "from a point of balance and understanding."[30] (Note Childre and Martin's use of the film terms "freeze-frame," "edit," and "frame" to explain their methods, implying a deep-seated connection between cinematic form and human vitality.) The freeze-frame technique has five steps as follows: first, the practitioner must recognize a stressful feeling that is dominating their thoughts; second, the practitioner takes a break by focusing their energy on the heart and "breathing through [their] heart" for ten seconds or more; third, the practitioner recalls a positive experience and attempts to relive it in embodied detail; fourth, the practitioner turns back to the stressful feeling and reconsiders how to address it efficiently so they can "minimize future stress;" fifth, the practitioner listens to what the heart answers.[31] Once a practitioner becomes adept at following these steps, the freeze-frame technique can be completed in a few minutes. That said, film scenes rarely provide enough time and scope for characters' and/

or audiences to follow all five steps. However, a scene from *A Beautiful Day in the Neighborhood* (2019) provides an uncanny match for the whole technique as Childre and Martin describe it. The film revolves around the beloved children's television host Mr. Rogers and the relationships he makes possible through his heart-led kindness and truthfulness. Since the story is modelled on a real-life person enacted with uncanny verisimilitude by Tom Hanks, it is a marvelous example of film and life fusing. Given that Mr. Rogers passed away in 2003, it is also a bittersweet example of bringing a benevolent presence "back to life," reminding us that cinema can do much more than entomb the dearly departed.

In the scene I focus on (1.10.37–1.14.16), the main character (Lloyd) learns a version of the freeze-frame technique with Mr. Rogers's guidance. Lloyd is a journalist assigned the task of writing a profile piece about Mr. Rogers for *Esquire* magazine, but the film develops their relationship far beyond its being a strictly professional agreement. Mr. Rogers's capacities for care and gratitude lead Lloyd to greater heart intelligence after he slowly begins letting his defenses down. During this scene, Lloyd's process of transformation is only beginning, but he is visibly changed in under four minutes. In the establishing shot, the two men are seated for lunch at a Chinese restaurant, and Lloyd is looking at Mr. Rogers with an attitude of quiet defeat. With a hint of bitterness (or perhaps even revulsion), he says to Mr. Rogers, "you love people like me." Mr. Rogers asks, "What are people like you? I've never met anyone like you in my entire life." After a heavy pause, and with a tiny smile that seems to acknowledge his own churlishness, Lloyd responds, "broken people." Mr. Rogers nonverbally objects to this response by gently putting down his cutlery to stop dishing up food and focus entirely on the conversation. Then he insists that he does not believe Lloyd is "broken" and that he perceives Lloyd to be a man of conviction who knows "what is wrong from what is right." Mr. Rogers encourages Lloyd to understand that his father helped shape his morality, despite his father being the most difficult presence in his life. The awfulness of this father/son relationship has already been established by the film's backstory: Lloyd's father is an alcoholic who was unfaithful to his mother and left the family to be with his mistress while Lloyd and his sister were still children. Nevertheless, Mr. Rogers insists to Lloyd, "he helped you become what you are." Lloyd gulps silently in response: his contrary reaction of resisting *and* trying to accept what he hears is a manifest strain. Mr. Rogers than kindly asks Lloyd to take a minute to "think of all those who loved us into being." He explains that this is something he likes

to do himself sometimes. The film therefore implies that Mr. Rogers's inner peace is the result of his disciplined and repeated focus on gratitude. Lloyd protests "I can't," but Mr. Rogers insists, "They will come to you." The scene falls uncannily quiet, the closest a film can get to the complete withdrawal of sound without actual silence. A series of cuts shows the other restaurant patrons participating in the act of silent reflection. Some of them evidently overhear Mr. Rogers's instructions while others intuit that being quiet is necessary. The camera closes in more tightly on Lloyd's face to reveal that his expression has softened. He says nothing, but his deeper breathing and the tears in his eyes show his heartfelt change. Mr. Rogers thanks him and then speaks for them both: "I feel so much better." Again, Lloyd says nothing, but he manages a smile that communicates a spectrum of possible feeling states: acknowledgment, bemusement, incredulity, and a hint of happy surrender to the fullness of the moment.

What Mr. Rogers leads Lloyd to do is akin to the step-by-step freeze-frame technique outlined by Childre and Martin: stopping in the moment of feeling the impact of a stressor, breathing through the heart, redirecting thoughts toward appreciation, returning to the original stressor in an altered, balanced state, and finally being ready to engage with life anew. The visual design of the scene matches Lloyd's shift from being wary of Mr. Rogers's words to taking his lead by example. The *mise-en-scène* begins with barriers to Lloyd and Mr. Rogers in the form of restaurant architecture and ends with a clear shot of them across the main space. The implications are clear: everything within, around, and between them has opened up (see Figures 3.1 and 3.2).

Though I do not ask my students to turn inward as Mr. Rogers does, for requiring that they revisit personal truths and/or memories would feel like a breach of boundaries within our pedagogical context, I do ask them to stop and dwell on film scenes that might be uncomfortable at first but which can free up possibilities for their emotional awareness through measured contemplation. Each of our in-depth discussions follows an entire film screening, so we can return to any part of a given film without losing its initial and complete impact. This enables me to focus on teaching my students skills of moment-to-moment analysis, often by pressing pause repeatedly while we talk about a given film scene, or by zeroing in on a short extract from a film that builds time into itself for taking all its details in. I make it clear to my students that there will be time for us to come to terms with the most challenging material together. If we take our time, we give ourselves the chance to perceive everything a film does for us. This requires patience and

Figure 3.1 The camera is positioned so that there are immediate barriers to our clear vision of both Lloyd and Mr. Rogers, symbolically suggestive of the hesitancy Lloyd feels in opening up emotionally.

Figure 3.2 There is no architectural barrier between us and the main characters anymore. They are now shown among other patrons in an open restaurant space. This symbolically underlines that Mr. Rogers has helped Lloyd rejoin humanity, or at least mediated his isolation, through a freeze-frame technique.

the willingness to stay focused, which can yield amazing results that I can never anticipate in their fullness. Before teaching a class, I imagine something like a compass rose for a map we have not yet drawn together. I ask questions designed to take us in certain directions, but without a clear sense of the terrain we will find. Like the time-lapse roses opening slowly through the opening credits of *The Age of Innocence* (1993), I hope for the unfolding and beautiful ideas that can only blossom through our unhurried exchange of ideas. I also recognize that every person enters my classroom having known stress, pain, anxiety, anger: all those emotions that place stress on the heart. Without requiring my students share these feelings or the unique experiences attached to them, I am creating an environment where it becomes possible to slow down, breathe differently, engage with and absorb details, share the burden of what hurts, and be conscious of our pacing through always being grounded in our shared close analysis. My practice of slowing the conversation down through close analysis, especially for films that are distressing, is a form of the freeze-frame technique that helps us find what those films lead our hearts to understand. By extension, this practice provides my students with some transferable skills to process what is difficult beyond the classroom. Contrary to Mulvey, who finds remnants of death in every moment of a film and *particularly* when a spectator interrupts its flow by pressing pause, I find that cinema is often most life-affirmingly moving when I take the time to pause on certain moments with my students. Having explored the freeze-frame technique in miniature for a scene from *A Beautiful Day in the Neighborhood*, I now explain my application of this technique to teaching the entirety of *Dancer in the Dark*.

The Heartening Possibilities of *Dancer in the Dark*

For me, one of the great benefits of studying cinema is the chance to displace my hurts and work through them within the safety of responding to other people's stories. *Dancer in the Dark* presents me with an extreme opportunity to test this out for myself and with my students. The story follows Selma Ježková, a woman going blind who is determined to save her son, Gene, from developing the same disability. Selma has immigrated from Czechoslovakia to America, where Gene can get the operation he needs to prevent his going blind. In the context of her dwindling sight and fearfulness for her son's vision, Selma holds fast to her love of music and Classical Hollywood musicals

especially. As she explains to her neighbor and landlord, Bill, Selma hates for any of these musicals to end. She routinely leaves a cinema before the last onscreen song performance so that it can "go on forever."

Dancer in the Dark introduces Selma while she is rehearsing the lead role in a stage production of *The Sound of Music*. At her musical rehearsal, Selma is empowered by being center-stage and directed with compassion. In the very next scene, however, the film highlights her intense vulnerability: she is preparing for an eye test and using a cheat sheet of the vision chart before the optometrist enters the scene. Passing the vision test enables her to keep working at a factory where the work is increasingly dangerous because of her dwindling sight, but she is motivated to keep working there to raise money for Gene's operation. Selma takes her script for *The Sound of Music* into the factory, attempting to bring that musical's fanciful hopefulness into the space where she is most at risk. The foreman kindly but firmly disallows her distraction from the work: he says, "You can't bring the script to work, Selma." He is soon obliged to fire her after she breaks an expensive machine due to her not being able to see its operations clearly. Selma's circumstances become increasingly desperate after she loses her job. She discovers that Bill has stolen her life's savings due to his own financial desperation. Since she has been saving everything she could possibly earn to pay for Gene's operation, she confronts Bill and pleads with him to give her money back. After refusing to return the money, Bill tussles with her and accidentally shoots himself. Bill then begs Selma to finish killing him, which Selma does in anguish. Selma is consequently arrested for Bill's murder, tried, convicted, and sentenced to death by hanging. Against the wishes of her friends, she refuses to use her savings for Gene to pay a lawyer who could have her death sentence commuted: so, she sacrifices her life for her son's sight.

Given its fraught narrative, *Dancer in the Dark* could seem like a very strange choice for exploring the calming, restorative, and healing application of *The HeartMath Solution*, let alone the freeze-frame technique. But it is precisely because the film presents such a traumatic experience that it is the ideal opportunity for exploring what studying cinema can do for any of us in the face of a great challenge. Though excruciating, *Dancer in the Dark* rewards a complete investment in its own processes. Where I have already applied Frampton's concept of the filmind, I will now write of the film body that inspires my embodied, heart-led response. While I cannot speak for what every individual student has felt about *Dancer in the Dark*, I can report the special strangeness of film screenings during which I have

heard the breathing of my students change along with mine. This has made the fact of our hearts' overlapping electromagnetic fields seem palpable to me. Moreover, the film itself pulses with a life that does not end with its final frames: instead, the ending leads us right back to the place where it began, as if asking to be replayed. Through its unusual structure, *Dancer in the Dark* offers a potent example of the awe-inspiring gift that is an unending life.

Preparing and Leading My Students

Before a course screening of *Dancer in the Dark*, I have routinely prepared my class by explaining the foundations of the Dogme '95 manifesto that was cowritten by Lars von Trier and Thomas Vinterberg in 1995. Though the film does not adhere to all their "rules" for avoiding manipulative construction, it still chimes with the spirit of their "Vow of Chastity" that claims cinema can be rejuvenated and newly radical.[32] As Rachel Joseph points out, Dogme '95 "forbids using multiple still cameras, sounds that split from the diegetic universe of the film, and the theatricality of the musical numbers."[33] Ironically, *Dancer in the Dark* breaks all these rules, most (in)famously in the factory musical number that was created using two hundred digital cameras to capture its kinetic choreography and numerous angles on the workspace that Selma sees differently when she sings. The scene features quickly paced editing and digitally enhanced colors to match Selma's elevated and gleeful mindset while music dominates her mind. The scene therefore shows manipulated reality in the service of representing Selma's feelings with radically extreme compassion. Despite being a tour-de-force in film style and technology, this number is still a strident response to spectacle-for-its-own-sake cinema in keeping with the Dogme '95 manifesto.

The week before I host a class screening of *Dancer in the Dark*, my students and I watch a Classical Hollywood musical together, usually *White Christmas* (1954). This is a familiar musical to many of my students, and its familiarity enables us to leap into the details of its form. We discuss its easily identifiable usages of music for setting scenes, developing characters, buttressing spectacular visual displays, and providing escapist hope in the narrative context of the Second World War and its aftermath."[34] By the time I screen *Dancer in the Dark*, my students have spent months learning about genre as an elastic concept and every film as a unique part of an unfinishable conversation about generic expectations, all paving the way for this film that will demand

more from them than any other in my "Film Genre" course. I know *Dancer in the Dark* will be disturbing for my students, especially since most of them are new to it. The screening is a consistently nerve-wracking event, to the extent that it almost feels dangerous. I have gripped the desk in front of me as my body went cold, struggling to maintain control over my own breathing while attending to the breathing of my students. The room will always become uncommonly quiet because we are all folded into the intensity of the experience. During in-class screenings of other films, some students will leave for a brief restroom break, or shuffle about a little, like typical audiences confined to a room for two hours. I am always struck by the comparative stillness and the near-silence of the room when we watch *Dancer in the Dark* together. After other film screenings, a few students will routinely talk to me, usually to share their initial impressions, but almost all students leave the screenings of *Dancer in the Dark* without speaking. It is too difficult for most of them to talk about what they have witnessed right away.

For our discussion class a few days later, I adapt the steps of the freeze-frame technique that I have outlined as follows: identifying a stress, taking a break by focusing energy on the heart and slowing the breath, recalling a positive experience, and then returning to the subject of stress to rethink how to approach it using heart intelligence. First, I begin our conversation by acknowledging the stress of the film experience. I open up a conversation about what *Dancer in the Dark* has done to everyone in attendance. Second, I focus on calming everyone, to facilitate breathing differently by slowing my own speech and methodically explaining what we are going to do. I reassure my students I will not be replaying any of the most traumatic scenes and songs of the film for them. The following parts of the film do not need replaying to be fully felt: the horrific murder scene that lacks music; Selma's heartbreaking fantasy scene of being forgiven by Bill, his wife, and Gene as she sings "Scatterheart"; the scene of her singing "107 Steps" to help move herself from a holding cell to the place where she will be hung; and the final scene of her execution and broken-off performance of "The Next to Last Song." Since I know that our recalling these scenes and songs is enough for the purposes of the class, I then give my students instructions for returning to the film's gorgeous beginning: the orchestral "Overture" based on the same melody as "The Next to Last Song," along with the opening montage of paintings by Per Kirkeby (15sec–3.46). This is the positive experience we will relive together and I replay it for them without interruption. I ask the students to focus on what happens through that beginning and to do some free writing

about their moment-to-moment impressions while it is playing, without editing their own responses. I encourage my students to write with as little self-censorship as possible because I want them to try capturing those rare and fleeting impressions that require being totally in the zone of the film. This can happen almost effortlessly if we feel we are pulled within the electromagnetic field of its beating heart. We discuss what the beginning audiovisually communicates and how it anticipates what follows. Our close analysis inevitably includes my students and I raising questions. Having slowed down to focus on the film beginning's details for long enough, we then look back on the overwhelming experience of the whole film, reconsider what it all means, and answer the questions we have raised with heart intelligence.

What follows is a summary of how I understand *Dancer in the Dark* after ten years of developing this approach to teaching it. Through the different nuances and details of every class discussion, I have reached a cumulative understanding of what the film does for my heart that is directly inspired by all that my many students have said. Their open-hearted willingness to revisit the film's beginning has led me to discover the film's surprising kindness. I now internalize this as a lesson for coming to terms with death. This lesson leads me back to a celebration of life.

The Big Surprise, the Greatest Gift

From the outset, *Dancer in the Dark* strikes me as an energetic being. The beginning represents Selma even before her first scene, previewing her extraordinary way of seeing and the majesty of her internal music. This only became clear to me after my own first audioviewing of the entire film: Selma is not immediately onscreen but most of the action after the beginning revolves around how Selma sees and hears the world, in ways that correlate with Kirkeby's abstract paintings and Björk's "Overture." The paintings are rich in changing colors and shapes, evocative of cells shifting under a microscope, with lines as unique as fingerprints. The paintings morph through dissolving transitions. The colors of the montage become increasingly bright and thick, then disperse, and then fade out. This morphing abstract art anticipates the entirety of Selma's journey through the film as well as the perishability of her body: though she cannot see sharp contours, her story becomes increasingly "colorful" through the vibrancy of her musical numbers, right up until the closing scene of her death. Most of the scenes that

are dominated by Selma's music are brighter than the others. Her music is attached to elevating the *mise-en-scène* in accordance with her non-literal vision, which makes her subjective perception the audioviewer's own.[35] Therefore, the paintings of changing shapes and lines are suggestive of the ways Selma sees *and* the dynamic richness of her vision despite, or even because of, her growing disability. Along with having such strong narrative and symbolic logic in themselves, the paintings are virtually inextricable from the "Overture" that plays with them: the cue features a full orchestral range of "colorfully" changing timbres and textures that complement the shifting tones of the paintings; the pinnacle of the score comes with the colors reaching climactic intensity; and when the music decrescendos and trails off, the colors and shapes disperse widely before fading out. Through these audiovisual patterns, the beginning of *Dancer in the Dark* is an extraordinary example of added value: the music and visual logic are completely unified in anticipating Selma's onscreen presence.[36]

While Kirkeby's paintings evoke Selma seeing the world through shapes and lines, the opening music is as physically involving as any of the numbers she performs through the film. "Overture" features brass instrumentalists playing long held phrases that require deep inhalations of breath, and these breaths are at least subconsciously perceivable. This gives the music a strong feeling of human embodiedness, especially in combination with the strong timpani beats that punctuate the climax of the cue and that evoke images of a percussionist's manually deliberate action. In short, I find that the body of the music cannot be separated from the bodies that made it. This music merges with the visual logic so much that the whole "body" of the film seems unusually and organically powerful too. This musically driven experience invites my students' and my own embodied engagement, pulling us into irresistible entrainment with its pacing.[37] In short, the entire beginning of *Dancer in the Dark* prepares my students and me to be fully absorbed with Selma's life in conceptual, physical, and heart-led ways.

The "Overture" is an orchestral variation of the final song that Selma sings onscreen ("The Next to Last Song"), right before she is hung by the neck. Over the closing credits, her voice returns over yet another variation of the same music (titled "The New World"). Upon a repeat screening of the film, the whole experience becomes a mobius strip because the ending doubly echoes the beginning. Selma's voice for the closing credits suggests her spirit coming back after death, which can lead us back to the beginning where her voice is absent but lingering in the mind's ear. Directly after "Overture," the

film cuts to the title "Dancer in the Dark" and a sound advance of Selma talking to her stage director in a rehearsal for *The Sound of Music*: she says, "you're sweating," and he says, "I know, I'm excited though. I can see it all happening." By implication, the film is announcing that everything important is already happening and we can "see it all" if we want. Through my discussions with students, I have found this to be true in the film's beginning. Even though its music has always led us to confront the tragedy of the film's ending, we have shared excitement about how much we feel is happening from the start.

By the time Selma is about to hang, at the climax of *Dancer in the Dark*, bright colors have drained from the film and she can barely see. Unlike other scenes that become more vibrant with Selma's music, the palette does not change in the final minutes. In the absence of vibrant color that signifies Selma's ability to escape her immediate reality, this scene is the most uncompromisingly painful. With a noose around her neck, and while a prison guard waits for the official phone call to proceed with hanging her, Selma begins to scream Gene's name. Her friend Kathy seizes a chance to run into the execution chamber to reassure Selma that Gene is waiting right outside and that he will receive the operation he needs to prevent his going blind. Kathy is pulled out of the execution chamber by a prison guard, but not before she calls out a crucial last directive to Selma: "listen to your heart." Kathy's reminding Selma of her own heart's power leads Selma to find solace in her ability to sing once more. As if knowingly adapting the freeze-frame technique, Selma slows her own breathing so that she can control her own voice, sings lyrics that remind her of sweet memories with her son, and appears to access the full power of her heart (see Figure 3.3). This mediates the terror of her imminent death. The sound track features a strong heartbeat that begins moments before her first lyric and which continues subtly under her singing at a regular pace. I assume it is Selma's heartbeat, but it is irreducible to one point of audition when I think of the film having a bigger body than hers, and one that enters my space on her behalf. The fact that the heartbeat sounds so much louder than it possibly could as her internal sound is reason enough to believe that it comes from the film's entire "body" rather than Selma's alone. As I have absorbed this scene with my students, I have felt that heartbeat merge with my own so that it takes on extra-diegetic meaning. Even more than in the beginning, I feel the film is knowingly pulling me into entrainment with its heart. Though the film revolves around Selma, its body has to be bigger than her life

alone to keep going after she dies. Its sonic design folds me into its own mysterious immensity.

Selma is suddenly hung before she finishes the song, during one of her longest held notes, and when her voice gathers most strength. The film thus honors her desire for a musical to avoid the finality of a complete last song. As shocking as it is when her voice suddenly cuts out, her song remains an undeniably incontestable power to me. As is common with climactic performances within musicals, the relative volume and audibility of her singing voice do not change although the camera's vantage point shifts often. Despite this stylistically generic conventionality, the visual fluctuations of the scene are unusually turbulent to me. There are marked changes in the camera's proximity to Selma and its angle on the action with almost *every* cut, including juxtapositions of extreme close-ups and medium-long wideshots. It is as if the film is already preparing to leave Selma, even though her voice remains consistently at the top of the aural hierarchy. That the film is sonically intimate but visually pulling in different directions represents the paradoxical logic of an experience that I think anyone can understand, whether they have already lived it or not: the desire for a loved one's death to be over while holding on to their life *at the same time*. By the same token, Selma's triumph through singing to the end of her life is what matters most. Her victory

Figure 3.3 Just behind Selma we can glimpse prison bars and a prison officer's shoulder, but the scene audiovisually prioritizes her personal, heart-led interior space.

extends even beyond that too. The final quotation that appears onscreen over the image of Selma's body cannot be her voice, but it honors what she might say if she could: "They say it's the last song. They don't know us, you see. It's only the last song if we let it be." Perhaps this quotation comes from the filmind. It leads me, or any potential audioviewer, to cherish my oneness with Selma on the deepest level. With this quotation, "she" and "we" have become "us" against "them." After her final song that "isn't the last," this closing quotation is another way of honoring Selma's desire for a musical to keep going forever.

In more ways than one, Selma's musical parting gift is the refusal of an ending. She gives her son an open letter in song form, one that invites him (and any of us, by extension) to remember her words and her voice. Though he is not present at the execution, we know from Kathy that "he's just outside." There is every chance he can hear his mother:

> Dear Gene,
> of course you are here
> and now there's nothing to fear
> oooh, I should have known
> oooh, I was never alone
>
> This isn't the last song
> there's no violin
> the choir is so quiet
> and no-one takes a spin
> this is the next to last song
> and that's all, all
>
> Remember what I have said
> remember, wrap up the bread
> do this, do that, make your bed
>
> This isn't the last song
> there's no violin
> the choir is quiet
> and no one takes a spin
> this is the next to last song
> and that's all

Is this not the *ultimate gift* of a mother to her child?: instead of languishing in martyrdom, Selma uses her last breaths to sing words that insist on her triumphant ability to keep going ("this is the next to last song"), that remind Gene of simple instructions that he will undoubtedly play over and find solace in ("wrap the bread," "make your bed"), and that invite him to remember her voice ("remember what I have said"). Selma's focus on "speaking" with her son with such compassion and clarity reminds me of how my own mother died. Her death came all too quickly: there were only five days between her diagnosis of terminal cancer and her death. In that brief time, she achieved an extraordinary grace that she extended to me. In our last two-way conversation, I cried about the diagnosis but she assured me "I can never really leave you." This led me to be braver in my final FaceTime call with her just a few days later. By that point, she could not speak anymore. I looked right at her without crying and expressed my thankfulness for her life instead of speaking out of my bitterness that she was slipping away. With her fixed gaze back at me, I know she took in everything I said. Because of her strength, I was able to hold myself together for her. This was the greatest thing she could have done for me. These days, I carry her strength forward in the conversations I have, and not only in sharing the last words she spoke to me. The lifeshock of her dying has informed my teaching of *Dancer in the Dark*. As I honor my mother through replaying my memories of our final interactions, I teach my students about the value of holding on to Selma by remembering her voice in its absence. In my more private returning to the film's end that dovetails with Selma's implied presence from the beginning, I understand her as the mother who never really leaves me.

Selma's final diegetic performance is followed by the return of her voice with the final credits, underlining that she never truly leaves. A near-minute of silence follows her hanging, during which the movements of all onscreen characters are inaudible, including the prison officials who walk toward her body to pronounce her dead and draw a curtain across the execution chamber. This grave silence offsets the significance of Selma's voice coming back once the diegesis has finished. The final credits play over her different lyrics to the tune of "Next to Last Song," now titled "New World," and with an orchestral backing that recalls the beginning of the film albeit with different instrumentation. The final credits include some replayed footage of Selma and other main characters of the film while the actors' credits appear, virtually bringing everyone back into joyful life along with her. She sings of her favorite things and of a new life opening up:

> Train-whistles, a sweet clementine
> Blueberries, dancers in line
> Cobwebs, a bakery sign.
>
> A new world, a new day to see
> I'm softly walking on air
> Halfway to heaven from here
> Sunlight unfolds in my hair
> ooooh, I'm walking on air
> ooooh, to heaven from here.
>
> If living is seeing
> I'm holding my breath
> In wonder, I wonder
> What happens next?
> A new world, a new day to see.

Perhaps I (or any audience member) can be "what happens next," because I can define a "new world, a new day to see," one in which other Selmas do not have to die. However these lyrics register, the ending leads us back to the beginning and a "new day to see" that is the continuation of Selma's life after death.

Looking back on the whole film experience, I think the bigness of the opening "Overture" is unforgettable in relation to the small body that is destroyed in the end, even though that body houses Björk's most distinctively powerful voice. Though the body of the film and its orchestral scale may be bigger than her, they also cannot exist without her. Given that the end returns to the music of the beginning that is shaped in terms of her audiovisual experience, Selma is certainly much more than a destructible body. Her song that is *not* the last song leads me to not only revisit the beginning but to stay with it as something endlessly new. In the words of T. S. Eliot, "the end of all our exploring/Will be to arrive where we started/And know the place for the first time."[38] Moreover, I find that returning to the beginning is a most extreme and valuable opportunity for enacting the freeze-frame technique. Even after living all the trauma of the film, I consistently feel restorative calm, balance, hope, and joy by replaying and reabsorbing the beginning's wordless logic. It anticipates everything to come with the grace of foreknowledge that I can only appreciate after-the-fact. When I analyze this beginning with my

students, the film opens up before us like water spreading out through many channels. We free ourselves from fixating on what was most painful so we can better comprehend what the film does to lastingly honor Selma and what we have lived with her.

Dancer in the Dark is the ideal film for my teaching schedule because I always hold a discussion class a couple of days after the given in-class screening. With the benefit of a little hindsight, as opposed to the rawness of having just experienced the film, it is richer for my students and me. The film virtually holds my students and me in a conversation that is invariably more tender and less rushed than usual. It holds us in Selma because it honors her devotion to music that changes how she sees. It holds us in the ritualistic experience of the "Overture" as a musical anticipation of everything to come. It holds us in the compulsion to keep listening and watching an extraordinary example of added value. It holds us in time through ponderous pacing too. Though everything audiovisual is in a continuous state of flux through the beginning, there is no sense of hurray. Instead, there is a sense of complete control as the forms of color gradually grow, come into focus, and change in ways that complement the music, as if the film were asking us to breathe with it and the instrumentalists breathing into their instruments. Through our class discussion, we rediscover the beauty that honored Selma's life before we knew what it was doing.

I teach my students how the film's beginning offers us a compelling chance to use our collective heart intelligence. After having had the entire film experience, they can comprehend its emotional and embodied suggestiveness, as well as its heartfelt implications for themselves. Sometimes it has led my students and me to play over the words of real loved ones after they have died. The abstract shapes of the painterly montage have also reminded us of how indistinct memories of a person can become, and how the contours of a person's face become less defined in time. In this context, we cherish our audiovisual intimacy with Selma's internal life after having seen her moment of death from a visual distance. We pay tribute to her by returning to the "Overture" with her voice in our mind, and by returning to the colors that were brightest when she sang. In returning to the film's beginning, we make ample time for the process of coming to terms with her death together.

By slowing down enough to review that beginning with my students, piece by piece, I have come to fully accept the pain *and the gift* of *Dancer in the Dark*. My feelings of gratitude and appreciation for this film nourish my heart and thereby every cell of my being. As Childre and Martin explain, "we can look at

life as a high-speed movie," and the "thoughts, emotions, and experiences that make up our lives" rush by as quickly as cinematic frames past a projector.[39] Or, we can choose to slow down, feel the film's full emotional impact through our hearts, and choose to hold onto life even while it flows through us along with the film. This is the most sustaining possibility that *Dancer in the Dark* provides: though we are all like Gene in that confronting a loved one's death is the greatest test of our hearts, we still have the choice to keep living in the face of that. Even after that loved one is gone, we can return to her singular voice, to our gratitude for what we felt with her, to the details that honor her, to the remembrance of what she said, and to the music that she made.

The Widening Conversation

Along with engaging its audience unusually, *Dancer in the Dark* self-consciously opens up a conversation between itself and other films, especially Classical Hollywood musicals. It is most directly influenced by the stage and film versions of *The Sound of Music*. This is established with Selma's first onscreen appearance rehearsing the part of Maria singing "My Favorite Things." In later scenes of *Dancer in the Dark*, Selma's own song titled "In the Musicals" floats above a slowly rising major scale, echoing Maria's "Do-Re-Mi" song. On the evening that she kills Bill, Selma performs "In the Musicals" at her last rehearsal of *The Sound Of Music* as a free woman. This is an upbeat and intricately choreographed number showing Selma's virtual escape from the world and her fantasy that "there is always someone to catch [her]." The other characters involved in the rehearsal dance around Selma as she sings. Police officers enter the scene to take Selma into custody but their threatening presence is almost nullified by their becoming part of the show in her mind: they lift and carry Selma to their car instead of frog-marching her out of the rehearsal (1.28.11–1.29.44). Selma reprises "In the Musicals" when she is on trial and her case has become hopeless (1.38.26–1.41.39). Both examples of "In the Musicals" are about relaying Selma's internal life that rises with as much sense of assured direction as an ascending scale. Though the characters with Selma in rehearsal and at court join in the choreographed numbers around her central presence, the film's heightened colors during these numbers underline that they are not *in fact* joining her. The other characters only "catch" Selma in her imagination, but the *music* she loves "will always be there to catch [her]."

Selma's devotion to what music can do and her connection to Maria culminate in her adaptation of the song "My Favorite Things" from within a prison cell. At this point, her singing voice begins weakly: her self-soothing is more of a struggle than ever before.[40] That said, Selma manages to claim the song for herself with her own favorite things in addition to those that Rodgers and Hammerstein imagined: after the familiar lyrics including "raindrops on roses, and whiskers on kittens," Selma adds, "crisp apple strudel, doorbells and sleigh bells, and schnitzel with noodles. Wild geese that fly with the moon on their wings." The differences between Selma and Maria's stories are painfully clear, ironizing Selma's version of "My Favorite Things": Maria escapes danger in Germany during World War II, successfully slipping away into hiding after she performs at a music festival with her new family, whereas Selma's music never connects with her actual escape from danger. That said, the films parallel each other in that music is a great comfort to both protagonists as they face overwhelming danger.[41]

Along with alluding most obsessively to *The Sound of Music*, *Dancer in the Dark* draws from preexisting melodramas. Key examples of melodrama include Douglas Sirk's most celebrated films, such as *Magnificent Obsession* (1954), or *All That Heavens Allows* (1955), both of which revolve around female characters whose turbulent internal lives are made manifest through film style, and both of which are scored with lavish orchestrations by Frank Skinner. In these Classical Hollywood examples, the female protagonists' feelings are represented by the abundantly expressionistic *mise-en-scènes*, notwithstanding the emotional impact of Skinner's music, whereas *Dancer in the Dark* uses music as the *primary means* of communicating and honoring Selma's uncontainable extremities of feeling. The uplifting vigor of her music comes as a particular surprise in the context of von Trier's infamy for subjecting his female protagonists to physical and emotional agony. From Bess's descent into depression and death after being raped in *Breaking the Waves* (1996), to the climactic clitoridectomy scene after "She" endures losing a child in *Antichrist* (2009), to the complete annihilation of two sisters and the entire world around them in *Melancholia* (2011), von Trier's name is associated with "feel-bad" cinema at women's expense.[42] In addition, *Dancer in the Dark* has a nasty metacinematic meaning given Björk's well-documented allegations of von Trier's tyrannical behavior during the making of the film.

The consoling, humane power of Selma's music in *Dancer in the Dark* is a surprise amplified by its generic forebears but complicated by its auteur-centered reception. While some scholars embrace the film's uncommon

stridence, others question von Trier's motives. For example, Charles Burnetts dismisses the entire film as the work of a prankster manipulating his audience without care for their true involvement: "Embodying a rather grosser kind of postmodern parody, *Dancer* invokes sympathy for Selma while complicating the extent to which identification is truly possible. Is this Björk or a fictional character? To what extent are we supposed to sympathize with her off-kilter character? In such respects, *Dancer* certainly succeeded in distancing a fair number of critics and spectators, yet as the Cannes jury seemed to acknowledge, such a fostering of camp detachment seemed to be part of von Trier's game all along."[43] Graham Rhys acknowledges being moved much more than detached from Björk's performance, but still calls the film "emotional pornography."[44] Peter Bradshaw dismisses it as "the most sensationally silly film of the year—as well as the most shallow and crudely manipulative. Everything about it is silly, from the faux naivety and implausibility of its plot to the secret little idiot savant smile on the face of its Victim Heroine played by Björk—a squeaking, chirruping diva turn sufficient to curdle every carton of milk within a 10-kilometre radius."[45]

Other critics take the film much more seriously by stressing Selma's tragedy, but still with devastating conclusions. For example, Rachel Joseph pays respect to the film's revisionist unconventionality but emphasizes the dead-ended futility of Selma's delusions. She argues that where most musical numbers provide a "safe space" of joy and spectacular display, the musical numbers of *Dancer in the Dark* can only "shield" Selma from trauma so long.[46] Although Selma luxuriates in her internal music at the factory, Joseph stresses the danger of her becoming so lost in the number "Cvalda" that she breaks a massive machine. Therefore, Joseph dwells on the music as it connects to Selma's physical vulnerability over and above its robust and transformative energy. Joseph also writes of the film as a melodramatic "call into the void for someone to witness the character's love, pain, etc."[47] I take exception to this claim: we are surely not called into the "void" that Joseph imagines. Instead, I find the film pulls my students and me into a place of fullness. It is made to work for us as living, breathing beings whose lives are largely determined by our hearts and who can positively change our own and each other's lives through our growing heart intelligence.

The most crushing critique of *Dancer in the Dark* comes from Jennifer Iverson: though she stresses that Selma's "pointless" suffering is an important critique of an "unjust culture" where we "ignore the social crisis that surrounds disability," she concludes her analysis by asserting that "in fact,

Selma does die in vain."[48] I find this a severe underestimation of what the film does and how an audience can feel in response to it. Selma does not have to be relegated to the place of a pawn who dies pointlessly in von Trier's nasty game of chess—she can be liberated by the very form of the film that compellingly invites us to keep living her truth. Though Selma's pain leads to my own suffering, I know I can withstand it, especially when I realize the gift of returning to where I began with her: she does not have to end, and neither does the life-affirming power of the film.

Dancer in the Dark makes strident statements against ableist culture, along with its stand against the death penalty, a capitalist society that runs on exploitative labor, the plight of immigrants without access to affordable healthcare, and deep-rooted problems in the justice system of America. Still, I stress the gift of the film that many have ignored but that others have implied through writing about what the film does to and for them physically. For example, drawing from Laura Marks's work on the "haptic visuality" of cinema—that is, the impact of virtually palpable images in relation to concepts of touch and kinaesthetics—Davina Quinlivan writes about how the very form of the film is shaped in terms of Selma's bodily movements and embodied feelings.[49] As Quinlivan explains, when Selma begins to experience euphoria in her number "I've Seen It All," thus disavowing her need for actual sight, the editing is "a burst of energy" that matches her excitedly breathing body.[50] Selma performs "I've Seen It All" by the train tracks to reassure her loving friend Jeff that she is accepting of her near-blindness despite their being perilously close to an oncoming train. In contrast with this euphoric scene, Quinlivan writes of the micro-montage within Selma's cell that shows pieces of her body as she struggles to find her singing voice. Quinlivan describes her own distressing physical response as follows: "something morbidly turns in the pit of my stomach," and "my lips part, dryly, aghast, my breathing slows down and my heart beats a little faster." Here, Quinlivan echoes Nathaniel Rogers, who also observes a direct connection between his body and Selma's: "By the end of the film I felt like I could only breathe if Selma could—the shifts to Selma's musical world became my own flood of emotion and relief."[51]

I personally find that *Dancer in the Dark* both appropriates and reinvents what a musical can do for my heart, which has physical *and* metaphysical depths of meaning. As I am willing to be wholeheartedly attached to Selma, to the extent of consciously noticing my heartbeats and my breathing in alignment with hers, I am primed to action in honor of her death. This is

why I teach the film over and over again, even though I always worry about how my students will receive it. In addition, as I accept the film's invitation to return to the opening montage, and to remember the voice implied by the "Overture," I am not only accepting an opportunity to memorially reinsert Selma's voice but to consider what that voice has meant, what that body suffered, what I lost when she died, and what I can choose to preserve of her and my own humanity because of that. I invite my students to live all this with me, and I always find they are willing.

In addition to this personal and pedagogical experience, I understand that Selma lives beyond the film through Björk's release of the album "Selmasongs," which includes most of the music she wrote for *Dancer in the Dark* (albeit with some adaptations of lyrics and variations of instrumentation). Through "Selmasongs," Björk's performance of Selma can keep happening to me and in the world at large, reuniting me (or anyone) with the essence of Selma's internal life and the lasting vitality of her music. The album was released the same year as the film, but it is often reviewed as an independent entity that is representative of Björk's musical originality, agency, and prowess despite von Trier's notoriously oppressive directorial control over the star's performance within the film. Whatever control von Trier exerted over Björk during the making *Dancer in the Dark*, I hear "Selmasongs" as another form of freedom for the character that she brought to life.[52]

Instead of a Conclusion: A Student's Heart-Led Response

In applying principles of HeartMath to teaching, I am creating space and time for an unorthodox but carefully managed kind of classroom experience. As the opening montage of *Dancer in the Dark* features some patterns of paint that look almost cell-like, I am reminded that "core heart feelings keep our cells regenerating."[53] Like bell hooks, I am not attempting anything like traditional therapy through my pedagogy, but I recognize the healing potential for using and teaching cinema to develop heart intelligence. This has not only led me to understand why I love *Dancer in the Dark* better—it has helped me lead my students out of the film's pain and toward its hopefulness.

Some students have used the film to make sense of their own lives. I close this chapter with a representative example of the extraordinary connection one student felt to the film. Instead of providing a typical conclusion, I finish with this student's words because they fully encapsulate what he gained from

a holistic, personal, and heart-led engagement with the film after our application of the freeze-frame technique in class. In the last few minutes of our collective discussion time, he took the opportunity to share a story about fearing for his mother's life, and to connect Selma's songs with his own related retreat into music. He knew that his self-disclosures were unusual, but he chose to share them after asking for my vocal go-ahead to "speak personally." A few days later, I asked him for a follow-up interview to expand on what he had said in class. What follows is a transcript of that interview. Though I have his permission to share this text, I have given him an alias: Ray. I began our interview with some comments on the importance of writing in the first person as a form of honesty. Ray reminded me that in both high school and college he had been dissuaded from writing from a personal angle. Then he continued as follows:

RAY: Your class is the only one where I was told you could write in the first person. I've gotten essay papers back with notes written on them in pen saying, "too emotional," "too much you!" Even if you're not using first person, if there's an inflection of bias that's not factual information. I wrote a paper on immigration and I started the paper with "imagine you're the immigrant," and I stated facts about the perilous journey but I tried to put it in an emotional context and [there was] red all through the paragraph because we're not supposed to be building empathy, we're supposed to be building a logical argument based on facts.

EW: And this was in the context of what course?

R: This was my community college, probably English 101.

EW: So, then you come into this class on *Dancer in the Dark* and we have this conversation about the way the film shows how crucial music is for Selma's fantasy life and her escape. Now, here's what I remember you saying, but I would like to hear it again in your own words. I remember your saying that the way that she uses music reminded you of being in the hospital when your mother was ill and listening to music on your headphones. And you also talked a little bit about the harsh lighting in the hospital because we, among other things, talked about the light and colors changing when the music comes in. I just wanted to recap a little bit to refresh your memory, but do you think you could paint the scene for me again?

R: In *Dancer in the Dark* there's a scene where she's working in the factory and she's taken up a number of shifts so she's getting tired. And she starts fantasizing like she's in a musical. The color palette changes and everyone

starts dancing and she's smiling where before it was this bland grey. Then it gets this warm, less florescent, more natural yellow. Back in Elementary School, my Mom had gotten breast cancer so I had spent a lot of time in the hospital sort of just waiting in waiting rooms, not knowing too much of what was going on. And I had a little CD player before I had an iPod. I had one disc with me. It was *Company*. And I would just . . . I remember it was the song "Being Alive" at the end. I would just stare at the lights, I would look up at the ceilings. Later on, I would imagine parts of the musical in my head. When I would walk, people would come up to me because I would be so in my own zone I would stop walking straight—people thought something was wrong with me. But whenever there was news, or it was time to go, or any situation where I needed to pay attention, they would just pull the headphones right off my head.

EW: Who's "they"?

R: My Dad, sister, family—it wouldn't be doctors or orderlies doing that. I can understand. It would have been a tough time for them too. But they would just take the headphones off and the fantasy would be gone—I'd be back in this boring, bland hospital room with these giant lights, everything would be white. It was just morosely b—. I don't want to say boring because that undercuts it. [That] feels so sanitized.

EW: And just going back to the music? What particular music was it on the CD?

R: Have you ever seen the musical *Company*? [sigh] I love it. This didn't come out until after but they did one with Stephen Colbert. The big part that I like is this song called "Being Alive" where this guy, he's just talking about . . . he wants to fall in love with somebody, he wants someone who will ruin his sleep because they worry about him so much, someone who'll sit in his favorite chair, just all the mundane boring things that people are annoyed about. But really that love is what living is all about. And I don't know why but I just always adored that song.

EW: Something interesting emerges there because you talk about the hospital being mundane but then you talk about this man singing about how the mundane can become—

R: Beautiful?

EW: Yes.

R: Yeah. Well, all his problems seem so small. He's just a guy, there's no pressure, no one is dying, it's just someone trying to find love.

EW: So there's a lot of hope in that as well?

R: Yeah. If he fails, in comparison to how I felt the stakes weren't that bad.

EW: So, thank you for going back to that moment. I know it's difficult. This is my last question. Can you tell me how that experience informed your response to *Dancer in the Dark*? In other words, what did it help you understand about *Dancer in the Dark* and why we studied it?

R: Well that goes to some personal experiences from this year. I had two uncles from the two different sides of my family died. One of a stroke, and one of a brain aneurism. And I loved them. This year I've had a lot of anxiety about my own death. There's this scene in *Dancer in the Dark* where she's just up there. She has to walk to the noose. She's singing to herself, she's humming, and it's horrific and in a weird way I couldn't help putting myself in that situation. That could be me. Maybe not today or for a long time but we all have to deal with that anxiety eventually. It almost felt like a borderline panic attack in the screening room.

EW: Oh! [involuntary gasp]

R: No, no, don't feel bad. It's okay. But it was *very* scary. After that, it felt like I was faced with something I was really trying to ignore and twenty minutes after it was euphoric. I guess what makes *Dancer in the Dark* so special to me is she's doing this for her son so he can live a better life. She wasn't by any means okay with it. Just feeling like you love someone so much you'd be willing to volunteer and do something so horrible. In a weird way it's kind of hopeful too. I guess I'm still processing a lot of emotion about *Dancer in the Dark*. It's the value of life and the fear of mortality. It gives me hope to think you could love so much that death becomes irrelevant. That's what *Dancer in the Dark* meant to me.

4
Hearing Life in the Midst of Death

Psychological Healing within *Life of Pi*, *Ikiru*, and *A Star Is Born*

> Keeping grief in means keeping joy and wonder out. We cannot live in full bloom without it.
>
> —Sophie Sabbage[1]

> Death exposes the fragility of life and the futility of everyday busyness and strivings. Death focuses and clarifies. The terror of death teaches us what really matters and how to live authentically... Thus, the sting of death is swallowed up by our engagement in a meaningful life.
>
> —Paul T. P. Wong and Adrian Tomer[2]

For a period of about two hours, I choose to invest in the lives of characters I have never met, that I might never meet again, and who cannot look back at me or hear me. I invest my heart in a process of coming to know these characters, which means that losing them might make me cry. Even if they live on in my mind and through repeat audioviewings, like Selma from *Dancer in the Dark* or Yuki from *Nobody Knows*, I suffer when these characters die. I feel this risk with such tearjerkers as soon as they start. Still, I willingly spend my time with these films because the love I feel for the main characters is bigger than their deaths. This emotional investment makes me wonder how much more I could invest in my own life and the lives of others that are so many hours more.

The films of this chapter— *Life of Pi* (2012), *Ikiru* (1952), and *A Star Is Born* (2018)—show me how to grab hold of life's preciousness, even while absorbing the most painful lifeshocks. The protagonists of these films must confront mortality and handle grief in ways that are extreme but that can

resonate for anyone. Each story grows around death, but death itself happens offscreen: the lead-up to death and its aftermath matters more than death itself. Each narrative structure involves nonlinear scenes, and flashbacks that teach me about mediating between the past and the present, between life before and life after great loss.

As Sophie Sabbage puts it, "the landscape of loss" belongs to us all because "we drop like leaves from trees, not only as winter draws in but *in every season*." Despite this, Sabbage says that too many of us are taught how to "achieve but not how to let go." She alludes to the well-known and entrenched influence of Elisabeth Kübler-Ross's linear model for five stages of grief: denial and isolation, anger, bargaining, depression, and acceptance.[3] For Sabbage, this model implies a need to "get over" loss, rather than welcoming in grief as part of existence that is not only unavoidable but *important to living*. Rather than resisting grief "with all [our] might," Sabbage says we should all understand that it is "transformative pain." In this context, she alludes to the psychological depth of *Inside Out* (2015), in which it is "Sadness who saves the day." Though Sadness is the most rejected character in the film, seemingly serving no purpose other than to drag everyone down, she also represents understandably depressive reactions to a dangerous "culture of relentless positivity." Riley, the little girl whose emotions are the driving force of *Inside Out*, must learn to accept Sadness—the one emotion that "it's not okay" to feel—before she can positively adjust to her new life in San Francisco. As Sabbage says, "it's only when Sadness takes over and Riley bursts into tears that her turmoil ends." Such a film example supports Sabbage's argument that many of us have done grief an "injustice." In her unusually impactful TED talk titled "How Grief Can Help Us Win When We Lose," she takes her argument to an extreme by sharing her personal growth through living with cancer. Despite her vision, mobility, and language starting to fail, she says, "I became more myself . . . Grief showed me what mattered most. It reminded me that my terminal condition is everyone's condition. It made me more loving, forgiving, grateful, boundaried, feisty, authentic. Which was everything I had longed, strived for." Grief opened her up as strongly as love: it is the "emotional oxygen that helped me breathe again." With this chapter I take Sabbage's teaching to heart, and I echo her use of *Inside Out* as an instructive example. The three films I discuss (*Life of Pi*, *Ikiru*, and *A Star Is Born*) educate me about being positively transformed by sadness.

Along with following Sabbage's work, I draw from psychological studies of understanding loss that chime with hers. For example, Sabbage's serious

attention to *Inside Out* parallels Margaret Stroebe's recent groundbreaking psychological article on poetry about grief. Like Sabbage, Stroebe argues that Kübler-Ross's stages "do not—and must not be expected to—apply generally to bereaved persons": indeed, "to suppose [they do] can have a devastating impact."[4] She uses many examples of poetry to make the case. Most movingly, she quotes the first and last lines of Linda Pastan's "The Five Stages of Grief" that liken grief reactions to ascending a staircase that goes up and circles back down:

> The night I lost you
> Someone pointed me towards
> The Five Stages of Grief.
> Go that way, they said, It's easy, like learning to climb
> Stairs after the amputation.
>
> ***
>
> Acceptance. I finally reach it.
> But something is wrong.
> Grief is a circular staircase.
> I have lost you.[5]

Within this same article, Stroebe tells the story of her attempt to compile an anthology of poems about grief, with the hope that it might bring comfort to many. She was turned down by several publishers, partly due to her lacking a literary background and therefore being deemed "unqualified" by them to make suitable selections of verse. Such exclusionary practice might discourage any of us from combining art and science. But since death and grief are great levelers, humbling us all in the pain we cannot avoid as human beings, this is reason enough to join disciplinary forces. Certainly, Stroebe makes the case for a fruitful combination of psychological and poetic understanding: "While scientists have documented the phenomena and manifestations following the loss of a loved one in quite some detail, poets can add to our understanding by portraying these vividly, bringing the feelings to life."[6] I parallel Stroebe by applying psychology to cinema about death. My findings have helped me manage my own experiences of mortality and grief: when I first drafted this chapter, my best friend (Danijela Kulezic-Wilson) was dying. Since I have therefore lived (and continue to live) my own arguments about the psychological benefits of some cinema, this chapter is

another death-defying challenge to Mulvey's insistence that cinema is always about what has already ended.

Through this chapter I address a gap in *both* cinematic and psychological studies: there is surprisingly little research on how much films can help us confront mortality, despite some important studies of movies in therapeutic contexts. Ryan M. Niemic and Stefan E. Schulenberg provide an unusually detailed survey of films representing a spectrum of attitudes toward death: from death denial in *The Fountain* (2006), to death defiance in *Fearless* (1993), to making the most of a terminal diagnosis in *The Bucket List* (2007), to a "healthy curiosity toward death" in *Wings of Desire* (1987). They acknowledge that "movies often feed unnecessary fears and support unhealthy death attitudes. At the same time, [movies] provide an opportunity to challenge personal attitudes toward death and teach the viewer a healthy perspective."[7] Mary Anne Sedney examines several films that depict children in mourning—including *Fly Away Home* (1996), *My Girl* (1991), and *A Little Princess* (1995)—and suggests that the internal/external journeys of their main characters could be therapeutic for children suffering real loss.[8] Both these studies focus mostly on plot summaries, character trajectories, and touching narrative subtexts, without any extended consideration of the specific cinematic techniques that are therapeutically important in themselves. I focus on film style more than they do, with special emphasis (again) on sonic meanings. The productions of *Life of Pi*, *Ikiru*, and *A Star Is Born* are exhilarating examples of creativity as well as compelling stories about grief. Harkening back to Sabbage, this creativity signifies the energy of life as it can make gains in the face of loss. Like the characters they revolve around, these films knowingly *make life-affirming sense of pain*. More specifically, the films use music in particularly potent ways for representing the main characters' resilience.

In the last chapter I focused on Selma's dying and her musical life after death in *Dancer in the Dark*. The films of this chapter feature protagonists who are living while facing death in various forms: from a family lost at sea (in *Life of Pi*), to a terminal diagnosis (in *Ikiru*), to a spouse's suicide (in *A Star Is Born*). Parallel to Sabbage's account of her personal growth in relation to having cancer, the protagonists' rules of engagement with life have to change at emphatically and positively transformative levels. They all shift from dwelling on their pain to cherishing the life they have left more fully. In *Life of Pi*, the protagonist has to deal with the death of his family in a storm that leaves him stranded on a boat. He survives his mourning by

transforming his trauma into a fantastical story of what happened. Mychael Danna's original score offers a benign perspective on this process. *Ikiru* shows a man learning of his own terminal cancer diagnosis and deciding to live differently as a consequence. The film culminates with a scene of his singing in the playground he helped build, placing his favorite song in the context of a space that he has transformed for a new generation. In *A Star Is Born*, the lead character's alcoholic husband commits suicide. She sings a song to him after he has died, thereby continuing a transformative "conversation" with him. With these three case studies, I journey from the macrocosmic to the microcosmic: from the full scale of Danna's entire score, to the variations of a song in *Ikiru*, to the single performance of just one song in *A Star Is Born*. Though I focus on increasingly compressed and concentrated examples, the stakes are consistently high.

Life of Pi

> Stories—individual stories, family stories, national stories—are what stitch together the disparate elements of human existence into a coherent whole. We are story animals.
>
> —Yann Martel[9]

Life of Pi is based on a novel by Yann Martel, and it focuses on the incredible story of a young man surviving a shipwreck. After his family have all perished, Pi inhabits a lifeboat with several animals from his family's zoo: a hyena, an orangutan, a zebra, and a Bengal tiger. The hyena kills the Zebra and mortally wounds the orangutan, and then the tiger kills the hyena. Pi observes these horrors without the ability to intervene and must train the tiger to coexist aboard the lifeboat with him. The tiger's name is "Richard Parker"— the name of the hunter who caught him, and the odd result of a shipping clerk's error.[10] The tiger's human-sounding name has psychological weight, for its presence is inseparable from how Pi's *personhood* changes. Over the course of his journey Pi makes the transition from adolescence to adulthood, and from debilitating grief to self-sustaining resilience, even while he is in close proximity to what frightens him most. On a literal level, Richard Parker represents a constant physical threat of mortal danger as well as reminding Pi of survival instincts that he learned from his father. Richard Parker's presence makes Pi necessarily alert and focused on his own will to

live. Therefore, the creature that could spell his death makes him hold on more voraciously to himself. To invert a phrase from The Book of Common Prayer: in the midst of death (Richard Parker), Pi is in life.[11] More conceptually, the tiger represents everything that is most fearsome *and* glorious in Pi's journey at sea. As the last surviving animal from the Zoo where Pi lived with his family before their untimely deaths, Richard Parker embodies Pi's most lifeshocking losses (as Sabbage might say). Pi's ability to come to terms with the tiger's presence, and even learn to love it, signifies his remarkable capacity for posttraumatic growth.[12]

Many years after the shipwreck, Pi tells his miraculous story to a journalist who wants to record it for a new audience. In the film's final minutes, after he has seemingly recounted everything, Pi tells the journalist an alternative version of the story in which the animals are substituted with humans: he initially survived the shipwreck with his mother (the orangutan), a crew member (the zebra), and the ship's cook (the hyena). He witnessed extraordinarily inhumane brutality aboard the lifeboat: the cook severed the crew member's infected leg, used his body as bait for seafood, and murdered Pi's mother with a kitchen knife. In retaliation for his mother's murder, Pi mortally stabbed the cook. The film thereby reveals that Pi has created an allegory to mediate the awfulness of what he saw and enacted. As part of this coping strategy, he has displaced his own violent revenge for his mother's death onto a tiger acting on instinct. Since the film's portrayal of Pi's animal-centered allegory dominates the story (as it does the novel), the "truer" and much more repugnant version of what happened to him seems weirdly less credible. *Life of Pi* is the most spectacularly stylized film of this chapter, but this does not undermine its lessons on coming to terms with grief in actuality. The film holds emotional truths that are fully supported by recent psychological research and that exceed any kind of contrivance.

Life of Pi resonates with three of the most dominant emphases in current studies of bereavement: first, the necessity of adapting to grief as opposed to getting over it; second, making new meaning from life after loss; and third, continuing bonds with the deceased. Irwin N. Sandler, Sharlene A. Wolchik, and Tim S. Ayers argue that "rather than the concept *recovery* ... the concept *adaptation* best captures the process of change following bereavement."[13] Similarly, Jamison S. Bottomley identifies a "central process in grieving" as "the attempt to reaffirm or reconstruct a world of meaning that has been challenged by the loss, with *success in doing so being associated with better adaptation*."[14] The grief counsellor Lois Tonkin writes about the importance

of adapting to life after loss in relation to one of her clients: a mother whose child had died, and who had internalized a belief that her grief would shrink over time. The bereaved mother never reached a feeling of simple resolution: the "grief stayed just as big, but her life grew around it." Tonkin writes of this mother "integrating the loss," and making a new life with it, like a plant might grow around concrete.[15]

There is a consensus within bereavement scholarship that adapting well is *most* difficult in relation to "the great tragedy of a sudden death," due to the complete lack of any sort of inner preparation for this loss.[16] This is an important consideration for the protagonist of *Life of Pi*: he is very suddenly the sole shipwreck survivor after losing his entire immediate family. It makes psychological sense that he matches the extremity of his circumstance with the extremity of his allegory. The importance of his allegory as a form of "restorative retelling" also resonates with psychological studies of real people whose loved ones suffer violent and/or sudden deaths and who repeatedly retell others about what happened to "gain some sense of control over the traumatic impact."[17] In short, Pi's allegory and his retelling it to a journalist represent the strength *and necessity* of his adaptive will.

Many authors in the journal *Death Studies* stress the significance of *meaning-making* while people adapt themselves to living with grief. Juanita Meyer and Hané Fourie argue that "pain remains when [p]ain is not only the result of a story that did not succeed in the past but probably the inability to construct a meaningful future story from it."[18] Along similar lines, Neil Field explains that "the death of a loved one has been described as an assault on the individual's meaning system that affects many central aspects of the bereaved individual's life story. Such disruption sets in motion an active mental process toward re-establishing meaning within the bereaved person's new life situation."[19] In the words of Paul Wong, the fantastical aspects of Pi's allegory represent "the integration of unpleasant and challenging events into a coherent, *transformed* worldview."[20] Simply put, Pi's far-fetched narrative represents a most deliberate act of meaning-making in response to his unfathomable loss.

Healthy bereavement was once considered a process of thoroughly detaching from one's relationship with the deceased, but psychologists now favor acknowledging the significance of *continuing bonds* with the deceased. Freud's argument that a continued attachment to the dead can be an "indicator of pathology"[21] has been debunked in recent years—instead, it is a person's ability to evolve after the death of a loved one, often through a kind of

continuance of their relationship with them, that can effect positive change. A continued bond to the deceased can be experienced through engaging with memories and the "internalization of their reconstructed image[s] to enable positive psychological attachment."[22] Kathrin Boerner and Jutta Heckhausen explain that a positively adaptive person often achieves a *balance* between retaining and changing the relationship with those who lived, sometimes through remaking the relationship into "mental representations that can serve as substitutes for the actual presence of the loved one."[23] This resonates with the force of Pi's ability to mentally reimagine what happened to his family. The power of his process shapes the entire film that is almost entirely devoted to rendering his allegory as if it were literally possible. Most crucially, instead of replaying his mother's murder as the barbaric choice of another person, Pi reimagines it as the violence of a vicious hyena that attacks the orangutan on instinct rather than with conscious cruelty. Even if he cannot obliterate the reality of her horrible death, he can at least make it more naturally understandable. Reimagining his mother as the most human-like animal, the loveable orangutan named "Orange Juice," is another way of honoring his continued bond to her.

Scoring Pi's Journey Through Bereavement

Mychael Danna's original score is like a therapeutically weighted blanket thrown over the entirety of Pi's suffering and post-traumatic growth. Though the score sometimes marks profound shifts in mood and experience at a moment-to-moment level of immediacy, it much more frequently suggests a broader perspective, an understanding that reaches far beyond the present, and a sense of looking in on what Pi is doing with trust, calm, and greater knowledge than he can possibly possess in the midst of his struggle to survive. The camerawork *sometimes* conveys a similarly broad perspective: there are multiple crane shots of the boat to observe Pi and Richard Parker from a focused yet far-off position. However, the camerawork is more frequently closed in on the action, bringing us close to Pi's trembling hands and the tiger's teeth. Danna's music never succumbs to a straightforwardly pleonastic or programmatic function in relation to any of these visuals. Given the extremities of the narrative—the big storm, the violent deaths, the close proximity to wild animals, the turbulent life at sea, and Pi's extraordinary survival—the score for *Life of Pi might* have been orchestrally melodramatic

as well as programmatic in a more conventional Hollywood way. However, the score is an unusually deep experience of nonliteral value: while the visuals often show extreme or intense action in-the-moment, Danna's music is more about a bigger reality of extended time.[24] This sense of extended time is built into several patterns of Danna's music: the frequent held notes and free rhythms, the extremities of pitch, the wide intervals within open harmonic textures, and the contrasting timbres of ancient and modern instrumental sounds that give the score a breadth of suggestiveness and possibility. If Pi is imaged on the boat through most of the film, the music knows about the truth of his eventually becoming "grounded" in the meaning he will make from everything (or, as Pi puts it, in finding "the way of God").

Danna's music relays purposefulness throughout Pi's journey, but not in a clichéd-sounding way. First, the whole score features a wide range of instrumental colors to reflect the multicultural dimensions of Pi's adaptive self: he comes from Pondicherry, a part of India once under the rule of colonial France, and he settles in Canada after surviving the shipwreck. From the outset, the music honors his Indian/French/Canadian identity by combining Eastern and Western timbres, rhythms, and textures. The entire soundtrack features a large studio orchestra along with Indian vocals, bandari flutes, kanjura tambourines, santoor hammered dulcimers, gamelans, sarangi cellos, tanpira lutes, mridangam drums, sitar, tablas, accordion, and mandolin.[25] Second, instead of favoring the recognizably anchoring leitmotif repetitions that dominate Classical Hollywood scoring, Danna favors shifting and multiculturally evocative textures, "many of which overlap and blend together to create a magnificent tapestry of true world music."[26] The music is surprisingly accessible given its originality. For example, even when the texture thickens, it is always possible to hear the different music lines. There is grace in this sonic clarity, especially in comparison with the struggle Pi has to find clear meaning in what is happening to him. There is never too much for the audioviewer to perceive despite everything that is going on, even when a storm takes over and the visual editing becomes frantic. Third, Danna's music often matches Pi's ever-evolving self and story by sounding "unfixed," and moving in and through air (quite obviously with the wind instruments). The music sounds "fluid" too, complementing the scenes at sea through patterns that go beyond particular melodies or movements in time that have strictly linear musical logic. Every cue ends deliberately but without a sense of ever being completely finished, suggestive of Pi's constant need to keep being open to redirection and change. Time moves unusually

in that there is sparing use of percussion too—though Danna added sections with shakers to appease a studio executive who felt the sound track was too listless, and who even argued that Danna should be fired as a result, the score is still comparatively thin on rigid rhythmic markers.[27] Danna's emphasis on a big and *malleable* perspective of reality instead of any fixed programmatic function is profound as well as innovative: it reflects his professed belief in music as a metaphorical presence, which complements the flexible logic of Pi's allegory as an elaborately stylized representation of his adaptive self.[28]

Overall, it is as if the music not only knows something beyond the specific onscreen action; it never wants us to get sonically lost. Danna's scoring has such a powerful, expansive, all-embracing, future-oriented, and transportive function that it parallels Meyer and Fourie's writing on the therapeutically pastoral power of music to help people externalize their problems and step back from them, change their narratives, surpass painful moments, and open up "the possibility of healing."[29] Because it never seems overly caught up in the immediate action and more devoted to overarching patterns of change and comprehension, Danna's music implies the benefit of hindsight that leads Pi to gaining more control over his own story. In other words, the music communicates an overseeing level of consciousness that relates to Pi's retrospective meaning-making before we can identify it as such. Perhaps the music is "speaking" from the place Pi has reached in his older life while looking back. The music might equally be a representation of the filmind that exceeds his subjectivity altogether.

Life of Pi revolves around Pi playing over the past and reconciling himself with it, partly by telling his story to a journalist. Even decades later, he is still coming to terms with a surprisingly painful part of his story: after finally making it safely to shore, Pi watches Richard Parker walk away into the jungle and then leap out of view. The tiger's unceremonious leaving after their enormous journey together brings Pi to despair. A flashback shows the young Pi crying piteously after the tiger leaves him; his grief initially eclipses his relief at survival. Within the film's present, Pi explains to the journalist that he was waiting for Richard Parker to look back, to "flatten his ears to his head, growl, [so] that he would bring our relationship to an end in some way. But he just stared ahead into the jungle." The middle-aged Pi cries while he remembers Richard Parker's leaving without his having a chance to speak. Middle-aged Pi explains that he wanted to thank the tiger for saving his life and to tell him, "I love you, Richard Parker. You'll always be with me. May God be with you." Although he acknowledges that his father was right in teaching him

that "Richard Parker never saw me as a friend," he "has to believe there was more in his eyes than my own refection staring back at me. I know it, I felt it, even I can't prove it." Danna's music gently underscores Pi's speech here, as if willing his middle-aged self to the realizations that he soon shares with the journalist: "I suppose in the end the whole of life becomes an act of letting go. But what always hurts the most is not taking a moment to say good-bye. I was never able to thank my father for all I learnt from him, to tell him without his lessons I would never have survived." In its cutting between past and present, from the adolescent to the middle-aged Pi, the film underlines the time it has taken for Pi to gain such insights and voice such self-disclosures. The music that sutures this cutting suggests patience about the time he needed and respect for the significance of his words. The cue here is Danna's "Back to the World." It features long held notes, gradually shifting chords, sonorous strings, soft piano, and light choral voices that delicately join the mix, evoking Pi's return to other people and the land of the living after his protracted near-death-experience. Danna's music is a healing presence in relation to the pain that makes Pi cry, honoring his grief while finding beauty in the lasting love that it represents (1.46.19–1.47.38). Allegory and reality fuse because he refers to his love for the tiger and his father in the same speech. This resonates with contemporary psychology about grief as an ongoing process of "reworking" what has happened: in the words of Nancee M. Biank and Allison Werner-Lin, "as the bereaved child grows, s/he reinterprets their parent's life and death in light of more finely developed cognitive and emotional tools. We suggest here that this reworking is a lifelong process."[30]

In Yann Martel's novel, the botched farewell with Richard Parker prompts Pi to insist, "I am a person who believes in form, in the harmony of order. Where we can, we *must give things a meaningful shape*."[31] In Ang Lee's film, he does not speak these words, but Danna's music provides the form, harmony, and meaningful shape that he needs, and it signifies the beautifully coherent wholeness that Martel says we all crave as "story animals." This is the crux of what matters in *Life of Pi*. We all know that loss can be "messy," particularly the shock of a loved one dying: whether sudden or not, there is the agony that disrupts everything, and the common feeling that there was no satisfying last "scene" to make everything neat before it happened, contrary to the death scenes of countless films where the deathbed is a place of longed-for resolution. Death is a chaos that resists the order many of us want to give it, but we can still feel wholeness in the way it makes us cling to and revaluate life, much as Richard Parker's presence keeps Pi alive and alert, much as Pi

uses allegory to remake his story of loss, and much as Danna's music conveys a kindly comprehension of all this.

The extraordinary components of Pi's allegory, and his keeping Richard Parker's company in particular, requires a leap of imaginative faith to sustain the audioviewer's interest. That said, I do not believe we must share Pi's religious faith to feel the power of the story he tells. Indeed, Pi's identity as Muslim, Hindu, and Christian is reason enough to understand *Life of Pi* is nondogmatic about belief systems. However, I think the film *does* ask us to consider the power of the stories we tell ourselves about our own lives and of those who pass away. In the last scene, Pi asks the journalist which story he prefers given that in both versions "the ship sinks, my family dies, and I suffer." After a measured pause, the journalist says he prefers "the one with the tiger" because it is "the better story." Pi thanks him for this, and then invites him to dinner with his family—his wife, their children, and a cat. The journalist is surprised to hear of Pi's family for the first time. "So your story does have a happy ending?" he asks, fusing the allegorical tale he has heard with Pi's current reality. Pi says that is up to him: "The story's *yours* now" (my emphasis). The truth of the allegory does not matter so much as its purpose. The allegory has served Pi because he needed to take control of his life, and his owning a cat signifies he has successfully "domesticated" the terror that could have killed him.

The film further underlines Pi's resilience through the subtextual logic of several final transitions. The happy scene of Pi's wife and children arriving home after his interview dissolves into the final image of his younger smiling face aboard the lifeboat. Then, the tiger's image's is briefly superimposed alongside Pi before a dissolve into a replayed/morphing shot of Richard Parker walking into the jungle. The film therein makes a connection between the life Pi has made with his own family and his reimagining of the past according to the story that has made it possible for him to keep living. Ironically, the last shots of Pi at sea and Richard Parker leaving him show both characters very differently from how the film shows them up until then. Pi is smiling broadly on board the lifeboat in a way that he never appears during his sea voyage. He is looking directly at the camera, as if knowingly taking the audioviewer into his confidence (see Figure 4.1). The film then shows Richard Parker's image fading into Pi's, through a superimposition that holds the two together for a moment, memorializing the importance of their relationship. Finally, the film shows Richard Parker alone again and disappearing into the jungle, much as he did earlier in the film, but now with a

Figure 4.1 This is a false image of the past as Pi lives it, but it does truthfully represent his ability to keep reconstructing what happened to him.

digital enhancement: the static shot of the jungle morphs through an effect that mimics time-lapse photography, as if the vegetation could spontaneously change and grow at rapid speed. This is a crucially new representation and re-understanding of the moment that broke Pi's heart, reenforcing a sense of his posttraumatic growth that is symbolized by the dynamic jungle life. These final images of Pi, Richard Parker, and the jungle as they never appeared before all point toward Pi's adaptation to and meaning-making from loss. I read Pi's breaking the fourth wall rule as an invitation for me to respond in kind: he inspires me to reunderstand my own pain with a new, smiling face and with a sense of miraculously growing possibility.

Danna's music puts a seal on the film's restorative last images with his cue for the final credits: "Pi's lullaby." This is the last version of a song that is first connected to Pi's origins. *Life of Pi* opens with the first iteration of this song, along with a montage of the animals in Pi's home life. The song's Tamil lyrics translate as "My dear one, the jewel of my eye/Sleep my dear precious one." It is performed with clear steadiness and vocal elasticity by Bombay Jayashri (who cowrote the song with Danna). For Danna, this opening music is all about "a mother's love" in the South Indian language that Pi would have grown up speaking. It is about "comfort, love, a safe place."[32] Some instrumental details relay a sense of humor that matches the light movements of the animals. Danna enjoys his own Mickey-Mousing choices here, like the gazelles leaping along with the "brrring" of bells, for instance,

and the "flutes imitating the birds." He uses the Hollywood studio orchestra with unusual playfulness: strings play "Indian lines" through glissandi and slides, establishing a self-aware mix of East and West. Then, an accordion joins the orchestra with a "whispy" Indian melody, musically combining the protagonist's racial identity with his birthplace in a French colony. This exuberant music belongs to the world of Pi's childhood as well as establishing the happy place where he lives with his mother.

A fragment of Jayashri singing "Pi's lullaby" returns briefly during Pi's darkest night at sea, almost exactly midway through his journey (1.16.28–1.16.50), and again most fully with the aforementioned last part of the final credits (2.03.14–2.06.51). When the lullaby recurs, it evokes that circular experience of grief that entails playing over loss (leading me back to Pastan's poem). That said, this music also comes from a place of harmony and safety (as established from the film's opening), and its resurfacing midway through the film gently reassures me that Pi's time in peril cannot last. The final iteration of Pi's lullaby is a comfort that matches the hopefulness of the film's final images. By ending with Pi's lullaby, the film tells me that nothing in Pi's life has been lost though everything has been re-understood. Pi maintains an evolving bond with the past and the people in it, which entails his transforming the most traumatic part of his life into new visualizations. Danna's final music is a benevolent affirmation of what Pi achieves, as well as being an "answer" to the ultimate, disorderly pain of what he suffers. On a nondogmatic, spiritual level, the lullaby folds me into Pi's transcendent resilience.

I know that to be "on board" with *Life of Pi*, I must be open-minded about that which defies everyday logic. After all, Pi's allegory dominates *Life of Pi*: it lasts for most of the 127 minute film, with less than five minutes devoted to the strictly believable account of what happened after the shipwreck. That Pi must recreate reality to manage what has happened to him is not exceptional, as many psychologists would argue, but the extended dominance of the allegory sets it apart. Moreover, the film's speech and music weight Pi's allegory and his belief in it with special sincerity. His intermittent narration for the journalist often plays as a retrospective voiceover that frames the images onscreen, giving credence to the allegory from the older Pi's retrospectively authoritative position. This complements Danna's music as it relays the older Pi's point of view and/or an even broader perspective of looking back that exceeds literal logic without ever undermining the truth of his allegory. The unusual and nonliteral logic of the allegory, music, and

narration parallels many accounts of near-death-experiences (NDEs) in which rules of time, space, physicality, and language change: as Lisa Smartt explains in her book about *Words at the Threshold: What We Say As We're Nearing Death*, during a NDE blind people "see" visions, people leave their bodies, speeches become nonsensical in the strictest sense, and metaphors of journeying dominate.[33] Ironically, the nonliteral components of *Life of Pi* have helped me come to terms with an actual grief that has changed my life beyond the bounds of reason.[34] Just as Pi's experiences of life and death require that he be profoundly adaptable, the film presents me with an unusually fantastical form to help me adapt alongside him. While Pi can learn to live with the extremities of his experience through remaking his own story, I can use what I learn from him to confront a death in my own life. I fully respect that my own experience cannot map onto a fictional character whose racial and cultural identity differs radically from my own, and whose story is undeniably far-fetched, but the film still gives me practical and psychologically legitimate strategies for coping with my sadness. *Life of Pi* helps me recognize the necessity of adapting to the grief of my friend's death, making meaning from that loss, and continuing my bond with her through publishing this work.

Life of Pi is a wise film. Beyond the moment-to-moment actualization of Pi's allegory, made most tangibly impactful by the film's release in 3D, I attend to the musical voice that knows more than him. Danna says, "we can see one step of the journey in front of [Pi], and know how difficult it is. We feel compassion for him and a connection to him. The music *had* to have a sense of compassion while watching this young boy go through all this grief and torment. As Ang [Lee] would point out, we have to be compassionate to our audience too."[35] Danna's music was therefore made to invoke empathetic and generative listening. It brings me close to Pi *and* helps me imagine the greater being I can be after having witnessed and absorbed his experience. As with *Dancer in the Dark*, the musical logic only makes complete sense to me after experiencing the film in its entirety. After that, *Life of Pi* can happen to me all over again.

Ikiru (To Live)

Loss is the spouse of change.

—Sophie Sabbage[36]

Ikiru focuses on a man named Kanji Watanabe (Takashi Shimura) in the last several months of his life. In the beginning, the film allows for contrary views on its main character and it judges him dispassionately. The audiovisual form of the film breaks apart through its mixed messages and push-me-pull-you impact. By the end, the film invites its audience's deep attachment to Watanabe: all its visual and sonic details are aligned in honoring his legacy. The plot begins with an anonymous voiceover over an x-ray image of his torso: "This stomach belongs to the protagonist of our story. Signs of cancer are already present, but he doesn't know that yet." The film's visual introduction to Watanabe is oddly and intrusively personal (the x-ray) though the voiceover is emotionally detached. This inside/outside audiovisual combination inspires a strange fascination in me, which compels me to perceive every subsequent expository detail with heightened alertness. The x-ray image dissolves to show Watanabe working on a pile of paperwork at his desk, stamping pages without reading them entirely, and checking his pocket watch: this transition connects the disease within his body to the limits of his routinely deadened life. The first diegetic voice of the film belongs to a female citizen appealing to a City Hall clerk, one of Watanabe's colleagues: she says, "The water gives my child rashes. And it breeds mosquitos." While she is speaking for a group of women with her, the film cuts to signage in Watanabe's office that reads "Where Citizens and City Hall Meets. Please Don't Hesitate to Submit Your Complaints and Requests Here." The cutting not-so-subtly emphasizes that this City Hall is about the show of offering help more than meaningful attention to those in need. Another agitated mother speaks to the clerk, urging him into action: "Can't you do something? It would make a great playground if you filled it in." The clerk then slowly walks over to Watanabe, tells him of the sewage complaint, and without hesitation or pausing his paperwork, Watanabe simply says, "send them to Public Works." Watanabe's back is to the camera, inviting my critical distance from him as well as my curiosity in him. Then the camera slowly moves around to show his face again, coming at him differently, although the voiceover remains detached: "Here's our protagonist. But what a bore it would be to describe his life now. Why? [Watanabe checks his pocket watch again.] Because he's only killing time. He's never actually lived. You can't call this living." Here, I perceive the film challenging me to stop engaging with it, which ironically holds my attention. Suddenly, the only female colleague in the scene (Toyo Odagiri) laughs—her youthful expression of joy is a noise that pierces the sound track and disturbs Watanabe's peace. He looks up, as if woken from

a waking dream. A colleague working across from Toyo, at the same table with several other seated men, stands up in protestation. He is immediately outraged by her undignified laughter: "Miss Odagiri!" he exclaims. "How dare you [laugh] during business hours?" When Toyo explains she is simply responding to a joke from "The Liar's Club," he insists that she share it, like a schoolmaster telling a disruptive child to share what they find funny with the class. She then recites the joke that is an imagined exchange between two City Hall workers, while trying to stifle her own giggles:

"So you've never taken a vacation?"
"That's right."
"Because City Hall cannot run without you?"
"No, because everyone would realize City Hall doesn't need me at all."

By finding this funny, Toyo tacitly agrees that the work of City Hall is done by replaceable people achieving nothing distinctive. None of her male colleagues laugh with her, and they resume their work without reflection. As Watanabe puts his head back down to focus on his paperwork, the voiceover says, "This isn't even worth watching. He might as well be a corpse. In fact, he's been dead for some twenty years now."

Watanabe's death-in-life state doing pointless busywork is a manifestation of a broader post–World War II reality. In his commentary included within *Criterion*'s release of *Ikiru* (2015), Stephen Prince explains that reforms of the Japanese civil service system were meant to make it more efficient, democratized, and beneficial to the general public. These reforms were failures, however, and the entire social structure had been "destroyed" with devastating health consequences. In the opening scene of *Ikiru*, the mother who speaks of her child's rash is speaking for many actual families: Prince says that in 1951, 51 percent of Tokyo children suffered intestinal parasites, and the rate was as high as 72 percent in some towns. The well-being of children is an important concern in *Ikiru*, but so too is the well-being of a man whose time is running out.

After the first City Hall scene, Watanabe visits a doctor who avoids telling him the truth of the stomach cancer that will kill him. Before the appointment, another patient in the waiting room approaches Watanabe unexpectedly, correctly guesses Watanabe's ailment, and explains that the doctor will deliberately mislead him. This other patient specifically says that the doctor will state Watanabe only has a "mild ulcer" with "no need to operate," and

that he can "eat whatever" he wants "as long as it's easy to digest." Watanabe is thus primed to recognize the death sentence that the doctor does not speak aloud. Prince explains that the film therefore represents and critiques the troubling disconnect between patients and doctors who adhered to a principle of nondisclosure in post–World War II Japan: "Doctors felt that true knowledge would be too debilitating to justify telling the truth, and this was common practice up to the 1980s." Though the doctor uses phrases that the other patient anticipated, the scene of Watanabe's indirect but doom-laden diagnosis is free from melodramatic diegetic sound. Fumio Hayasaka provides some suggestive, nondiegetic orchestral underscoring with low-pitches, subtle dissonance, and ominous percussive beats, all of which relate to the grimness of everything Watanabe hears in the doctor's words, but there is no sudden change in the doctor's modulations of speech, no gasp from the attendant nurse, and no exclamation from Watanabe. Nevertheless, every line from the doctor sounds harsh because Watanabe visibly absorbs every word in light of what the other patient has already told him. I feel such alignment with Watanabe that all the doctor's phrases matching the other patient's forewarnings sound as strongly as clanging cymbals. This diagnosis scene primes me to hear everything else within *Ikiru* with uncommon care for its implications.

Watanabe's diagnosis is lifeshocking, like the metaphorical defibrillator Sabbage writes about: it jump-starts Watanabe's heart so that he can eventually reawaken to life and take meaningful action with the time he has left. Unlike the doctor withholding truth, the voiceover relays what Watanabe needs to recognize: he is dying, both physically and metaphysically. He must adapt to the truth and the *unshakeable reality* of his own diagnosis. He cannot externalize his grief as a fantastical allegory (as in *Life of Pi*); instead, he is stuck within an indisputably plausible and often-callous social realm. Where Pi must learn self-reliance though his solitary survival, Watanabe must learn to live for others. Before *Ikiru* is over, he takes his biggest and most hopeful action: bringing about the playground that the mothers requested, a space where younger lives can thrive. Ironically, despite their very different existences and trajectories, Watanabe eventually parallels Pi: in the midst of death, he is in life as never before.

Watanabe's journey toward enlightenment is encapsulated by two scenes of his singing a song that he remembers from his youth: "Gondola no Uta" ("The Gondola Song," composed in 1951 by Shinpei Nakayama, with lyrics by Izamu Yoshie). Leading up to his first performance of this song (49.06–51.50),

Watanabe has been on the town getting drunk with his new novelist friend who pontificates profundity. The novelist muses, "we humans are so careless. We only realize how beautiful life is when we chance upon death. But few of us are actually able to face death." He redirects these realizations to Watanabe with urgent energy: "You were a slave to your own life. Now you are master," and "Let's go reclaim the life you wasted." These words are more about posturing than intent, however. Instead of helping Watanabe address his interior pain, the novelist soon focuses on making Watanabe indulge himself— getting drunk, going to a Pachinko parlor, buying a fancy new hat immediately after his old one is stolen, picking up prostitutes, and going to nightclubs.

The agony of Watanabe's waning existence is sonically stressed many times by the film, even while he is in the company of hangers-on like the novelist. At one nightclub, Watanabe is suddenly startled by trombone players— their blaring is a stinger that causes him to suddenly stand up in alarm (43.51–43.54). The instruments in the foreground cut through his body in the middle-ground: here, the music is not his own and it sounds hostile to him (see Figure 4.2). At another nightclub, young patrons dance to a pianist playing American blues to accompany his own scat vocal line, a signifier of Japan in the post–World War II transitional time. This era belongs to a new

Figure 4.2 Watanabe is startled by the trombones: the image of the instruments cutting across his body, along with blaring notes, stresses his separation from other people with audiovisual force.

generation, and not to Watanabe. The playful nonsense of the rambunctious scat singing is at odds with the close-ups that reveal Watanabe's disturbed mental state. In a raucous atmosphere of drunken decadence and musical looseness, patrons set off party strings that make small firework-like pops— they startle Watanabe as much as the much louder trombones did, signaling his increasing sensitivity to (and separation from) everything and everyone around him.

The establishing shot of this nightclub scene shows the hammers of the piano pounding away, then pulls back to show a woman pouring beer into the pianist's mouth. The stripped-down piano is a visual parallel to the x-ray of Watanabe's body, and it anticipates how Watanabe will lay himself bare by singing strangely. As the music keeps going at a frantic tempo, Watanabe enters the frame with his arms extended like a zombie, walking toward a dancing young woman who smilingly dodges his reach after she has grabbed his new hat. "Heyyyyy, ho-ho, hey-hey," sings the pianist with gusto, indirectly mocking Watanabe's powerlessness, drawing out his notes like musical laughter. He slides off his stool with tipsy clumsiness, but after skipping just a beat keeps playing from the floor, with his arms akimbo. The young woman finishes dancing and thumps down upon the hat she stole from Watanabe. He removes the hat from under her in petulant anger. She playfully puts the hat back on his head and drapes her body across his lap, oblivious to his outrage.

The pianist asks if the patrons have any requests for favorite songs. Watanabe immediately asks for "Life Is Brief. Life Is Brief." The pianist looks unsure of the reference, so Watanabe continues with more lyrics in a frail, sing-song voice: "Fall in love, maidens." As Watanabe sings this line, the young woman is still drunkenly dangling over his body, but there is no sense of a connection between them. Parallel to this, his failure to remember the song title signifies his already-meagre vitality is slipping away. The pianist condescendingly responds that he knows "that love song, from the nineteen-teens." Watanabe's recalling just a phrase ("life is brief") rather than the proper title matters here, since this is an essential message of "Gondola no Uta" as well as *Ikiru*.

Just before Watanabe starts singing, the film cuts to show the piano for a moment, waiting for the pianist to enter the frame and sit down on the stool. He pauses to take another swig of beer first, and the scene falls near-silent for a few seconds. This pause allows for a shift in tone, in accordance with Watanabe's depressed subjectivity and in anticipation of his doom-laden singing. The pause also communicates the entire film's perspective. To reapply

Frampton's writing on cinematic agency, it is as if the filmind is redirecting and reasserting itself quickly: here, if the film were to speak, it might say "Stop! Notice this quiet for a moment, prepare yourself for a different musical performance, something more formal and deliberate, *a change you must feel*." The pianist performs differently than he did before, now poised at the keyboard with relative decorum. His playing is legato and sustain pedaled, smooth and rhythmically languid, a marked contrast with his playful blues improvisations at forte a minute before. Where single women danced giddily and jerkily to his music at the start of the scene, now young couples at the nightclub take to the dance floor slowly and sway with the traditional, regular, triple-time rhythm of "Gondola no Uta." As the pianist plays the song introduction, the camera shows the couples dancing through a beaded curtain, positioning the audioviewer as if seated next to Watanabe and cut off from them as he is. The beads are swinging back and forth, obscuring a clear view of the couples: this one detail is symbolically suggestive of Watanabe's blinkered memory, his inebriated state, and his aloneness. Shortly after Watanabe begins singing, the couples stop to stand, stare at him, and then sit down. The woman who draped in his lap moves slowly and determinedly away, like a cat moves warily away from a predator that poses danger. Though Watanabe embodies no physical threat, the emotional truth of his singing evidently unnerves her. Perhaps it is too much for her to bear.

Watanabe starts singing several seconds before the film shows him delivering the song. The brief separation of his image from his voice subtly suggests he is alienated from his own body as well as everybody around him. Watanabe changes "Gondola no Uta" from an airily accessible pop song to a haunting, heavy dirge, and the film shows everyone at the club visually registering the shock of hearing this. Even if I were predisposed to reject the emotional weight of his song, like the club patrons, I would feel no choice but to absorb it. Shimura experimented with making a "raspy falsetto" in some scenes of *Ikiru* after studying a real cancer patient, and this is often how Watanabe sounds after his diagnosis. However, in this scene and in response to Kurosawa's request for an "otherworldly sound," Shimura/Watanabe sings "Gondola no Uta" with a relatively low, heavy voice, quavering with aged vulnerability.[37] His singing evidently comes from the deepest place within himself. He sits throughout his own song, immobilized by feeling the heaviness of mortality upon him. He is an audiovisual oddity: a presence of unnerving stillness (his immobile body, his eyes fixed) *and* movement (his voice wobbling, and tears falling down his face). He is transporting himself

to a metaphysical place that is horrible and mesmerizingly lifeshocking at one and the same time. Even though I am one with him on a physical level, feeling the sound waves that come from within his body, I also recognize that he goes where no one else can join him.

For the first part of this nightclub scene, Watanabe is engulfed by the motion of others, the *mise-en-scène* that keeps pushing him to the margins of the frame, the streamers that reinforce the party atmosphere at odds with him, and the music that is not his own. However, after the film cuts to him singing, he is the center around which the scene revolves: the camera is increasingly focused on his face until an extended close-up that lasts for 75 seconds (50.35–51.50). Watanabe does not have the capacity to musically "chew the scenery" through a virtuoso performance, but he reaches me on a new level here. There is something both sublime and ordinary about the way he sings while the camera and the other characters stare, making me attend with more care than the people of his world: the other patrons are agog without comprehension, aside from the novelist who pretends to understand but promptly drags Watanabe away to another diversion (a strip club).

As Claudia Gorbman writes, Watanabe performs an example of "artless singing" that exists "somewhere between speech and music." Instead of using "Gondola no Uta" as an opportunity for his own vocal display, he makes it about "revealing truth that dialogue could not credibly contain."[38] He uses the song to "organize something out of chaos" and thereby manage this pain: the roughness of his singing makes it a credible representation of this inner struggle. Moreover, Gorbman explains that Watanabe's amateurish singing parallels the real "imperfection and evanescence" of "the present world."[39] No matter how stylized the performance, staging and the long take might seem, Watanabe's artless singing has moved others with its apparent real-world authenticity: Geoffrey O'Brien remembers the song as a "jolt of awareness when the line between screen and life dissolved."[40] O'Brien's response shows that Watanabe's dreadful anticipation of his own death can easily become the audioviewer's own. Indeed, Gorbman argues that in watching Watanabe sing, the audioviewer is "*inescapably* face-to-face with the consciousness of death."[41] Since Watanabe dies well before the end, and the voiceover primes us to expect his death almost as soon as the film has begun, Michelle Aaron argues that *Ikiru* "deprivileges" him by decentering him and his death.[42] For her, this is a way of "distracting [us] from emotional pain or loss."[43] Conversely, I believe that no audioviewer can avoid perceiving the psychological pain Watanabe feels and the physical pain he anticipates in

his artless singing at the club. Though *Ikiru* does avoid showing Watanabe's death, as well as many awful details of his physical decline, I find this scene uncompromisingly truthful and focused on his suffering.[44]

Watanabe's performance in the nightclub could be used as another opportunity for enacting a version of the freeze-frame technique. The film builds in considerable time for the audioviewer to stop with Watanabe, focus on his stress, then fixate on what they have loved in their own life (since the song's lyrics invite them to do so), think back lovingly on those personal memories, and return to audioviewing him with a newly heightened, heart-led feeling of compassionate understanding. The significance of Watanabe's stomach cancer diagnosis in a Japanese context also resonates with the teachings of HeartMath. As Prince explains, though most of us in western culture talk about the heart as the center of our body and being, Japanese people locate the center and metaphorical place of "character, feeling, personality, or soul" in "the stomach, or the abdomen, which is known as 'hara.'" Prince provides supporting examples of such thinking: the ritual suicide of *seppuku* involves cutting open the abdomen and this means showing "your true self." Japanese people describe character traits through metaphors about the abdomen: being frank means "cutting the abdomen," whereas being "tricky or untrustworthy means that the abdomen is black," "getting mad means the abdomen stands up," and "being generous means the abdomen is big." The leading cause of death in America has long been heart disease and Americans speak of many feeling states in heart-based metaphors (being heartfelt, heartened, sick at heart, or blackhearted). Parallel to this, the hara is the "seat of feeling, but also of thought," and the locus for a person's essential state. Stomach cancer was the most common cause of adult death in Japan when *Ikiru* was first released.[45] Whether Japanese or not, I think the film invites each of us to check our own hara, much as we might notice our own heartbeats when we hear Selma's pulse in *Dancer in the Dark*.

In 1987, Francis G. Lu and Gertrude Heming conducted an unusual study of *Ikiru*'s psychological impact: they tested seventy-one respondents to determine how the film affected people dealing with death anxiety. They called this the first psychological report "on the effect of a fictional film on the film audience's death anxiety and attitudes toward death."[46] After a screening of *Ikiru*, the people in the study experienced a measurable reduction in death anxiety. Lu and Heming attributed this to how "the audience identified with the hero and his change in consciousness about death from despair to final acceptance as the film progressed."[47] Watanabe's "personal and transpersonal"

change in consciousness inspired these authors to suggest there should be other empirical studies of cinema as a therapeutic way of addressing death anxiety.[48] Their groundbreaking work leaves scope for analyzing *Ikiru* and other films more fully as opportunities for any of us to confront mortality and to learn from that.

In their more recent study of films about coming to terms with mortality, Niemic and Schulenberg call *Ikiru* "one of the most significant films regarding death and life meaning ever made."[49] More specifically, they write of Watanabe's journey as logotherapy, "which posits that there are three primary values related to the discovery of meaning: creative (what we give to life), experiential (what we receive from life), and attitudinal (the stance we take toward unavoidable suffering." Niemic and Schulenberg explain that "in *Ikiru* the protagonist not only discovers meaning through the creation of the [playground], but the [playground] is something that can be experienced as well. Finally, the act of creating and experiencing in this fashion is an attitudinal choice the character makes when confronted with his mortality."[50] When Watanabe sings "Gondola no Uta" once more near the end of the film, in the final flashback scene of his last day, I believe he knowingly embraces all these meanings. The film shows him in the center of the playground, enjoying that space in a state of sweet and full acceptance. His final performance is radically different from his impromptu singing in the nightclub: where before his voice was low and heavy, and accompanied by the thick sounds of a pedaled piano, now it is soft, quiet, and supported by lighter instrumentation (high-pitched tremolo strings, plucked harp, flute, and xylophone). This time, instead of performing in a public setting surrounded by others who fail to understand or engage with the profundity of his song, he is on his own onscreen, oblivious to the presence of anyone else, and swinging back and forth for the easy joy of it. This scene is a flashback after a policeman shows up at Watanabe's memorial service. It is a memory that solely belongs to the policeman as the only one to witness Watanabe swinging, though Watanabe did not see him. This makes the scene one of privileged access to the last day of Watanabe's life that is denied the other onscreen mourners. Where they sit before a frozen photographic image of the man as he was, we get access to his final motion in life within a space he made for the lives of children. This is the scene from *Ikiru* that scholars remember with reverence most often.

Most of Watanabe's mourners are stuck in their routines and will soon return to their regular roles at City Hall. The final version of "Gondola no Uta" signifies Watanabe's liberation from the vocation that limited him and the

people whose ideology dominated his life. He exists as the culmination of everything he could become, revealing his adaptive self in the face of grief. He is no longer in a state of terror while he sings about the brevity of life. His new and surprising acceptance of death inspires my continued bond to him. In addition, his final music reminds me of Chion's definition of music as the "spatiotemporal turntable." For Chion, music can communicate "all times and spaces of a film, even as it leaves them to their separate and distinct existences."[51] Chion is writing with specific reference to a montage from King Vidor's *Hallelujah* (1929) in which the protagonist Zeke "moves through several locales" (a boat on the Mississippi, the roof of a train, and a prairie) while the soundtrack includes just one spiritual song: "Going Home." For Chion, this example "prefigures the formula of music videos" in that there is no single scene "anchored in a coherent spatiotemporal continuum."[52] With Watanabe's last living scene, I spin Chion's spatiotemporal turntable in some new ways. First, Watanabe is traversing time and space in a figurative sense. He is staying within one place (the playground) during his final scene, but he is *internally travelling* through his final song. He moves through all the stages of his life with the lyrics: "life is brief," "fall in love," "crimson bloom/ fades from your lips," "the boat drifts away," "the hand . . . becomes frail," and "the flame in your hearts/flicker and die." Time may move forward in a linear way, but Watanabe moves *back and forth*, swinging with this song about the brevity *and* vibrancy of recollections that bring the past into the present. The idea of Chion's spatiotemporal turntable—that free movement across time and space—applies to the song as it encircles so much of Watanabe's life. The music leads me to believe that Watanabe feels the whole of his life is before him as a complete and harmonious entity, and without his being resistant to its end as he was before. The tender peacefulness of Watanabe's final singing, and its lasting reverberations as the most-cited part of the film, are testimony to the strength within his character despite (or perhaps because of) the weakened state of his body.

Ikiru repeatedly stresses Watanabe's increasing decrepitude. This is searingly obvious in those scenes where he spends time with his young female colleague, Toyo, in the weeks following his terminal diagnosis. He bumps into her on the street after taking sick leave for the first time in his life, and she becomes his unlikely, temporary companion. Toyo confesses she has unkindly nicknamed Watanabe the "Mummy," presumably for his stagnating state at the office as much as his advanced age, but he manages to laugh with her about this. She embodies the giddiness of younger life to him, which is

bittersweet given that he is alienated from his only child (a son, Mitsuo). The film repeatedly shows his body is agedly incompatible with hers: he leans on her arm as they walk, he sits with a bent and rigid posture while she sits up and shuffles about excitedly, he can no longer enjoy food but she repeatedly devours food in front of him, she leads him across an ice-skating rink where he still falls down, and he sleeps though a movie while she laughs along with it. Where he seems to be persistently winding down, she has boundless energy.

Toyo eventually rejects Watanabe's company at a restaurant. He leaves her while clutching one of the wind-up bunny rabbits she has made at her new factory job. These toys make her feel like she's "playing with every baby in Japan." As Watanabe holds the rabbit that is connected to childish play, he suddenly moves with new dynamism. After insisting that "there is something I can do," he hastily descends the restaurant stairs while a group of youths are cheerily singing "Happy Birthday" to their guest of honor ascending the same stairs. The implication of this audiovisual punctuation is clear: Watanabe is moving silently downward unlike others, toward inevitable decline, but he is also seizing his last chance to live and even be "reborn" through his new idea of building the playground. As with the earlier on-the-town sequence with the novelist, Watanabe is sonically separated from others, but now the music ironically *reinforces* his choice to re-engage with life.

With his final singing in the playground, despite his age and weariness, Watanabe returns to the time of his childhood by sounding and moving in memory of it. The camera positions the audioviewer where the unseen policeman stood, peering at him through the bars of a climbing frame. His voice is closely miked as he sings to soothe himself, as if comforting the child that he once was and that the audioviewer once was too. This final singing lives on in the policeman: he tells the other mourners he is "haunted" by the voice because Watanabe "poured his whole heart into that song of his." It is a very private performance that becomes a public invitation to hear him differently. I find this exhilarating because it matters both within and beyond the world of the film. Watanabe's song communicates the perspective he gains in dying, and it urges me to hear that perspective so that I myself might live better in his memory.

The impact of Watanabe's final song is bigger than mortality because the film includes it after his death. As scholars often mention, the structure of *Ikiru* is surprising in that Watanabe dies two-thirds into the film, tipping the emphasis toward the meaning audioviewers can make from his existence. In

the absence of a guiding voiceover after Watanabe dies, the onus for making sense of his passing and/or providing the shape of a new commentary on his life falls on the audioviewer. In this way, the film can move through any of us, and any of us can extend Watanabe's life. The photograph of Watanabe in his memorial service freezes him and the flow of action in a comparatively life-denying and traumatic way. Unlike the image of him in motion on the swing, this still photograph is consonant with Laura Mulvey's *Death at 24× a Second*: the film always shows it in the presence of those who mourn him, many of whom seem unchanged by the loss and who thus embody death-in-life in a Mulveyan way. By contrast with the photograph that stops time, Watanabe's final song involves duration and movement in defiance of his body about to stop. The film includes a brief superimposition of his swinging body and the still photograph that his mourners use to memorialize him (see Figure 4.3). Through this superimposition, the film implicitly and ironically compares Watanabe's dynamic moving toward death with the stagnancy of his mourners who are unmoving in their younger lives. The superimposition fuses Watanabe's younger and older self too, reminding me of the energy he finds within himself as a dying man as opposed to his static younger self. The film then cuts to show the mourners who remain immobilized in their

Figure 4.3 The still image of Watanabe is briefly superimposed upon the image of his final scene of singing: ironically, we see him most alive when he is closest to death.

ritualized grief. Though most of the mourners will not learn from Watanabe's example, I believe the film trusts that *its audioviewers can and will*.

Several of the mourners make inebriated comments on Watanabe's achievement in overseeing the playground's creation, but they couch this in terms of his having overstepped the perimeters of his job description. Only one younger civil servant (Kimura) makes a concerted effort to defend Watanabe's achievement, echoing the voices of those women who are grateful for the playground and who cry more openly than anyone else at his memorial service. The film ends with a wipe from Kimura leaving piles of paperwork at City Hall (a visual echo of how the film introduces Watanabe) to show his visiting the playground that is Watanabe's legacy. Kimura's looking over the playground is underscored by Hayasaka's most sustained and delicate nondiegetic version of "Gondola no Uta" featuring flute and strings, and this bridges into a splendid fanfare that suggests a surprising triumph.[53] This final cue suggests to me that Watanabe's voice and reminder that "life is brief" has turned into something newly hopeful about the precedent he has set. Perhaps Kimura will carry on the new commitment to social service that Watanabe began. In the absence of Watanabe's voice, the song is waiting for any of us to pick it up too.

Most scholarly commentators on *Ikiru* dwell on Watanabe's individual trajectory above all: this is understandable given his centrality throughout the plot.[54] However, the implications of *Ikiru* extend far beyond him. The sound track stresses other moments of transformative energy that pull in other characters, like a series of heart compressions building toward the return of a strong pulse (or the resurgence of life that is Watanabe singing in the playground). Many characters sound different over time. This aural pattern communicates that all their existences are in flux, whether through their new awareness, their re-engagement with life, *or* sadly (in some cases) their return to intransigence. For example, Kimura first appears working silently and doggedly along with his colleagues, as a participant in the endlessly futile processes of paperwork and inaction. He is nicknamed "rice noodle" by Toyo for his apparent weakness and trembling state. But Kimura eventually stands up and stands apart from others at Watanabe's funeral, by speaking out loudly against the other bureaucrats for failing to give Watanabe due credit for the playground after his death. He also openly sobs for Watanabe when the crowd of other office workers is silent. His emotional outburst registers like an act of rebellion. By contrast with Kimura, Toyo's sounds separate her from Watanabe and the humanity

he comes to represent. We first see her along with her burst of infectious laughter at the Public Works office, in contrast with Watanabe as the silent "Mummy" of the opening scene. With her final words to Watanabe, her voice takes on a cruelly blunt dimension: she accuses him of being parasitically attached to her, and she confronts him with his lack of reason to live. While she does not appear to grow as a character, her brutal honesty is an important lifeshock for Watanabe; it is the catalyst for his making good use of his limited time. The bureaucrats who stay at Watanabe's funeral long enough to get drunk make noisy promises that they will honor his legacy by doing meaningful work as he did at the end of his life. However, in the final sequence they have returned to working in silent conformity once again: much as the voiceover described Watanabe in the first scene, they return to the "minutia of the bureaucratic machine and the meaningless busyness it breeds."[55] Other characters embody the truth with kindness and growing sonic expressivity, most notably the women who petition the city clerk in the first scene. They speak in pleading tones, then fall silent, and then rally behind one among them who speaks out against the bureaucrats of City Hall for failing to give them serious attention. These same women weep openly for Watanabe in the final sequence, even as his son and daughter-in-law are silently in attendance and seemingly incapable of grieving for him. The first time these women appear onscreen, one of them has her toddler strapped to her back, a representative of all the children they are speaking for. This visual detail stands out because the toddler is awake and wide-eyed but strangely quiet. This child's silence is "answered" by the happy noises of numerous children who are delightedly enjoying the playground that is Watanabe's legacy at the end of the film. These children are both seen and heard by Kimura, with the camera diving down among them as if pulled toward the exuberance of their voices and their bodies moving across the space that is forever changed. Therefore, *Ikiru* is a film of many sonic details that make me perceive the characters and the lives they embody differently over time. Still, my biggest sonic reevaluation comes with Watanabe's singing "Gondola no Uta" in his last living scene. Despite its being his last night of life, he makes the film's most beautiful music. This music represents his assured heart intelligence to me. His voice is calmer and smoother, mellower and steadier than it was ever was before, a parallel to his newly free and light movement on the swing. Along with hearing his internal change, I absorb it into my body with joy. I feel the change in his hara and it changes my own.

A Star Is Born

> Most adults can easily identify a solace-filled object to which they repair when they need soothing: a memory of a special place, a person who is no longer physically present, a piece of music or art, an imagined more perfect world, a sense of divine presence. It comes in those moments when we know, not just know about that which consoles us. It comes when we hear the music, not just listen to it.
> —Dennis Klass[56]

In *A Star Is Born* (2018), the main character Ally uses a last song to reach her husband, Jackson, after his death by suicide. During part of this last song, "I'll Never Love Again," the film includes a montage of some of the best times they shared in public and private. This montage visually underlines that her singing is a spatiotemporal turntable, giving her "winged feet" across space and time, taking her back to when Jackson was still alive. Her winged feet extend beyond the space and time of her entire film world too: the soundtrack debuted at No. 1 on the Billboard 200 chart in America.[57] By June 2019, the album had sold over six million copies globally and over two million equivalent units in the United States.[58] For the millions of us who have been listening to Ally's songs again once the film has finished, our time with her is extended beyond the sum of all her scenes and her spatiotemporal turntable widens within us. While I recognize that this extended connection with the character is illusory, replaying the songs leads me to virtually relive the film. I carry it around in my daily life and the diegetic limits on staying with Ally cease to matter to me.

The musical numbers of *A Star Is Born* are chiefly focused on establishing and developing the two main characters and their romantic relationship as they exist in life, but I focus on the final song about Ally continuing to live after the trauma of Jackson's death. With this culminating performance, Ally emphasizes her continued bond with her deceased husband. Catherine H. Stein et al. explain that such a bond can take various forms, including communication with the deceased person, remembrance activities, or "taking on personal characteristics, values, or beliefs of the deceased."[59] Ally arguably demonstrates all these possibilities in *A Star Is Born*. Her last performance is a form of maintaining communication with Jackson through taking possession of the song he wrote for her. The song leads her to remember specific scenes with him (signaled by the montage of several visual flashbacks) and

becomes her public statement of unending attachment to the music that they valued together and the belief he expressed in their love. Ally's final performance is also a strong artistic demonstration of her adapting to life without Jackson, but not at the expense of her continued bond to him. By claiming the song after his death, she asserts her voice *along with* reminding me of his. Her past with him fuses with her present musical assertion, especially when her concert performance cuts to a flashback of his first singing the song to her. This is not a film about "getting over" grief any more than *Life of Pi* or *Ikiru*. All three films honor their protagonists who *make meaning from loss*.

As Ronnie Susan Walker writes, "Suicide catapults survivors onto a journey—not of their own choice."[60] Moreover, since Jackson commits suicide in private, Ally is denied the chance for a final conversation with him that might have "brought closure."[61] In their study of final conversations before the deaths of loved ones, Mark A. Generous and Maureen Keeley explore the cost of sidestepping talking points for fear of discomfort, distress, or "saying the wrong thing" to the person about to die.[62] Though these authors are focused on those who mourn for family members with terminally ill diagnoses, as opposed to those who die suddenly, their writing about the devastation of not being able to talk freely resonates with what Ally does not get to do: "The choice to not engage in the conversation potentially leaves the living holding the heavy remnants of the relationship, and retrospectively wishing the discussion had occurred."[63]

Jackson hangs himself in the quiet, enclosed space of a dingy garage. Ally finally honors his life by singing a song that he was writing as a tribute to their love, in a large concert hall with superb acoustics, beautifully illuminated with hundreds of soft lights. She turns her private grief into a public act of ritualized mourning, refusing to be constricted into silence by the double taboo of her husband's destruction by addiction and suicide. Like Pi's allegory or Watanabe's playground, Ally's final performance shows that she has created something beautiful out of her shock and sadness. She claims what was denied her: a final chance to communicate her feelings for Jackson in full awareness of his imminent death, without fear or self-censorship.

This version of *A Star Is Born* has made me revisit the earlier movies of the same name, in order to hear all those echoings of speech and song among them. When Ally tells Jackson she is self-conscious about her nose, for example, the film alludes to *A Star Is Born* (1976) starring Barbra Streisand.[64] In every iteration of *A Star Is Born*, the male lead delivers the same line to his wife shortly before he kills himself: "I just wanted to take another look

at you." The recurrence of the same words in the contexts of parallel stories that focus on big narrative themes—star power, entertainment industries, drug addiction, creation bound up with romantic love, and the drive toward suicide—reminds me that these themes resonate across generations and specific circumstances. The echoings thereby do more than pay homage; they position each film to "speak" to the others in its family and to enrich my memories of what they mean separately as well as together. The repetitions relay loving inter-relatedness among the films, while also reminding me that every moment and character is subject to bigger patterns across time. Each iteration of *A Star Is Born* brings certain words and ideas back to newly embodied life, paralleling how Ally brings Jackson's song to a new life on her own terms. Ironically, the scene of Ally's final song is also instructively *different* from the last scenes of her *A Star Is Born* predecessors.

Ally's final song recalls earlier scenes from the film that include pieces of the lyrics and music as Jackson was writing it for her: so, she finishes the story by completing her husband's creation on her own terms. She thus presents herself as more than the examples of being a "Mrs." that I have met in other *A Star Is Born* movies. Recall Janet Gaynor in the 1937 *A Star Is Born*, ending the film by finally presenting herself as "Mrs. Norman Maine" to an adoring crowd. Similarly, think of Judy Garland prompting a rapturous standing ovation with her final line, "Hello everybody, I'm Mrs. Norman Maine," right before she is about to give a concert performance that the film withholds by ending at that point. By contrast, Ally performs her entire final song for a crowd in a large and splendid concert hall. In her last self-possessed and finished musical assertion, she is more like her comparatively recent *Star Is Born* predecessor Barbra Streisand as Esther Hoffman. That said, the differences between Esther and Ally's final performances are instructive. There is overt conflict in Esther's last vocal performance: Streisand performs the song "Finale: With One More Look at You/Watch Closely Now" as a manifestation of complex grief, running the gamut from tender regret to furious determination. Since her lover (John Norman Howard) literally drove himself to death, Esther now dreams of reclaiming their narrative to "drive" it somewhere else: she sings, "Bring the last straw to me/I turn the straw into gold." She begins her song with regret for what she cannot reconcile ("With one more look at you/I could learn to tame the clouds and let the sunshine through"), which she eventually turns into a declaration of deciding to keep moving on her own terms ("But I can take it/I won't look down"). In the first part of the song, Streisand often closes her eyes, as if retracing every memory

with her lover while she sings, but she remains open-eyed more consistently as the song's rhythm picks up in the second half. The song shifts from being a slow-paced ballad to free-wheeling rock. She embodies the musical change, from stoically standing still to frantically shaking her entire body. This external change represents her internal shift from controlled despondency to newfound vitality. The film casts expressionistically changing lights on her face (from low-key, blue-tinged illumination to a range of bright, warm tones) to visually stress all this dynamism. Each of the two clearly defined parts of the song feature lyric repetition: the first repeated lyric focuses on Esther tragically losing John ("With one more look at you"), while the second repeated lyric is about her reclaiming her life with pride ("Are you watching me now?").

In contrast with Esther, Ally sings a song that represents a much more straightforward and consistent *fusion* of the man she loved and her new self. She stands relatively still throughout the performance, with all her physical energy funneled into her increasingly assured voice. She starts with the verse she added to the start of the song that Jackson wrote for her, so she communicates a much more immediate sense of reframing her time with her lover without believing she could change where it would lead. Like Pi lamenting that moment when Richard Parker walked away, Ally honors her own sadness that she never got a big final scene with Jackson, while also acknowledging the choice he made without her:

> I wish I could, could have said goodbye
> I would have said what I wanted to
> maybe even cried for you
> If I knew, it would be the last time
> I would have broke my heart in two
> Tryna save a part of you.

Despite her wishing she had been able to intervene before Jackson's suicide, Ally's new verse tells me she has already found a way to make sense of the pain she could not prevent. Her addition to Jackson's song reminds me that he previously added a verse to a song *she* wrote ("In the Shallows"), which begins, "Tell me something, boy/Aren't you tired tryin' to fill that void?" His addition addressed what she might want *from him*, by his starting with "Tell me something, girl/Are you happy in this modern world?" With her final performance, Ally therefore makes her performance another collaboration

with him that honors their history. She musically demonstrates their continued bond with unwavering clarity of purpose.

Lady Gaga is diminutive, as the Netflix-distributed documentary named *Five Foot Two* (2017) underlines, but her face, body, and voice are *commanding* in the final scene. She dominates the foreground, just as her voice dominates the aural hierarchy. Ironically, Lady Gaga filmed this scene when she was extremely vulnerable, on the same day that a close friend of hers died of cancer. She enlisted her audience to be with her in singing to her friend (Sonja) and felt that this collective energy would feed into the performance.[65] She even hoped Sonja might hear it. While outwardly expressing her grief, Lady Gaga was internally traversing space and time, spinning her own spatiotemporal turntable into the memories of her friend as well as the memories of her character Ally.

As Ally sings, the camera begins to circle her body, and this circling motion continues with a cut to one of the earliest concerts where she performed with Jackson. This is yet another strong representation of the spatiotemporal turntable, albeit visually enforced, pulling me into Ally's experience of traveling through music. Evoking that "circular staircase" of grief, she sings of her world "turning, turning, and turning/I'm not moving on." Yet as she keeps singing her voice becomes fuller, louder, and surer, suggesting that she is has already discovered her newly adaptive self, growing around the grief (as Tonkin might say). The circling camera reveals silent audience members giving Ally their supportive attention, and an increasingly illuminated orchestra playing behind her. Unlike Esther commanding the screen for an entire long take in close-up, and whose final song is about her interior journey albeit in a public space, Ally's final performance is an act of sharing her love for Jackson with a crowd of respectful witnesses and participants in the process. Though the circling camera and the lyrics remind me that grief is not a linear process of recovery, her rising voice reminds me of the strength that comes with confronting grief without expecting to fully recover from it. Her performance affirms the value of sharing the truth of grief with those who are willing to hear it too.

After Ally's performance has reached a trembling yet assertive peak, the film cuts to Jackson singing part of the song. The cut is perfectly timed to create the sense of a virtual duet, while also inevitably reminding me that this is impossible in literal terms. Here, Jackson's voice is surprisingly thinner and more plaintive than it sounds through most of the film. From the very first scene, *A Star Is Born* establishes the surprising thickness of Bradley Cooper's

"deep, gravelly, guttural voice" that he took six months to develop for the role.[66] As director of the film, Cooper knew that changing his voice was vital for the character he wanted to create: he says, "The voice is everything. It all begins and ends with the voice, as an actor—and as a human being." Jackson's human vulnerability and his ending are *in* his voice. Because his voice is less robust than it was before, it is as if part of him has already gone in the flashback, and before Ally could know that. With the final flashback of Jackson playing Ally the song in private, I am shocked to realize just how much bigger she has made the song in her climactically public performance. On a deeper, metaphysical level, I hear how much bigger she has become in making the song her own. This is an exhilarating postmortem tribute to Jackson, as well as an inspirational representation of her choice to stay alive after his death.

Jackson's singing from the past is the last vocal element of the film. After this brief flashback, the film cuts to one silent shot in the present: Ally looks up, presumably to his spirit, and then smilingly to the camera, sharing her realization of his death-defying presence with the audioviewer (see Figure 4.4). Though I cannot be sure that Jackson's unearthly being exists, I imagine that he will keep existing for her through the song that she performs in his honor. Having shown the resilience of her hara through her final performance, Ally's moment of breaking the fourth wall rule makes me look straight at her

Figure 4.4 Ally looks at us, making us part of her remembering Jackson. By extension, she invites us to remember anyone we have lost.

strongest self. I see her clear-eyed gaze in relation to what the film's cinematographer Matthew Libatique calls the "white light of sobriety."[67] I see her inviting me to acknowledge her paying tribute, making meaning from loss, and asserting the value of her own ongoing life. She urges me to recognize that I too can be emboldened in the face of grief. Like *Ikiru* and *Life of Pi*, *A Star Is Born* emphasizes that I can have a relationship with its protagonist that breeches the boundaries between fiction and life.

Ally's final musical "conversation" with Jackson parallels Yasmine A. Ilya's study of bereaved people who were encouraged to sing imagined dialogues to those they have lost. They used their songs to revive memories of the deceased, replay loss, and accept reality. This was a comparatively small study of just five participants from a hospital in New York City in 2012. Nevertheless, Ilya's quotations from improvised songs are suggestive of what Ally might be saying through her final performance. One participant sang "directly to her deceased grandmother" as follows: "Seems like reality's waking me . . . Holding on is part of me."[68] Illya argues that this musical form of "therapy intervention," helped participants "establish and strengthen a sense of connection with [the deceased] while moving forward with life."[69] Hearing Ally's song makes me want to sing to those I have lost too.

Conclusion

Life of Pi answers death with a benevolent sense of transcendent possibilities. *Ikiru* answers death with the goal of social service that has lasting impact. *A Star Is Born* answers the more particular, taboo agony of losing a loved one to addiction and suicide by insisting on an unbroken communion with the deceased. These films give me stories, voices, and music that I reunderstand through replaying and finding new meanings in what I love about them. As they consoled me while my friend was dying, they now teach me about coping with life after her death and remembering what matters in the face of mortality. Such films need never be death at the rate of 24 frames per second. Instead, I see many forms of life in their distinctive sonic structures and in the resilience of their protagonists. Pi, Watanabe, and Ally show me how to keep going in the absence of my friend.

5
Turning the Microphone Around
Hearing from Alumni

> For communication to have meaning it must have a life.... If I truly communicate, I see in you a life that is not me and partake of it. And you see and partake of me. In a small way we then grow out of our old selves. And become something new.
> —Hugh Prather[1]

> You are you. Nothing in you is identical to me. I want to hear you with all your surprises.
> —David Augsberger[2]

At the time of writing, over a million Americans have died from COVID-19. In this context, I assess the value of what I am doing in this finite life.[3] I feel new urgency about believing in what I teach and research. Through this book, I have made the case for cinema as a life force in relation to the pandemic, the Black Lives Matter movement, contemporary feminism, personal lifeshocks, and broad realities of mortality, grief, and death acceptance. Though I have drawn on the work of many others, everything is inevitably written from my limited and individual standpoint. To make a stronger case for cinema as a life force, I now move more outside myself. My students have taught me how to value cinema far more than I could from within the bounds of my solitary experiences. This chapter pays tribute to the life of our classroom conversations that have helped me grow along with my students. This chapter also celebrates the unending *afterlives* of these classroom conversations that help my former students live well and inspire me to keep teaching.

In spring 2021, I created a survey approved by the Institutional Review Board (IRB) of my institution: Salisbury University (Maryland). The survey is about whether the films I taught alumni still relate to or enhance

their lives in any significant ways, and whether these films continue to be *alive* in that sense. I ask about films they remember, replay, rehear, and talk about (even if only with themselves). I want to know about any films that have strengthened their hearts, helped them manage lifeshocks, and inspired them through representing values they can embody, claim, emulate, or champion in what they do and how they understand the world at large. In short, I created this survey to gather evidence of cinema as a lasting and sustaining source of life.

I wrote to thirty alumni of the Cinema Studies program at Salisbury University to ask if they would be willing to answer my survey. I also posted an open invitation to my former students on the Facebook page for our program.[4] A total of forty-six people volunteered to participate. I sent each person a consent form giving me permission to share their responses to the survey anonymously in this book. The participants then had a month to complete the survey, which I estimated would take approximately an hour and a half. I sent every participant a survey form on which they would identify themself by a unique number instead of their name: I hoped this would encourage them to be as candid and detailed as possible without worrying about being personally exposed. In my summary of the results, I therefore refer to the survey participants by numbers, and I consistently refer to what "they" (not "she/he") wrote to avoid any assumptions of gender.

My survey uses subjective terms for understanding why cinema matters—including words like "significance," "impact," and "meaning"— and that is intentional. I am inviting reflections that are personal and unique, yet widely understandable and transferable to numerous situations. Given my assumption that subjective and individual viewpoints can be representative, I make claims that could be perceived as problematically universalist. Since 1979, when Lyotard strenuously argued against what he termed "grand narratives,"[5] the postmodern pendulum has swung us away from ultimate truths.[6] For example, Kimberlé Crenshaw's seminal work on intersectionality warns us against the dangers of assuming any common womanhood (and by extension, personhood of any kind) that disavows the realities of different experiences, especially those filtered through the identity politics of race, class, language, and nationhood.[7] My particular claims for the life of cinema could be read as constituting a grand narrative that neglects the realities of unequal access to the medium, let alone the specifics of any film language or cinematic culture that cannot speak

for and to everyone. Nevertheless, I reclaim the idea of universalism so that it includes an embrace of diversity as well as the belief that all human beings share some common ground. I believe that anyone who has studied film can potentially gain from what it reveals of our common humanity along with its infinite possibilities for representing and understanding that. As Alison Assiter asserts, universalism remains valuable as "a view of the shared characteristics of all humans," particularly with regard to our common needs and our right to be treated with equal fairness. Assiter argues this idea "is particularly necessary . . . in a world where ugly divisions between groups have once again become apparent."[8] If I fail to recognize the essential humanness of every person, I risk dehumanizing them or resorting to a dangerous form of Othering. Cinema helps me walk the line between universal application and respect for the individual. The medium enables me to see and hear as other people do, and in ways I can understand, internalize, and absorb within my body, even while I recognize my own separateness from what happens on screen.

My survey is a logical extension of the arguments I have been making throughout this book about how films represent life, honor life, teach us about living, and affirm our lives. Recall that in *Death 24× a Second* Mulvey insists that films always represent lives already lost, and death (or, what has already ended) is implicit within every frame. Where Mulvey emphasizes concepts of loss through cinema, I emphasize life-enhancing personal gain. This survey also builds on principles that drive my pedagogical practice—especially a commitment to the personal and social significance of cinema that teaches my students and me about living better lives for ourselves and others. Following from this, I have read the survey responses looking for the participants' socially and culturally driven responses as well as their personal stories. My emphasis on their ongoing engagement with films *after* contexts of formal study fills a significant gap in the current scholarship about teaching cinema too.

I hope this study inspires other professors who want to know more about how their students internalize film analysis and might apply that to their lives after college. Perhaps it will influence some future practice—including film selections, conversation starters, and theoretical frameworks for planning classes with students' lives beyond college in mind. Ultimately, I hope that all readers of this book will be encouraged to dwell on what they find personally sustaining within cinema.

The survey content that I distributed to all consenting participants is as follows:

SURVEY: *CINEMA AS LIFE 24× A SECOND*

HOW DO FILMS FEED OUR LIVES, REFLECT OUR LIVES, AND HELP US LIVE BETTER?

Thank you for participating in this study of what cinema can do for us. This survey should take up to an hour and a half for you to complete. Some of the questions may seem to overlap; so, don't worry if you feel that your answer to one question covers the bases for another.

To get started, enter the 4-digit ID Code provided by email here:

The following questions are all related to understanding how your film experiences have intersected with your life.

1. When did you study cinema at Salisbury University? Please indicate the year span or the specific semester.
2. Which film course/s did you take with Dr. Walker? (Choices include ENGL 220 Introduction to Film, ENGL 221 Literature and Film, ENGL 324 Film Genre, ENGL 404 International Cinema, ENGL 404: Special Topics in Film (e.g. Film Noir, or Soundtracks), ENGL 405 Hearing Cinema, ENGL 408 Film Theory, a.k.a. Film Politics.)
3. Did any of the films you studied relate to your life outside the classroom, while you were studying them? If so, please explain how so, and whether that mattered to you.
4. Can you remember any of the course films or discussions of any films that had a particular impact on you? Please explain why you remember any of these in some detail. (Perhaps they changed your perception of a subject, or of a reality, or helped you understand something in your own life, for example.)
5. Have any of the films you studied with Dr. Walker taken on new significance for you in your life after college? If so, can you explain how so?
6. Have you replayed parts of any film that you studied with Dr. Walker? For example, have you replayed a scene online or bought a copy and replayed it?
7. If you have rewatched any of the films you studied with Dr. Walker, or any part of these films, what was that like? For example, how was it a new experience for you personally?
8. Have any of the films you studied with Dr. Walker helped you come to terms with any important life changes since you left college?

9. Thinking more specifically now, can you recall any lines of dialogue, voices, or pieces of music from a film that have stayed with you or a soundtrack that you have replayed from any of the films you studied with Dr. Walker?
10. Now, thinking about your ongoing film experiences, can you think of any films you have watched since college that have intersected with your life directly? If so, please provide any details you feel comfortable with sharing. You can think in as specific or broad terms as you like. For example, perhaps you watched a film that dealt with a parallel life experience to your own, or you connected with a character in terms of certain truths about being alive.
11. If your answer to question 10 is "yes," please explain and expand on anything you *learned* from the given film for living life.
12. Can you remember any conversations that you had in Dr. Walker's classes that have influenced the way you experience a film *since you graduated*? For example, perhaps you remember a concept or a technique from class that you apply to a new film in your own right.
13. Thinking more specifically, can you isolate any particular lines of dialogue, voices, or pieces of music from a recent film (or, postgraduation) that have had an impact on your life or which you have played over because they meant something to you? If so, please provide the example/s and explain the impact and/or meaning for you.
14. Are there any other film experiences you would like to share that have held special meaning for you since you left college? If so, please explain why they mattered to you individually or in the context of your viewing them.

To avoid preempting what the participants' responses would be, I waited until I had received them all before coming up with some ways to group and categorize the results. After reading the survey responses, which added up to a total of 199 single-spaced pages (approximately 50,000 words), I could identify clear patterns in how the participants argued that cinema has improved their lives, even years studying certain films in class. I grouped the responses according to a set of dominant concepts, defined as follows:

Black Lives Matter: the participant applies cinematic experience to engaging with the urgency, reality, and significance of the biggest global social movement at the time of writing.

Communication: the participant is using cinema to improve their ability to hear and respond to others in meaningful dialogue.

Compassion: the participant becomes "more altruistic, sensitive, empathic, and willing or able to help others" in relation to cinematic experience.[9]

Coping: the participant uses cinema for "adaptively responding" to loss.[10] More broadly, this concept includes any film experiences that the participant has applied to dealing with their own significant lifeshock/s (whether positive or negative).

Emotionality: the participant expresses and revels in specific feelings that are generated by a film. As Gillies et al. explain, emotionality "covers a range of references to emotion or emotional expression that are not necessarily depressive or negative in nature, such as 'I'm more emotional now,' 'my emotions are different,' and 'deep emotion is a gift.'"[11]

Greater perspective: the participant "focuses on the notion of not being upset by 'small stuff' or 'little things.'"[12] This includes those instances where a participant finds meaning that is big enough to eclipse concerns or anxieties about what is fleeting or not worth extended attention.

Heightened capacity to hear: the participant provides concrete examples of, and reflections on, what it means to listen well, inspired by particular sound tracks.

Identification: the participant's engagement with film/s allows them to feel seen, heard, validated, recognized, and/or uplifted by meaningful correlations with characters' lives and/or trajectories.

Mental health: the participant makes direct connections between the processes of a film and/or its characterizations and the participant's own working through mental health challenges.

Ongoing reverberations: the participant observes how a film has lasting resonance and meaning for them, with special attention to those examples of particular scenes, moments, or sonic aspects that continue to have an impact as reference points and/or anchoring influences in life.

Personal growth: the participant connects a film experience to their internal development, which results in "greater strength, maturity, changed priorities, responsibility."[13] Personal growth often registers as a greater *sense of self* (that is, the participant writes in terms of new self-knowledge, self-articulation and/or self-worth that grows from a film experience). It also comes through in the participant's new capacities for *connections with others*, which the participant reveals through

voicing a socially minded awakening and/or a sense of meaningful kinship with characters and/or other people.

Professional development: the participant applies what they learned about cinema in a classroom context to the work they are now doing in the world beyond that.

In numerous responses to the questions, participants applied several of the dominant concepts I have listed above to their engagement with a film. Therefore, I have included one further category for summarizing the results: *multiple levels of meaning*. Regardless of specific emphases, all the completed surveys indicate the participants' enhanced capacity to value life as a result of studying cinema. Participant 25 summarized this by saying, "the conversations in all of our film classes remain important to me. Taking film classes has truly changed my life, since it has *completely shifted my perspective of not only viewing films but viewing life*" (my italics).

For convenience, I assume the reader is familiar with all the films mentioned by my survey participants. I include all responses with succinct analysis and minimal editing. I now turn my microphone around, and the participants' responses will dominate for the remainder of this chapter.

Black Lives Matter

Like a person who matters to us for a long time, a film can become more remarkable with age, more complex, and more vital to our being in the world. Participant 3 mentioned the ongoing relevancy of *Do the Right Thing* (1989) in relation to the growing Black Lives Matter movement: "Given the current climate of the United States, the film and our class discussion of it have floated across my mind many times over the past few years." Similarly, participant 40 remembered, "writing a paper on realism in *Do the Right Thing* and [subsequently] creating direct links to police brutality and the treatment of marginalized communities in today's society." Participant 29 has new respect for *Do the Right Thing*, after resisting the ending of the film in their first (in-class) screening: "I complained about it to you, to my brother who is also a huge film buff, and to anyone who would listen. *Do the Right Thing* doesn't offer the type of ending we want in films, but rather one that is ambiguous and unsatisfying.... And in the last four or so years (2017–2021), I've come to realize that the ending of *Do the Right Thing* isn't what I want it to be because

the reality isn't what I want it to be." Participant 15 also emphasized that *Do the Right Thing* not only "opened my eyes to racism and police brutality in the country, but that never sunk in as much until this past year. Given the recent interactions between police and African Americans, my eyes are more open than they were when I originally watched the film in class."

Do the Right Thing was the most-cited Spike Lee film by survey participants. However, participant 9 said *Bamboozled* (2000) "might be the one film that changed me the most. Growing up, discussions of racism and racialized violence rarely moved beyond 'racism is bad but was also a long time ago and isn't really a problem anymore.' Lee's film took that notion and threw it in the garbage can, then lit the garbage can on fire. I think the most powerful thing about *Bamboozled* for me, then and now, is the way that Lee draws a direct line between racist depictions of Black people in the media and racist violence, sparing absolutely nobody the weight of his criticism. It helped me to understand my own internalized biases."

Communication

Several participants reflected on their deeper understanding of communication through studying cinema. For example, participant 3 now teaches English composition and literature, and applies certain skills from film courses to their own classes: thinking and writing critically, focusing on a "human layer" of understanding, and holding conversations that are "welcoming and free-flowing." Participant 43 wrote of applying ideas from *La Haine* (1995) to a specific interaction: the film "gave me another perspective when my French friend and I talked about the social problems in France with the immigrants. I could hear a little bit of prejudice in his voice when he talked about crime and terrorist attacks. . . . The more he talked . . . the more clearly I could see the cycle of hate and why it had grown so much." Participant 5 wrote about their ongoing engagement with themes of communicating in *Arrival* (2016): "The main character Louise says something like, 'How about we talk to them before we start throwing math problems at them,' in reference to the newly arrived alien visitors. This statement is the pinnacle of the larger point of the film, which is that conversation is key. What the film also illustrated well was that conversation is subjective. It challenges notions of conversational understanding and starts from a super basic point of communication. 'How to communicate?' becomes the first question. Those who

don't understand how, fail miserably, [and] those who understand how, don't necessarily know what to say." They added that the film "highlights the importance of context, concern, and empathy to understand what your words may mean to other people or, in this case, aliens."

Compassion

Many participants wrote of reaching transformative levels of compassion through cinematic inspiration. They aligned themselves with characters whose stories they not only witnessed but *absorbed*. For instance, participant 27 recalled studying *Brokeback Mountain* (2005): "Because Jack and Ennis fall in love in the wilderness surrounded by nature, the film's making an argument against the idea that queerness is unnatural. That's something I love thinking about when I'm outside: how our conceptions of nature are shaped by our oppressive systems." Participant 39 was also deeply affected by *Brokeback Mountain* and the freeing class discussion around it: "I was raised in a very far-right conservative household, which I know now was also very judgmental and prejudiced. . . . I remember homosexuality being a really big 'no-no' at home, but at college I was around a much more diverse crowd. . . . I was learning on my own that people are people and there are good and bad things about everyone, but they don't necessarily have any correlation with race, sex, religion, or sexual orientation. *Brokeback Mountain* just helped cement the newfound empathy I had for closeted homosexuals and homosexuals in general." Participant 37 spoke just as candidly: "*Brokeback Mountain* was certainly eye opening for me in terms of my reaction to LGBT cinema and my personal need to 'get over' any final issues I had with honest portrayals of homosexuality in society at the time. . . . Don't judge without getting to know someone, or even something, first. This goes for people as much as it goes for movies about people."

Several other participants wrote of respecting and accepting differences more willingly after studying films that inspire kindness. Participant 35 wrote that "*Never Let Me Go* (2010) had a big impact on me in terms of how I view people who may not necessarily be like me. The exploration of clones being raised through youth into adulthood just to have their organs harvested and donated to regular humans desiring to live longer was both incredibly intriguing and heartbreaking. The way the clones are treated throughout the film as less-than is intended to enrage the viewer, especially since the clones

appear just as human as the humans they're helping—perhaps more so. At the end of the day, we are all human, and we shouldn't treat people differently just because their circumstances are different from our own. It's something I think everyone needs a reminder of, and it continues to meaningfully impact my life." Participant 29 wrote of a more culturally specific awakening: "I remember watching *Rabbit-Proof Fence* (2002) without too many expectations, but ended up being fascinated and really just overwhelmed by the experiences of indigenous people not just in Australia but throughout the world. I did know in theory what the dominant culture did to indigenous people, but being that I was white [and] in an American school system, the real damage felt far off. I remember the characters being such young girls, and wondering if at that age I would have had the courage and determination to make such a journey—I don't believe I would have. I honestly think after watching this movie I began to view the stories of the dominant culture in any society as a white-washed (at BEST) version of the actual history." Participant 21 was even more self-interrogative in relation to this film: "*Rabbit-Proof Fence* forced me to consider the role of nation-sanctioned violence, colonialism, and racism. I was not unaware that indigenous peoples have and continue to be violated by nation states, but the film forced me to think about how that happens on a daily basis. It also made me ask uncomfortable questions of myself. Why did it take a dramatized portrayal of these children's suffering to motivate me to learn these histories?"

For some participants, the compassion inspired by some films *grew over time*. For example, participant 31 wrote, "*Thelma and Louise* [1991] has taken on new significance, as I'm now a working woman in my thirties. When I was twenty years old watching that film, I thought it was an entertaining movie about strong, independent women (which it is), though I didn't grasp the weight of their decisions as much as I do today. This movie feels more significant now as I realize how many women, especially thirty years ago, can fall into feeling trapped in a housewife routine or have to make difficult decisions in the face of danger . . . Thinking about this movie now, I look at it as a story of two women recognizing the adventures and challenges beyond their home life, and deciding that it's worth the risk to live more freely and feel emotions more intensely, whether good or bad." Similarly, participant 31 took a more nuanced view of a film through repeat viewings that felt "more intense": "I have rewatched *Heavenly Creatures* [1994] a couple [of] times. . . . In college I was shocked by the girls' behavior and ability to murder the mother. Now, while still shocked, I also feel saddened about how they felt killing the

mother was the only way to be together and live their authentic lives. I've personally come to a [clearer] realization that they could have had some mental health challenges and not enough community support or awareness."

For participant 43, the new compassion was for people closer-to-home: "After I watched *Amour* (2012), I was able to understand why my grandfather was putting up so much resistance to moving into a retirement home. My grandma and grandpa lived in a really icky home; whenever I entered, I felt gross. They were hoarders. . . . On top of that, my grandmother's health conditions were worsening . . . My Dad almost had to bring his dad to court before he finally gave in. I didn't understand why they wouldn't move into a retirement home where she could have the care that she needed and a clean living space instead of living in a filthy home. It was not until I watched *Amour* when I was able to understand that their home was more than just a space to them. It was a protected space where they were always there for each other. It was a space that represented their shared identity, especially considering they [had] lived there since they got married."

Coping

Using films to cope with lifeshocks is one of the strongest themes across the survey responses. Many participants wrote of films that have helped them manage, gain control over, or at least better understand the greatest challenges of living, along with making them feel less alone in the process of confronting pain or significant change. Many participants recognized themselves in the lifeshocks of films and wanted to keep reliving these experiences, even when the films did not offer clear-cut solutions. I include a range of representative examples here.

Several participants focused on dealing with mortality, grief, and/or death acceptance. Participant 24 found solace in studying *Tree of Life* (2011) at the same time they were caring for their dying grandmother: "I found myself touched and overwhelmed by the film's themes of the mother/child (and mother/son specifically) relationship, the passage of time, memory, nostalgia, growth, death, love, and the grandeur of existence." Participant 18 wrote that *Rabbit-Proof Fence* "helped me think about my mom dying in a way that I hadn't really before. I don't know if it helped me to come to terms so to speak, but it was therapeutic to have these new feelings come out when watching the film." Participant 6 wrote that *Magnolia* (1999) helped "prepare

me for a string of older relatives entering hospice care in the years after I left college. Without the subplot of Philip Seymour Hoffman as a hospice care worker for Jason Robards's character, I don't think I would have been nearly as prepared for these instances. In a way it was like the scenes were a practice for the real thing. The overhanging dread, the tough conversations, the false hope that they're suddenly getting better right at the end, and the odd relief when it's all finally over. When it all happened it was like I was there before and [that] helped us all muddle through it and process what was happening."

Participant 27 gave another detailed, heart-wrenching, and affirming account about using a film to cope with a loved one's imminent death. *The Farewell* (2019) has "taken on new significance and meaning" for this person, even months after studying it in class: "I love the goodbye scene, especially that image of Nai Nai standing in the street. . . . And I love the final scene: Billi's yell and the cut to the birds outside Nai Nai's apartment. When I saw this film in class, the power of these scenes did impact me, but now that I'm caring for a terminally ill family member, I feel deeply impacted by and connected to these scenes." They added, "there are so many quiet, slow moments in the film where Billi simply looks at Nai Nai, or Billi looks around the room at her family and no one meets her gaze in the way she needs them to. That feels so true to me; it's so difficult to talk about loss with other people because I'm hurting and I know they're hurting, too." Participant 27 felt most psychologically connected to the film's editing rhythms: "There's a movement and pace to the goodbye scene that parallels my current experience with grief and saying goodbye. Time right now feels so unbelievably fast but so slow. I feel that sense of disbelief in the editing of the film. For example, there's a pretty abrupt cut from the family chatting inside to Nai Nai and Billi quietly hugging each other in the street. Then, when Billi and her parents are driving away, the camera is focused on Nai Nai waving before she breaks down, and the film feels painfully slow. It's brutal."

Participants reflected on a wide *range* of lifeshocks represented cinematically, from the most startling demands to the most joyous rewards of growing up. As a struggling student, participant 10 found validation in *The Red Balloon* (1956): "The boy in the film just wanted to stay with the red balloon to make him happy. To feel he had a friend and find beauty in the simple things. I left the classroom feeling like I could find magic in something as simple as a balloon and tried to focus on that mentality for the remainder of my college experience." Participant 46 said that they were especially "drawn to" the nightmare sequence of *Rosemary's Baby* (1968) because "I was coming

to terms with being groped in my sleep by a relative. I felt like Rosemary and I were connected to one another (though her situation was much, much worse than mine) and I wasn't so alone." Participant 43 wrote that "*La La Land* (2016) helped me come to terms with the fact that some people just are not meant to be together because of certain circumstances. It was hard for me to accept while I was in a long-distance relationship." Participant 42 wrote of replaying the song "Shallow" from *A Star Is Born* (2018) because the film's plot "parallels the loss of a dear friend. The main character struggles with mental health and addiction, and regardless of how much he was loved, he lost that battle. We lost our friend to addiction, and every day I ask myself what if we had done something different for him." Participant 41 explained that *In the Mood for Love* (2000) immediately touched them with its themes of "aching desire and restraint," but that became even more important shortly *after* college. At that time, they were in an unhappy relationship and "there was someone else in my life who had started to light me up." Believing they would never be with that other person, they suggested he go see the film. That person "made the connection" and, several months later, the participant "painfully and messily extricated myself from the previous relationship. The person I sent to go see *In the Mood for Love* without me has now been my partner for six years." Participant 41 now sees that entire period of change and the film anew: "At first, thinking about that time in my life was only painful. I'm now able to view it much the same way I experienced *In the Mood for Love*—painful yes, but also dynamic, beautiful, full of charged potential and longing." Similarly, participant 8 explained that *Arrival* resonates with their lives both during and after college: "The central themes of discovery and understanding, tied in with those of love and loss, really resonated with me as I prepared to graduate from university and move on with my life. The timing of my first viewing of *Arrival*—the semester before I graduated, and the same semester that I escaped a toxic relationship—gave me this external medium to process my own losses and changes, and I'm thankful for both the film itself and the timing with which it came into my life."

Other participants wrote about finding strength in those films that mirror their personal challenges in postcollege life. For example, participant 15 wrote of the gender politics in *Whale Rider* (2002) as follows: "The protagonist is a young girl who wanted to be the head of a tribe in New Zealand. Of course, traditional hierarchy belonged to men in the film. . . . The elder members of the tribe are disappointed that the young girl might be a better chief than any of the young men. For some older members in society, change

is a hard thing to adapt to, but the youth tend to adapt more easily.... And since graduating I've realized the generational differences are just a part of life. In my own life, I constantly struggle with accepting the way some of my older family members behave, but those have become lessons for myself as well." Participant 13 wrote that the coming-of-age themes in *The Perks of Being a Wallflower* (2012) virtually anticipated their personal journey after graduation: "I learned it's okay to be introverted and quiet, but also beautiful things can happen when you open yourself up to people. Recently, for the first time in my life, I have made a group of friends [and] this is the first time I've experienced such a welcoming group. These friends are all so inspiring and want to achieve beautiful things in this world by filling it with art through their voices. They push and support me to be a better person but also [show me] how to be forgiving with myself. This is not completely parallel with Charlie, but I think by the end of the film, he has found people who hold him and make him feel held, and that's what I've found in this group of friends that I hold near and dear to my heart."

By contrast with confronting death or interpersonal struggles, several participants foregrounded the *comfort* of certain films during current lifeshocks. Participant 24 turned to the warm family scenes in the exposition from *Fanny and Alexander* (1982) during their first Christmas away from family due to COVID-19–related travel restrictions in 2020. Participant 13 found similar comfort in rewatching the loving domestic dynamics of *Dan in Real Life* (2007) "during the height of quarantine because I needed some escapism. It was a nice reminder of the good the world can produce when everything is grim outside, from the fatherly love to the rom-com romance. It's a sentimental film that resonated harder while watching it cut off from the world. It reminded me to be grateful for time spent with friends and family and take time for myself and the things I want to pursue.... Over this past year (2020 into 2021), I've strengthened and developed my support system with people who want to see the best for me, and that's what Dan's family wanted for him."

Emotionality

All survey participants wrote of films that have affected them deeply, but some placed special emphasis on the life-affirming and life-changing *emotionality* of embracing particular film experiences. Participant 33 simply

said, "the films I watched and the skills I learned to analyze them have helped me grow emotionally." For instance, *Eternal Sunshine of a Spotless Mind* (2004) "helped me with breakups." Participant 4 wrote of having always loved *White Christmas* (1954) as a regular holiday-season experience but finding more emotional "weight" within the film years after studying it: "From recollection, in a class I had more than five years ago—there is so much going on in the moment when the General places his uniform back on and his granddaughter greets him. The fact that he survived the war, the loss of his comrades, his return to a position of a respect—it's all on his shoulders there . . . And there have been other moments of 'weight' I have caught since then. At the *very* end of the film during the final singing of the titular song, we catch one soldier going to another soldier at a table and shaking his hand. He's beaming, and in a single moment there is an unspoken history between them. They potentially experienced the horrors and comradery of war together and are happy to see each other again. A mere two or three seconds of film, but even that can provide a lot to unpack emotionally."

Other participants explained how they live the lessons of moving films, even years on from graduation. Participant 27 remembered "the *Bicycle Thieves* [1948] class discussion being particularly emotionally moving for me. That is a film that still affects me day-to-day. When I'm frustrated by never-ending, bureaucratic hold-ups, I find myself thinking of Antonio and Maria waiting in that long line, trying to sell their wedding linens so they can survive. *Bicycle Thieves* ignited something in me. . . . The film impassioned me and reinforced my political values." Participant 40 harkened back to the emotional power of some music from the *Shutter Island* (2010) soundtrack: "I think what was most important and impactful to me from [Max Richter's] 'On the Nature of Daylight' was how much emotion can be conveyed in the unspoken. The [piece] doesn't feature any dialogue, but still manages to tell its own story and produce emotion from myself . . . What I've learned from this experience (in relation to living life) is how some feelings and emotions cannot be put into words and are meant to be felt rather than spoken."

Participant 34 wrote of their evolving reactions to the emotional journeys of cinema: "Having now failed in big ways, gotten truly lost, and actually experienced feelings of alienation that I'd only really imagined before—the journeys of the characters while still romantic are now touched with something much more serious. When a character was gripped by the hands of fate before, I might have admired the talented director for eliciting an emotional response in me, or I might have just elated in the sensation of these grand

and sometimes novel feelings I was experiencing relatively safely through on-screen surrogates. Now, having lived through more of the death and loss endemic to adulthood, I think some of the sadness in the films would be felt differently . . . A new significance to any emotionally moving work of art is now not so much the novelty of feeling something, but an additional layer of relief and excitement at still being open to that volume of feeling. If a film makes me cry now, I also experience a deep gratitude for still being open to these feelings—to being alive." Similarly, participant 27 wrote about inviting emotion by replaying those scenes from *Blinded by the Light* (2019) that feature Bruce Springsteen songs: "Some critics (and I got this impression from some students in our class) thought this movie was cheesy, and I can see why someone would think that, but *Blinded by the Light* is such an earnest, feel-good film to me. I think a lot of great films can veer into being considered cheesy because a lot of great films embrace honest emotional highs and lows. Emotional truths are usually embarrassing because they make us feel vulnerable, but that's okay: we should embrace the initial embarrassment of acknowledging our feelings! I've rewatched the 'Born to Run' and 'Darkness on the Edge of Town' scenes the most; I really, really love them. The 'Born to Run' scene is giddy with joy and the 'Darkness' scene feels so cathartic because this is when Javed is internally struggling against his father's expectations for him and Bruce voices Javed's discontent before Javed can do it himself." Parallel to this, participant 25 wrote of repeatedly replaying the song "Visions of Gideon" from the end of *Call Me By Your Name*: "I felt the emotions going through the character's mind as if I were having them myself. I listen to that song a lot, especially when I'm feeling sad or lonely, and it helps me to go through those emotions. I also listen to songs from *Dancer in the Dark*, specifically the song when she's on the railroad track because it's so powerful since she lets go of her eyesight and lets go of her worries that come with losing her eyesight." Along similar lines, participant 41 wrote about "being *activated emotionally* by some of the stories and characters" (my emphasis): they explained, "I remember the way those viewing experiences expanded my emotional range, empathy for others, and empathy for myself—as well as a deepened acceptance of my own emotionality. Life is a wild ride! We feel about it and we feel our way through it. Seeing and discussing others, real and imagined, navigating their lives and their own emotional landscape was a gift that carried me forward. As I'm writing, films are flicking across my mind that vividly depict the beauty and pain and complexity and even cruelty of life: *Brokeback Mountain, Dancer in the Dark, Heavenly Creatures,*

In the Mood for Love, Beasts of the Southern Wild [2012], *No Country for Old Men* [2007], *Paris is Burning* [1990]." Since they graduated from college "11 years ago," this participant's memories of class discussions "have faded. I'm left with only how they made me *feel*—stimulated, engaged, empowered, and tapped into something rich, deeply human, and generative."

Greater Perspective

While many participants cited films that helped them grow, communicate, cope, and welcome emotion, others explained that films gave them a sense of greater or more worldly perspective on their troubles. For example, participant 4 wrote of the "unspeakably poignant, beautiful and bittersweet ending" from *Arrival*. They focused on how "Amy Adams's character decides to go through with having a baby despite being told in advance of the enormous pain it will cause her later on." From this, they concluded that "love and subsequently life—however fleeting they may be in some cases—are worth whatever sorrows they may cause." Participant 23 dwelt on the lasting significance of *Call Me By Your Name*: "When young Elio is heartbroken over Oliver's departure back to the US, his father delivers a brief monologue. For me, there is nothing romanticized in that moment; it is fully steeped in the realism that love and life are beautiful and at times crushingly painful. The way Elio's father discusses being human, friendship, or 'more-than-a-friendship,' just speaks so much truth about human nature in the most caring and understanding way, and every time I hear it, I hope that I'll be able to speak to my children with the same wisdom, love, and understanding. Additionally, the piano music that fills . . . the soundtrack always reminds me of how absolutely beautiful and passionate and heartbreaking the film (and life) is."

Participant 34 wrote of being able to "see" differently through many of the films they studied, due to a pattern they uniquely identified among the protagonists' journeys: "Many of the films Dr. Walker showed in class seemed to warn of the importance and danger of being able to 'see' clearly in an often deceptive, unjust, and antagonistic society. Special or especially clear sight was the most important attribute of most of the films' outlaw/ reluctant killer protagonists. Seeing what others couldn't see was what defined the characters, offered them salvation, and sentenced them to death. In *Dancer in the Dark*, this idea was explored quite literally in a world that could see Selma much less clearly than she could 'see' it. Likewise in *The*

Village [2004]—layers of secrecy threatened the blind protagonist who had the vision to reach past the veil of her oppressive world. Thelma and Louise, too, sought to get beyond the reach of 'the man' as they sailed eyes-wide-open into oblivion. *Unforgiven*'s [1992] reluctant killers aren't so different from William Blake in *Dead Man* [1995] (who actually goes on a vision quest)—protagonists who are haunted and saddened by their ability to see themselves as necessarily violent in an unjust society that herds them to their fates—this gift of sight is always a blessing and often also a deadly curse. In *Get On The Bus* [1996], *Rabbit-Proof Fence*, and *El laberinto del fauno* [*Pan's Labyrinth*, 2006], the protagonists all undertake journeys under the threat of, and in opposition to, an oppressive government force. All these subversive outlaws on their quests were obviously hugely inspiring to a college student trying to find their way in post–9/11 America. These were all films that made you want to be able to see things, badly, but didn't sugarcoat the great perils of being able to do so. Alienation and even death awaited most of these visionary characters. Direct lines can be drawn between the lessons of these films and [my] personal choices during college to go on a cross country bike trip or become a newspaper reporter—I wanted to SEE. So much of what I chose and choose to do in life (or feel shame for not choosing to do) can be related to the characters demonstrated in these films. They still serve as touchstones when thinking about how to be or what is the right thing to do. When I am brave, I think of them, and when I am not brave, I think of them."

Several other participants found perspective-giving beauty in surprising places, as in participant 13's response to *Amour*: the scene where "Anne reflects on her life . . . as she flips through that photo album and says that 'life is so long' is beautiful. So often, we privilege the perspective of youth and a longing to be young again or forever. Still, that dialogue is filled with so much contentment that the reflection is not a longing but an appreciation of all the stages of life and how it's truly a gift to grow old, not something to be Othered but instead accepted. As someone who struggles with the idea of growing older, I find comfort in the representation of a fulfilled life rather than an overly nostalgic one." Participant 15 had a similarly personal and all-encompassing reaction to *Chungking Express* (1994): "The fact that the cop meets two different love interests within a couple of hours gives you a snapshot at our daily lives. We meet people every day that could or could not play a major role in our future. The film puts such an emphasis on each relationship but, just like in real life, things quickly change and you have to move on. I remember thinking about how many people I meet every day on campus

and how many I will eventually meet throughout my life. Then, the song 'California Dreamin'' starts to play and the lyric 'I could leave today' brings everything into perspective. Everyone I meet could be entering or leaving my life within a matter of hours and that thought can be overwhelming at times, but it additionally amplifies my entire cinematic experience while watching *Chungking Express*."

Along with citing a variety of films—*Manchester By the Sea* (2016), *Sorry to Bother You* (2018), and *Call Me By Your Name*)—participant 24 said, "I think I'm still learning from those films, but I think one central lesson from these films is that life is fleeting, so it's important to live it. But also because of that fleetingness, loss is inevitable. Life is unpredictable, but tragedy is guaranteed. It's important to know this, in order to use our time on Earth well." Such bittersweetness came through in participant 23's ongoing engagement with *Tokyo Story* (1953) too: "This film sparked my interest in the Zen concepts of *mu* and *mono no aware*, and Zen Buddhism more broadly. I've now been studying Buddhist and Zen philosophy for several years, and it continues to guide my efforts to walk the 'middle path,' and remain balanced through life's many changes. In particularly painful moments when I notice that I have become very attached to a person or idea, I try to embody the stoic characters of *Tokyo Story* and remember that 'life is disappointing' sometimes." More specifically, participant 23 remembered the "pregnant pauses in narrative, stoic facial expressions, and compassionate detachment expressed by the elderly couple and young widow." They "like to remember those characters as role models in moments that feel painful."

Heightened Capacity to Hear

Several participants stressed the significance of developing a heightened capacity to hear through studying sound tracks.[14] Drawing on the work of Katherine Spring, I routinely include a "soundwalk" near the beginning of my course titled "Hearing Cinema."[15] Participant 40 summarized the experience and its aftereffects as follows: "In Dr. Walker's 'Hearing Cinema' course we were asked to do a soundwalking/listening experiment where we sat in different spaces all around campus, closed our eyes, and paid attention to every little sound we could hear. This experiment made such an impact because it not only made me aware of how much I wasn't already paying attention to [in] my surroundings, but also helped me (for future reference) to pay

attention to details more, in sound and overall. I think there's also something to be said about the importance of being quiet and listening—the process was not only helpful in terms of cinema but also in life (which are one and the same, no?)." Participant 25 wrote, "I enjoyed our soundwalk assignment because I had never listened in that way before. I was able to hear things I wouldn't normally hear, which honestly led me to have more appreciation for sound. I've done other soundwalks outside of class and it consistently amazes me." Participant 20 wrote of the soundwalk making them more "conscious about the sound I put out into the world. My playlist has been growing since my time as a student came to an end purely because I am more aware of the audible world around me. . . . There are moments in my life today—little moments, amidst the chaos of the world around me—where I will step back and just listen for a minute or two. There is an inner peace and tranquility that comes from the simple act of listening to what is happening around you." Participant 33 said, "I truly enjoyed learning about how even the most minute sounds impact feelings. Living in the city, I think about what I am subconsciously hearing whenever I feel calm or concerned or anything. It reassures me to casually close my eyes and try to identify the distant noises to understand how [they] may affect my mood, like we did on one of the first days of class and [this] has changed how I understand my own emotions and react to them."

Participant 10 recalled a different course assignment from me: creating a new soundtrack for a film with preexisting music. Their reflections indicate a heightened capacity to hear in the service of mental health: the assignment has "helped me in my life greatly. If I'm having a bad day, if I need to change my mindset, I think about how music and sound can alter a person's emotions. So, I listen to music, listen to nature, or simply listen to my kids' laughter and that can change my view on life very quickly. I use this on a weekly basis, if not daily, to help improve my outlook on life."

Some participants zeroed in on the lingering impact of specific sound tracks. Participant 12 wrote of embracing *Amour* because it focuses on an older couple who are "able to enjoy each other's company, without saying much dialogue. It showcases their relationship, love and contentment with one another. I have been able to appreciate quiet places more. During college, music would be my go-to sound. . . . Now I am able to enjoy the quiet. It also makes you realize that the world isn't really quiet; there is still ambient sound that our mind chooses to ignore." Participant 23 wrote of studying *Blowout* (1982) as a differently distinctive time of aural awakening: "The experience

of studying this film opened the door to not only a deeper understanding of my own strengths, but also to studying more deeply the relationship between the visual and aural, and the aural and the emotional. To this day, having a better understanding of how to articulate what I'm hearing helps my understanding of what I'm experiencing."

Other participants recalled specific conversations about the *act of listening* in class. For example, participant 13 recalled "a conversation in class about the film *Black Panther* (2018).... Some white people essentially felt uncomfortable about the overwhelmingly positive response from Black audiences. A classmate connected this perspective of white audiences to *Black Panther* by thoroughly analyzing Martin Freeman's character, Everett Ross. My classmate stated that Everett's purpose was to stay silent and listen to the needs of Wakanda rather than impose his opinion from a colonizer's perspective. For example, there is a scene where Everett tries to talk over M'Baku, but M'Baku and fellow tribe members repeatedly bark at Everette, demonstrating that this is not his place to speak. For the remainder of the film, Everett remains quiet unless spoken to by other characters. Listening will always be an essential part of communication, and when our society privileges certain voices over others, that creates injustice. This might be uncomfortable for the powers that be (like the previously mentioned white audiences), but necessary to decolonize the mind and body. We see this striving towards decolonization in movements like Black Lives Matter, where the positionality of 'well-meaning' allies can be reductive to the movement where what is needed is a genuine act of listening, as seen in *Black Panther* by Everett." Participant 25 recalled a different, no-less-specific conversation about *Rebecca* (1940): "We talked about how waves in the film are impressive but also frightening. I thought about that a lot and how certain things in life can be really painful or scary, but there can also be beauty during and after [their occurance]. This is something that has stuck with me and helped me in situations where I was struggling to find the beauty in difficult times."

Identification

Many participants wrote about their sense of identification with specific film material, especially as it affirmed their life experiences: this was a stand-out pattern across the survey responses. Since I value respecting differences among us all in every conversation and analysis, I use the concept

of "identification" in a very self-conscious, malleable, and often nonliteral, way. That said, I argue that finding connections with characters is often crucial for my students' learning through engagement. For example, while none of us have struggled with terminal cancer as an old Japanese man in the post–World War II period, we can all surely identify with the protagonist of *Ikiru* (1952) as he fears mortality, struggles to accept death, and grapples with inhumane bureaucracies. This makes the life of Kurosawa's film huge and unending. For a parallel example, participant 8 wrote about why *Nobody Knows* (2004) has stayed with them: "I watched it shortly after my father moved overseas to take a job, and at the time I was dealing with feelings of abandonment that came from his decision to place himself far away from my brother and [me]. I'm not certain that the film impacted how I processed him leaving, but I remember finding the movie's theme of parental abandonment particularly heart-wrenching at the time, especially since I could at least partially relate."

I believe that feelings of identification are often important for motivating audioviewers to understand others' lives. Such feelings can drive sincerely curious, imaginative, and creative thinking. As evidence of this, many survey participants took an example of identification to a generative place, whether in terms of how they live, or what they recognize in themselves, or what they perceive in others, or their gratitude for feeling seen and heard, or in their openness to fictional situations that influence their being in the real world. Most of the films that participants identified with directly portray emotional pain, yet the participants' responses were consistently and deeply life-affirming. This pattern suggests that even when cinema puts audioviewers through personally affecting traumas, the potential for finding hope, joy, relief, and growth can be big and lasting.

Some of the participants identified with films and characters quite directly: participant 23 wrote of how the "bright colors, costumes, humor and music of *White Christmas*" have always filled them "with joy," but now they find special meaning in the film because they were married at Christmas time and rewatch the film every wedding anniversary. Participant 8 wrote about the resonance of *Beginners* (2010) as someone who is "openly bisexual" and "as someone who's struggled in my relationship with my father." They added that the film "places a lot of value [in] authenticity and openness, two things I've needed to work hard to develop in my own life." Participant 31 asserted that "*Lady Bird* [2017] connects to ideas and truths about being alive, or at least life as I know it, because . . . I have to try to understand that while my

relationship with my own mother can be a challenge, it comes from a place of love and trying her best, despite physical and mental struggles." *Can You Ever Forgive Me?* (2018) was "exciting and relatable" for participant 27 "as a queer person." They wrote, "I love that [Lee Israel] constantly tried and failed throughout the movie, how mean and unapologetic she was, and how she had no interest in pandering to straight people or men." Participant 27 also related to the female protagonists of *Carrie* (1976), *Rosemary's Baby*, and *Cat People* (1942) "because all these characters struggle to hold onto their identities as male characters (and female characters invested in furthering patriarchy) try to erase [them]. Personal experiences I've had make me relate to these characters because all of us have struggled against sexism, and I love these characters fiercely because I identify strongly with all three of them."

Participant 44 wrote about the resonance of *Life Is Beautiful* (1997) as a story that revolves around a father and son in the Holocaust, an experience that opened them up on personal *and* professional terms: "Being a veteran myself, along with my father, just made things hit home while I tried to mentally place myself in the same situation and circumstance. My father can be quite witty and comical at times and those are things that [Roberto Benigni's] character used to help his son feel like he was safe even when he was not at all. This mattered to me because it made me realize the power of emotion as we view different films. With my work, I always keep the psychological element of filmmaking at the forefront of my shooting and editing.... This is what ultimately will keep audiences engaged."

Participant 5 explained why films focusing on loneliness, and especially *Taxi Driver* (1976), "resonated with me": "Travis Bickle spent his days searching for companionship and purpose, but at night the theme of loneliness was amplified by the sequences of him riding around in his taxi surrounded by people that he had no emotional connection with.... This relationship between the character and the streets surrounding him was invigorated by the soundtrack with its melancholic tones, guiding the viewer down the same emotional drain that pulled the protagonist into his own depression.... As someone who studied film often at night, my life was different from many of my classmates whose days were ending when mine was beginning. It magnified my own feelings of isolation, but it also brought me together with other people [who] enjoyed the same characters that I did, ultimately leading to new friends and a new understanding of myself."

Several participants stressed the importance of feeling their presences in the world were being acknowledged through cinema. For instance,

participant 5 found hope in the pointed directness of *Get Out* (2017): "As a Black male living in America, I found the director's ability to communicate the insidious and outright creepy nature of prejudice in everyday life for African Americans extremely relatable. The film illustrated how seemingly innocent or well-intentioned actions by the majority could be subconsciously degrading or destructive to the minority.... While no one is outright 'rude' to the protagonist, they are clearly making him and the viewers uncomfortable. This uncomfortable feeling and awkward state is something that many African Americans, including myself, have to deal with on a regular basis." Participant 5 then recalled a sonic motif of terror: "the noise of the spoon in the teacup, which the mother used to hypnotize Chris," adding "it was the simplicity and ordinary nature of the sound that made it seem so innocent, yet the viewers realize that that simple sound was the cause of so much trauma within the film. In fact, the greatest sense of relief that I felt in the film was when Chris finally smashes the teacup, therefore freeing his mind from the shackles of hypnosis." Participant 5 wrote about their related experience of going to "a nice liquor store in Baltimore County," where the store management called the police on them although they were simply shopping. They connected this experience to *Get Out*'s representation of unspoken sinister action: "I believe the person that erroneously called the police on me was Black! Proof that some people truly do live in the 'sunken place.' Additionally, my older white friend [who] was shopping with me never even noticed anything going on. I had to ask him if he had noticed the uniformed police officer following us throughout the store." *Get Out* helped participant 5 felt surer about trusting their instinct that "sometimes racism and prejudice hide in plain sight."

Participant 11 also argued that *Get Out* "correlated with my reality the most. While existing as a Black person in a predominately white university never took me down the same twisted roads presented in that movie, I still knew that the inherited weight that comes with being 'the Other' was something that I would lug around with me inside and outside of class. The dangers of displacement and angst are constant thorns that all minorities deal with, and given enough time, they can desolate even the strongest hearts and minds. I still struggle with dealing with those thorns." Studying the film and "talking about it with others" through "different lenses of cinematic thought" could "not get rid of the thorns or the weight, but it certainly helped."

Participant 12 felt a different, but nonetheless palpable, sense of connection to the visual details of a scene from *Moonlight* (2016): "In the film, the

pink color from the room is drawing you in. You see the mother screaming at her child [Chiron] in slow motion and he is staring back at her. That is the mother's room and she is a drug addict. It seems like the color from the room is her escape or fantasy. That is the only vibrant color that we see within the house and when she closes the door, the color vanishes." They explained that "I have a red light in my room [and] the color coming from the dark hallway reminds me of that slow and powerful scene," so "it "has always stuck with me." Participant 9 also dwelt on *Moonlight*, recalling when Chiron tells his beloved Kevin that "I built myself hard." They connected with this idea from a gendered perspective: "Masculinity studies is something that I got really interested in right around the time I was finishing graduate school and has continued to be something that I'm [passionate about]. The way that Chiron talks about constructing his identity, building walls of muscle around himself so he wouldn't get hurt again, really spoke to me on both an intellectual and emotional level."

Several other participants wrote about films that have come to matter more to them in new stages of life. Participant 42 wrote of how "becoming a mother has changed my perspective on many of the films we studied. I can perceive the innocence and tragedy of characters like Iris in *Taxi Driver* in a way that I couldn't originally. I can feel the terror that a mother feels thinking about their daughter walking a path that takes them to such a dark place. Even the pregnancy of Madolyn in *The Departed* (2006) holds so much more weight because of the loss that surrounds it—the loneliness that she must feel from the moment she finds out." Other films have gained "more significance" for participant 36 as a young mother too: "I also felt really deeply connected to the film *Australia* (2008) and the mother/child dynamic between Lady Sarah Ashley and Nullah pulled at my heartstrings so strongly that I have enjoyed many repeat viewings." They expanded on this to make a widely applicable point: "As my life changes, so do the eyes through which I view these films. As a mother now, my experience with many films has changed. My life experience is influencing the way that I view films by allowing me to see things I didn't see or fully understand the first time." Participant 18 also wrote of motherhood as an expansive and igniting theme of *Rabbit-Proof Fence*, which they have repeatedly watched with others since collage: "My mom passed in 2014, so watching this film after that made this movie even more powerful for me. Oh, the things I would do to get back to my mother now. That movie hits me even harder now than it did then."

A further example was most surprising: participant 41's reflections on rewatching *No Country for Old Men* after waking up "in considerable emotional and physical distress from an array of terrible decisions I had been making and unhealthy situations I was repeatedly finding myself in." They watched the film "in horror, feeling as if it were speaking directly to me. The themes of choices, chance, inevitability, and personal codes took on new meaning—coming in loud and clear was the idea that not choosing, not acting purposefully, is also a choice, also taking you somewhere. I'm thinking specifically of the scene where Javier Bardem's character walks into the rural gas station and demands that the attendant 'call it' after he flips a coin. When the attendant protests that he 'hasn't put anything up,' the response is 'you've been putting it up your whole life.' Since then, that scene has replayed in my mind from time to time, with all that was behind it for me that day."

With self-aware candor, participant 34 summarized what many of the participants implied: "In the way of most college-age people, I couldn't help but search for identity and meaning in nearly everything I was exposed to during that time. In this pursuit of puzzling together one's self and one's voice, film was uniquely fertile ground.... Seeing life and self reflected on the screen was huge for me—every film was a sense-making exercise as I looked to understand the world around me."

Mental Health

Though survey participants frequently implied that certain films improved their mental health, I single out two that explicitly stressed this. Participant 35 wrote that *Gattaca* (1997) resonated with them "deeply" because of its "theme of perfection" and "humanity's unhealthy obsession with it." The film foregrounds the need to preserve humane values in a world where genetic engineering leads to "genoism"—a form of prejudice against those who are born with unmodified DNA. Participant 35 asserted that the film ultimately concludes that "perfection isn't everything" and this still has a stabilizing influence on them: "I tend to strive for perfection in a lot of what I do, sometimes to the detriment of my mental health and sanity. I need to realize that I can give things my all while also embracing the beauty of imperfection. Seeing films tackle seemingly simple, yet hard, lessons such as this one makes me and so many others feel understood."

Participant 37 found solace in a surprisingly different example: the characterization of Blanche as played by Vivien Leigh in *A Streetcar Named Desire* (1951). Despite the different age and "completely different history" of Blanche, participant 37 wrote that her line "I have always relied on the kindness of strangers" resonated with their own experiences of "gender roles and interactions, particularly [instances of] sensitivity and masculine 'savagery,' as well as my passion and personal traumas regarding mental health." The line had an "emotional impact on me in regard to the constant feeling of hopelessness and a potential yearning for connection that I experienced during much of my time at Salisbury University." Participant 37 then quoted Blanche again: "Some things are not forgivable. Deliberate cruelty is not forgivable. It is the most unforgivable thing in my opinion, and the one thing in which I have never, ever been guilty." They saw truth and logic in these words: "I remember using that quote during my years at college as a 'check' for myself in times I felt I was being overly cruel or emotionally dangerous towards those in my circle. Though I'll admit my own failings in not always being capable of living by it."

Ongoing and New Reverberations

Many participants wrote about the ongoing reverberations of films that have morphed in their own minds into greater objects, growing dynamically as living beings do. For example, participant 21 wrote about repeatedly rewatching *Persona* (1960): "Even now with a PhD in film studies, the opening remains one of the most impactful cinematic moments for me. I think it forced me to deconstruct my personal response to the viewing and why I was so enthralled by the film. I oscillate between hating the opening, finding it incredibly frustrating, and finding it immensely poetic. The silence in the film makes me deeply uncomfortable at times but then I find myself returning to it. It remains a mystery I don't fully have figured out. . . . Maybe it helped me see how much I love film. Despite something causing such visceral responses, I find it so powerful that I need to engage [with] it. How can art do that to the human body?"

On the day of the Capitol riots (January 6, 2021), participant 11 found a sense of vital social reconnection in the ongoing, inconclusive reverberations of *Bamboozled*. They explained this as a self-identified African American: "*Bamboozled* came to me at the right time. I watched it the day after the Capitol riots happened. The day the riots were happening, I was working

in an area far away from my own. It was different in a lot of ways. Confederate flags waved off flag poles in front lawns. I lost count of how many 'Make America Great Again' signs I had spotted in windows just that day. I do remember the 'Fuck Biden' one, though. As the world watched what happened in the Capitol, I continued doing my job, unaware of the senseless acts that were happening far away. I remember people looking at me longer than I was used to. Neighbors talking in hushed tones in front of their houses. As soon as they saw me, they either stopped talking altogether, or went inside. If I waved or said "hello" I was not given a reply. Not even a head nod. I later saw a TV through a client's window as they were watching CNN. It suddenly made a bit more sense. I returned home later that night. [Watching] *Bamboozled*, I was reminded how powerful the genre of satire can be. America's relationship with African Americans has only become more bitter and bloody lately, and ... *Bamboozled* pulled me in different directions from start to finish. Even now, I cannot easily describe how that movie makes me feel."

For participant 6, *Jaws* (1975) was also worth re-understanding in the urgent present: "I remember watching *Jaws* originally and thinking that the mayor keeping the beach open seemed a little forced or contrived for drama. However, in the past year with COVID-19 spreading through the country and seeing essentially the same things happen as far as prioritizing business and the economy over individuals' health and lives, it doesn't seem so farfetched now. Within the first month of the outbreak my hometown announced it was shutting down beaches and not letting anyone rent hotels, but by the end of the month it completely reversed that decision. It puts the plot of the film and motivations of characters into a different perspective when you see a similar set of events happening in real time around you. It actually made the film more believable and the character's motivations more dire and understandable."

Personal Growth and Sense of Self

Some participants focused on a particular aspect of personal growth through cinema—that is, an experience of coming to new realizations about the self and/or others and learning about perspectives not already ingrained but consciously learned. For instance, participant 6 wrote of revisiting a film they studied in class that has helped them examine their own motivations since then: "When I rewatched *The Searchers* (1956) it struck me how dark John

Wayne's character can be at times. He's on this mission to rescue his niece, but at a certain point his journey becomes more about his dogged dead-eyed determination to complete the task rather than actually saving the girl. It's made me think about times in my own life that I'm striving for something and made me reexamine *what* I am actually trying to do and *why* I'm trying to do it. What is my real motivation to complete this task?" (emphasis in original). For participant 25, a new self-realization happened in class: *Rust and Bone* (2012) "related to my life . . . I was developing feelings for one of my friends, and while watching this film I came to the realization that I was in love with him. After we had the screening and I was driving home, I was smiling, and I also got teary-eyed because I had never been truly in love before. The love the two main characters have for one another showed how love can help them overcome the worst moments of their lives. Their love leads to triumph and recovery. The way that love was portrayed in this film helped me to come to the realization that I was in love myself and will always hold a special place in my heart and matter deeply to me."

Some participants gained a more confident sense of self as part of their personal growth. Participant 6 remembered that "in *Moonlight*, Mahershala Ali's character says, 'At some point, you gotta decide for yourself who you gonna be. Can't let nobody make that decision for you.' . . . It's a thing I consider whenever someone is trying to put me into a category or box, like an employer or even an acquaintance. They're trying to broad-brush me as one thing, when that's not their choice to do, and it's up to me to stand up and show who I am and not let them sweep me into some category where I don't fit." Participant 11 was also deeply affected by *Moonlight*: "Chiron's formation into the man he becomes (a reflection of the man who showed him that love was real and obtainable) resonates with me because he thinks himself unworthy of love. He doesn't accept the things that could make him whole, and as a result, he lives a numb, fragmented life. I think the film is superb in showing how life can play out without acceptance, and how the aches of longing and loving reverberate and flow through time."

Professional Development

Several participants reflected on classroom experiences that had direct influence on their professional development. For instance, participant 1 argued that "*Cahiers du Cinema* was [a] textbook and not just a magazine exploring

editing, narrative, & visual style," and they apply "French New Wave terms such as *auteur, auteur theory, mise-en-scène*, and *la camera stylo*" to "producing media content." Participant 34 used a film example to explain how they view the work they are doing and where they want to go: "*Parasite* (2019) was probably the most significant film I've seen recently and as an adult participating in capitalism it certainly refreshed some thoughts about how money flows and sustains us and how it degrades and separates us—how its relationship to survival changes us." Participant 34 sees their current work "as a freelance videographer and photographer making advertising content I don't care very much about" as "a steppingstone toward creating narrative or documentary content" through which they can become more than a "parasite on the capitalist system." They took lessons from the film to offset the hold of their immediate present: "In professional life, be careful of how deeply you are entangling yourself with a particular client or source of income. Be mindful of how you view the people that provide your income and how that affects how you view yourself. It won't end well if you lose sight of boundaries."

Participant 26 has been using films as an English teacher in Anne Arundel County in Maryland after becoming "much more aware of the racial and economic disparities that plague a significant portion of our student population." They have "sought out films and stories that have reflected not just what my students are experiencing, but also reflect the growing recognition of these situations and how we can effectively combat them." Participant 9 mentioned the significance of *Arrival* for teaching a high school grammar class: they begin with the protagonist's rundown of what scientists will need to teach the Heptapods "in order to do something as simple as ask 'why are you here?' ... because it points out just how much linguistic knowledge we take for granted in our day-to-day interactions." Participant 23 mentioned adding an international film to the library of the nonprofit they work for: *Whale Rider*. They chose this film because the (unidentified) nonprofit "seeks to empower adolescent girls with skills and experiences to build self-esteem, self-respect, and self-reliance. Because I found this film and its main heroine so powerful, I love exposing young girls to it."

Multiple Levels of Meaning

Many participants emphasized *multiple* forms of life-affirmation through cinema. For instance, participant 16 wrote about *Arrival* as a catalyst for

personal growth (a new sense of self and sense of connections to others), and greater perspective on both political and metaphysical levels. *Arrival*'s "ending touched me in a way that my heart needed at the time, moving me to tears which I desperately needed to get out of my system. When I left the classroom that afternoon, I felt cleansed, and more like 'myself' than I had in quite some time.... On another note, *Arrival*—a movie about listening to others and finding resolution through that—came out not long after Trump's election. At a time when the world felt so divided, a film about it managing to accomplish some level of unity had even more value attached to it. But more than anything, it was the unspeakably poignant, beautiful, and bittersweet ending in which Amy Adams's character decides to go through with having a baby despite being told in advance of the enormous pain it will cause her later on. Love and subsequently life—however fleeting they may be in some cases—are worth whatever sorrows they may cause when they are gone."

Participant 11 zeroed in on another specific film—*The Remains of the Day* (1993)—in terms of identification, personal growth, and compassion. They wrote with arresting honesty and humility: "Love can be a difficult thing to articulate, but when it is real, it demands an answer. It isn't something to be buried or reduced, but, speaking from experience, it often is when a person is convinced that it will not solve anything and certain obligations must take precedence. Watching Stevens and Kenton's relationship is a painful experience. The connection they have is chocked by duty and the inability to communicate honestly and openly. I have seen this in my own life. Still working on fixing it."

Participant 19 felt a surprising level of connection to *Adaptation* (2002), which they wrote about in terms of personal growth (especially sense of self), identification, and mental health: "The [main] characters, Charlie and Donald Kaufman (both played by Nicolas Cage), definitely connect with the on-going themes of self-exploration, existential crises, and loneliness throughout my life. I think both characters illuminate how opposing characteristics of the self can exist simultaneously and transform at an unpredictable rate throughout one's life. Charlie ... overanalyzes every single action (or lack thereof), ruins any chance at intimacy, and sweats profusely when nervous. Donald, on the other hand, is charming, confident, and a risk-taker; he can flirt, laugh, separate external perceptions from his own identity, and finishes projects with ease. At the end of the film, Donald's literal death appears to represent the figurative death of Charlie's seemingly one-dimensional self. Instead of a self solely thought to exist externally within

others and out of reach, Charlie comes face-to-face and merges with what he desired to be. As someone who also struggles with anxiously overthinking, getting lost in self-imposed limits, incessant awkwardness, and being too concerned with external perceptions and societal expectations, *Adaptation* taught me how important self-awareness is. It helped me grapple with questions such as: Why am I assuming how others perceive me? Does it even matter how others perceive me? Why do I think I'm ugly, fat, or unlovable? Why do I need validation or recognition from others? In what ways am I projecting my insecurities? How can I reflect without spiraling into an existential crisis and sustaining negative beliefs? Why do I simultaneously fear and crave intimacy? What traits do I love in others that I also possess, but sometimes refuse to see in myself?"

Participant 23 wrote about the ongoing and open-ended reverberations of *The Searchers*, as it has inspired their compassion and personal growth (especially connections to others). When studying the film, they were exploring "how the understanding of gender roles is linked to history, representation, and is thus understood differently between generations." They "drew clear parallels between the main character Ethan and the men—almost all of them war veterans—in my heavily patriarchal family. This was significant to me because I saw the gruff, violent, 'loner' mentality as no longer isolated to the men in my family and their own shortcomings, but as part of a larger cultural tapestry woven over time. I suppose this made space for greater awareness and compassion."

Participant 31 explained their learning from the park scene from *Good Will Hunting* (1997) with equal intensity: it is "an emotional dialogue that captures so much—how everyone has their own set of experiences and difficulties that we can't understand and how much we grow as people from one moment to the next. I used this scene when teaching a twelfth grade literature class years ago. The film also has several songs by Elliott Smith that I have listened to regularly for the past six or seven years. In fact, I got married earlier this year walking down the aisle to one of his songs—an artist I may not have discovered without this film." This participant therefore feels the ongoing reverberations of the film in an unusually embodied way, along with revealing their heightened capacities for hearing, compassion, identification, professional development, and emotionality.

Participant 21 looked back on studying *The Piano* in terms of a new sense of self, coping, identification, and mental health. Their reflections on the film show that it had an immediate impact along with *growing in retrospective*

significance for them: "The moment [Ada] is pulled into the ocean seemed to represent something inside of me that I didn't realize I needed to witness. The choice of letting go of something that defines you, something that is knowable (even if tied to trauma), or letting it swallow you whole (even if it means your destruction), seemed to speak to my own choices at the time. During that course, I was struggling with what it meant to be a person who was not defined solely by trauma. I could not visualize who I was without depression, trauma, and I truly feared that if I received help to be mentally well that I would lose a creative spark. In many ways my depression was like my piano. It made me feel like I could connect to the world in specific ways. Trauma was knowable, [and] I didn't know if I was ready to let that go for the unknowns of who I could be. Who was Ada without that piano? That moment of Ada letting herself be dragged into the water was so shocking because it felt so directed at my sense of self. I have since surfaced and found a deeper sense of self."

Participant 19 relayed personal growth through studying several films: "*Carol* [2015], *Moonlight,* and *Call Me by Your Name* related to my life outside the classroom . . . I was attempting to be open and exploratory in relation to my sexuality, so watching these films while analyzing other queer films and texts influenced the way I discovered parts of myself." They then wrote of identification and emotionality in relation to *Call Me By Your Name* especially: "The father-son scene towards the end . . . had the biggest impact on me, especially the lines: 'We rip out so much of ourselves to be cured of things faster than we should that we go bankrupt by the age of thirty and have less to offer each time we start with someone new. But to feel nothing, so as not to feel anything at all . . . what a waste.' I started crying once the scene began and I didn't stop crying until an hour later. This scene was so important to me because it highlighted parts of myself that needed to be healed, parts that I [had] accepted as a permanent emotional state and [had] refused to dissect."

Participant 13 remembers *Amour* in terms of identification, coping, and greater perspective. They studied the film "when my grandmother was in the advanced stages of Alzheimer's, and it was a hard film to watch at the time but a beautiful one. I distinctly remember a scene in the movie where Anne is looking through a photo album, and she says, 'it's beautiful,' and Georges asks, 'What,' to which Anne replied, 'Life. So long.' I was so touched by that line that I cried throughout the rest of the film and into the afternoon after class. I think it had such a profound impact on me because I was

experiencing some guilt. After all, I was away from home. I was the main help my mother received with my grandmother's caretaking, and the way Anne would act reminded me a lot of her, but that scene really made me reflect on how growing older is a gift and a beautiful experience. Even though my grandmother had her faults, she lived a long life filled with a myriad of experiences, much like Anne."

Participant 37 has held on to the experience of studying *Life Is Beautiful* ten years postcollege for its lessons in coping, emotionality, and greater perspective. They remember bursting into tears in class all those years ago, but without regret: "What cracked me up and made me bawl my eyes out is the idea that a father could provide such a necessary wall of kindness to his son in the darkest of times, and provide beauty where there was great ugliness. . . . In a postpandemic world, I feel like coming by these moments has become a real escape for me. To be teetering on the edge of despair, especially when there is no foreseeable future ahead of us, and then *BOOM!* something wonderful comes of it, it just crumbles me." They added, "I didn't know if I wanted kids when I was in my twenties. I started wanting kids in my early thirties. Every time I think about wanting a child, I think of Guido in *Life is Beautiful*, and what he did for his son." Though this participant argued that "we've all witnessed more than ever in the last year [that] the world can become an exponentially more terrifying place, practically overnight. It needs to be filled with more good people, and more beauty. No matter how dark the world gets, I want to be able to give that kind of beauty to my own child someday. I want them to know that they, too, can do the same for others."

Participant 16 also felt "strong ties to *Life is Beautiful*," which they studied about a year after their mother had died: "I was very affected by the relationship the father and son had in *Life Is Beautiful*, as my mother and I became very close before her passing. The way that the father put his own worries to the side for the benefit of his son's happiness reminded me very much of my mother's attitude while receiving her cancer treatments. It definitely matters to me to have a personal connection to the films I watch and/or discuss, as the films I remember most in life are ones I can relate to." Therefore, participant 16 self-consciously stressed the value of their identification with a film's characters for coping with a major lifeshock.

Unlike others, participant 6 placed most emphasis on a film that opened up new possibilities of identification and compassion beyond their personal frames of reference: *Paris Is Burning* "open[ed] my eyes to the underground world of drag shows and the gay and trans communities in New York City in

the 1980s. It was simply a world I never knew existed and was very far from my own. The way the film humanized its subjects, really focusing on their personal hopes and dreams and how these simple balls can actually mean so much, creating surrogate families and communities for these individuals often shunned from mainstream society, was very impactful. Also, seeing the discrimination and danger many of these individuals face was very poignant. . . . It really highlighted the importance of having groups, understanding, and safe spaces in life and underscored my own search for a community and forged family when I left my hometown shortly after college."

Participant 23 also wrote about the ongoing reverberations of *Paris Is Burning* in relation to compassion, as well as personal growth and professional development: it was "my first exposure to LGBTQ+ culture in a nonfictionalized context. I never had any understanding of the challenges, discrimination, and violence faced by gay men and trans women. *Paris is Burning* was truly eye-opening and heartbreaking in that respect, and I know that becoming an ally to the LGBTQIA community became a priority to me after studying the film. I went on to train as a Safe Spaces trainer [to] educate groups on sensitivity [toward] and inclusivity of LGBTQIA individuals. I still think about the film often and particularly one of the central figures who was tragically raped and murdered during the making of the film."

I close with a final moving testimony to the rejuvenating reverberations of a film. Participant 21 wrote about *The Red Balloon* in terms of emotionality, identification, coping, and personal growth through connections to others. They first saw *The Red Balloon* while they were still learning how a film can speak without words, and communicate "emotions like hope, fear, despair, and joy [that] defy language. . . . The relatively little dialogue and use of music make me feel those emotions rather than just think of them. I have returned to the film from time to time when I want to watch something that fills my soul." Participant 21 then explained what the film did for them during a uniquely profound lifeshock: "I remember the emotional shock and numbness that followed [my] hearing about the Pulse Nightclub shooting [2016]. A few nights afterwards, I curled up in bed and watched a YouTube version of *The Red Balloon*. I just needed something that didn't require thinking, something that felt safe, and something that I knew how it ended. I don't think the ending has ever made me cry so much [see Figure 5.1]. A few nights later, I was performing at a benefit show for Pulse in which one performer released balloons into the club. The power of a collective, of hope, and of defiant, radical joy will always be associated in my mind and heart to *The Red Balloon*."

Figure 5.1 The final shot of *The Red Balloon*: an image of transcendent joy as the boy is miraculously lifted away from the bullies who might harm him.

Conclusion

I celebrate all that cinema has given my survey participants. The responses of this chapter collectively affirm that films can reach across distant times and places to find inexhaustible new meanings with individual audioviewers. The participants explain how films teach them about hearing the inaudible and noticing the unseen, make them feel acknowledged, transport them while they stay in the same place, heal parts of them they did not know needed attention, remind them that others have suffered as they do, help them truthfully confront what makes them human, reveal beauties that can be bigger than tragedies, and connect them to people they will never meet in ways that are lastingly life-changing.

6

Life After Life

Rehearing *Call Me By Your Name* and *Portrait of a Lady on Fire*

> Art teaches us about the world, the human condition, and human experience by digging deep into our pain and then transcending it . . . I think that when we connect with art on a profound level, it can transform us in the same way that human relationships can.
>
> —Danijela Kulezic-Wilson[1]

As the last chapter shows, many of my former students have internalized the transformative power of films that they studied at college. Some of the survey participants also mentioned postcollege film experiences that have helped them grow and deal with lifeshocks. Before turning the microphone back around to give my final analyses, I dwell on how these survey participants have connected their ongoing lives to cinema. For example, participant 18 wrote of feeling "absolute joy" in identifying with the characters having an unplanned child in *Away We Go* (2009). Participant 18 wrote of *Inside Out* (2015) as "a terrific way to help get my two sons to speak about what struggles they have through life." Participant 37 found consolation and hope in watching James Bond (Daniel Craig) drink alcohol without losing control in *Casino Royale* (2006). As the child of an alcoholic father, they were "terrified" of being destructive like him, but "seeing an iconic hero do something as simple as drink a martini in a bar gave me the inspiration and confidence to pursue my own genetic freedom and not feel chained to the sins of my father."

Other participants described using cinema to be more resilient after college, though without necessarily finding direct correlations between characters' lives and their own. Participant 28 wrote of repeatedly listening to the song "To Be Human" from the *Wonder Woman* (2017) soundtrack to

get through their first half marathon as well as the sadness of their grandmother passing away. Participant 13 wrote movingly of the silence that dominates the end of *Sound of Metal* (2019), a film centered on the protagonist Ruben's struggle with his own deafness: Ruben's finally "being able to sit in public silently is a testament to [his] self-acceptance. As I get older, self-acceptance is something I both strive for and struggle to achieve. Though my circumstances are not like Ruben's, I think a large part of being comfortable with oneself is sitting in those silences and being content with hearing the silence and listening to what the silence has to say." Participant 18 faced parts of their past by replaying the soundtrack of *The Homesman* (2014): "I was actually homeless around the time this movie came out (I watched it years after it came out), and [the soundtrack] makes me think of those moments of having no one to turn to." After referring to themself as a "closeted bisexual," participant 4 wrote of their empowerment through the song "Show Yourself" from *Frozen II* (2019): "I relate [to] and empathize with [Elsa] in a manner that almost resembles that of a guardian angel. So, this sequence—with its quiet melody, like 'Let It Go' in the first film—gradually becoming more excited and triumphant as it goes along, was emotionally exhilarating for me in a way that made me want to experience it multiple times in the theater. It almost felt religious." Participant 23 wrote of *Room* (2015) being more surprisingly empowering: "Though I've never been kidnapped and trapped in a room, I see the main character's physical entrapment as being similar to (or a metaphor for) being trapped in clinical depression, which I do have experience with. Though every day can feel bleak, hopeless, and inconsequential, it is so important to keep going and not give up on living."

The huge metaphysical scope of *Soul* (2020) dominated several survey responses. Participant 42 wrote of refinding parts of themself with the movie: "Having a third baby girl, living during the time of a pandemic, while also maintaining a high level of work in higher education left me asking WHO I am versus what my TITLE says about me. In *Soul*, the main character [Joe] just waited for his 'big shot' when in reality he was already living it—he was searching for his passion and trying to help someone else find theirs, but the passion was in the music, in the connections with others, and in the everyday 'just living.' It made me refocus on the creative part of me that has gotten buried in the just getting through day-to-day. It also reminded me that life truly is short and that second chances do not exist—I know this as a cancer survivor, but get overwhelmed with the different roles I play." Parallel to this, participant 12 wrote that "*Soul* makes you rethink about life and

all the little things that [have] happened that someone can easily overlook. I think especially with the year we had due to COVID-19, everyone needs time for themselves to do what makes them feel happy." Similarly, participant 35 argued for the value of "Joe's journey to understanding that life isn't necessarily about finding one's purpose, but about living the best life one can and enjoying the wonderful moments life provides." This participant focused on the final sequence, with Joe "sitting at the piano in his apartment, having just come from playing his dream gig and feeling unsatisfied, even though he now has what he's always wanted. He has an epiphany about following his dreams and finding his purpose; being successful isn't what is going to make one's life fulfilling. The people, the memories, and the day-to-day joys of life are what make it full and worth living. A montage starts, showing moments in Joe's life that were seemingly mundane and normal, but [which] now take on a whole new meaning. There is no dialogue in this montage, only score and ambient sound. I've had both the score and the scene on repeat several times since first seeing *Soul*.... Whenever I feel like I've lost my way or have no purpose in life, I remember this scene, and it reminds me to live each day to its fullest and not get so caught up in what I think my life should look like."

Participant 27 found equally lifeshocking perspective in the final sequence of a very different film: *Minari* (2020). They wrote, "Grandma is looking at her sleeping family, and we see all the pain and guilt that she feels on her face, and this gentle instrumental music begins playing. Then the movie cuts to shots of the sun rising and the sun shining on the field outside with the music still playing, slowly rising in intensity. It's all sutured and edited together so seamlessly, and it felt like the film was telling me that horrible mistakes can change us forever, but everything can be rebirthed and regrown. We see Grandma and her pain, but we also see the world outside continuing. Everything is not ruined forever because of the fire Grandma started. Because the fire brings the family together, I felt like the film ends on a hopeful note by saying that, sometimes, burning everything down and starting over again is necessary." This participant's interpretation of *Minari* has made me understand its implications more fully than I could on my first audioviewing. With this in mind as a representative example, my survey participants' responses to films have humbled me. I see how much my former students read films independently of me, and my comprehension of these films expands through what they have taught me to perceive. My life as a professor feels bigger because of this role reversal. I also notice that many of my survey participants have applied principles of HeartMath: whether knowingly or not, they have

put the heart-led principles I taught them into practice on their own terms. In reviewing the surveys, I see the participants' heart intelligence in the ways they have self-reflexively embraced certain characters, stories, and truths.

The survey responses have emboldened me to examine how cinema has changed my own life more thoroughly. I hope and trust that my explanation of how cinema has helped me personally will be both relatable and transferable to anyone reading this chapter. Since I began this book, time has brought some remarkable changes—from the earliest days of the COVID-19 pandemic in America to the widespread devastation associated with the Delta variant of summer 2021; from the hopeful Black Lives Matter marches of summer 2020 to the terrifying riots at the Capitol on January 6, 2021; and from President Trump's presidential term ending to the inauguration of President Biden. I have shifted from teaching my students entirely via Zoom to cautiously re-entering the classroom, and from keeping my children close at home to risking their re-entry into society with masks. Through all these changes, cinema has been my anchor in life, and never more necessarily so than when my best friend, Danijela Kulezic-Wilson, died on April 15, 2021. Two weeks before she died, Danijela read a draft of the fifth chapter of this book. With that chapter, I thought about many of our conversations as I analyzed *Life of Pi*, *Ikiru*, and *A Star is Born*. I was adapting to the truth of her limited time, making meaning from that reality, and asserting my continued bond to her before it was too late for her to bear witness. After Danijela's death, I needed those films and some others for help with my grief. *Call Me By Your Name* (2017) and *Portrait of a Lady on Fire* (2019) taught me about managing my loss most immediately. Both films build toward climactic long takes that call for my heart intelligence, along with allowing time for the characters and me to process lifeshocks with compassionate patience. My survey participants' responses to *Soul* as a re-evaluation of the details that matter, and of *Minari* as a revelation of beauty that can arise from devastation, resonate with my final analyses of these two film endings.

Since Danijela died, time has moved differently for me—sometimes too quickly, sometimes achingly slowly. When time moves slowly, it feels like a useless expense of energy—like the day after Danijela died, when I put one sock on and then stopped because I lacked the energy to put on the other sock. I stared at that other sock and felt almost angry that I had to put it on after the effort of putting on the first one. I caught myself in this moment of suspended action and felt that it had no purpose. Since that day, I have learned that many psychologists have researched what emotion does to our

sense of time. For instance, Sylvie Droit-Volet and Sandrine Gil explain that our internal clock is "excellent" at adapting as follows:

> Although humans are able to accurately estimate time as if they possess a specific mechanism that allows them to measure time (i.e. an internal clock), their representations of time are easily distorted by the context. Indeed, our sense of time depends on intrinsic context, such as the emotional state, and on extrinsic context, such as the rhythm of others' activity.... Thus, there is no unique, homogeneous time but instead multiple experiences of time. Our subjective temporal distortions directly reflect the way our brain and body adapt to these multiple time scales.[2]

Despite there being a general consensus about the subjectivity with which we perceive time, grief is underrepresented in the psychological research about this. Similarly, while there are many studies of so-called slow cinema from aesthetic and cultural points-of-view,[3] cinema scholars have not yet dwelt on the rhythms of films that can teach us about the importance of slowing down to heal ourselves. The two films I dwell on here—*Call Me By Your Name* and *Portrait of a Lady on Fire*—are acts of kindness toward the protagonists who are working out the grief of their love affairs having ended. The protagonists need new forms of time to accommodate their excesses of feeling. By extension, I receive these films as timely gifts because they encourage me to slow down with more compassion for myself.

The endings of *Call Me By Your Name* and *Portrait of a Lady on Fire* are remarkably similar in impact. For me, they are bittersweet forms of gratifying fantasy because they both slow down time *yet retain its purposefulness*. They represent how much use I can make of time if I am conscious of the meaning in every moment and with no wasted expense of energy—in other words, they handle grief very differently from me being useless with my sock. These endings also teach me how I might experience time and the healing work of my own heart if I slowed down for long enough to perceive everything with patient kindness for myself. Both films use music to achieve their remarkable transformative power, along with sustained long takes. The big narrative actions of both films have ended before these long takes. This allows for psychologically weighted happenings to occur within the endings and within me without any distracting action, and as if in real time. I feel the films trust me to perceive the fullness of their final takes becomes I am in no rush to absorb what matters in either case. Both films assume that I am empathetically

engaged enough that I will stay the course with their protagonists, and that I will willingly perceive and absorb the moment-to-moment changes happening within these protagonists in their last scenes. My goal here is to show that the fundamental concepts of this book—lifeshocks, HeartMath, levels of listening, contemporary understandings of grief and healing, and the integration of personal and professional identity—all fuse in these culminating examples.

I must first explain the extraordinary pull of these film endings by referring back to the methods of HeartMath as explained by Doc Childre and Howard Martin in *The Heartmath Solution*.[4] Recall that Childre and Martin explain the significance of our hearts as they operate with a level of consciousness that is separate from the brain and that affects every part of us on a cellular level. Recall too the power of entrainment whereby the heart pulls the entire body into its rhythms, and the freeze-frame technique that helps us harness this power. Like the Chinese restaurant scene in *A Beautiful Day in the Neighborhood*, the final scenes from *Call Me By Your Name* and *Portrait of a Lady on Fire* give time for freeze-framing in five steps, much as Childre and Martin describe them: recognizing a stress that is dominating one's thoughts (step 1); taking a break by focusing on "breathing through [the] heart" for ten seconds or more (step 2); recalling a positive experience and attempting to relive it in embodied detail (step 3); turning back to the stressful feeling and reconsidering how to address it (step 4); and listening to what the heart answers (step 5).[5]

In the final take of *Call Me By Your Name*, Elio is sitting in front of a fire after he's just learned that his lover, Oliver, is newly engaged to be married to a woman. Sufjan Stevens's song "Visions of Gideon" plays in its entirety while the camera fixes on Elio's face. The film quotes the song in an earlier scene: the guitar-led introduction plays when Elio and Oliver first meet in secret for their first night together (21.17–1.22.21), when Elio acknowledges that he is "nervous." The absence of a musical voice in that earlier scene is "answered" by the presence of Stevens's voice in the last long take, as if the singer lovingly joins in when Elio is unable to speak anymore. I witness the pain Elio dives into (step 1), and then I notice him slow his own breathing (step 2). Eventually, after nearly two minutes of reflection, Elio smiles slightly, evidently recalling the best memories he had with Oliver that he doesn't have to lose (see Figure 6.1). Some of Stevens's repeated lyrics, "for the love, the laughter, I flew up to your arms," remind me of specific scenes where Elio leapt into Oliver's embrace (steps 3 and 4). After Elio smiles, just before the

Figure 6.1 After controlling his own breathing and reliving his memories with Oliver, Elio smiles.

film ends, he gains enough control over himself to hear his mother gently calling him. Then, he looks at the camera, as if sharing a moment of new peace with me before turning back into his own fictional space (step 5). Elio's mother calling him is an indirect response to his pain, bringing him back into his own life at the everyday rhythm. But through his final look, I feel a new connection with him that exceeds his onscreen world or immediate environment, and as if he could peek into my life beyond his own diegesis. As I have been empathetically engaged with Elio, I am self-aware about experiencing time as he does in this final take. I feel his pain as it extends time, but I also perceive how full the time is because the details of his changing face catch my attention. When he looks back at me, I feel him acknowledging my witnessing presence.

As "Visions of Gideon" plays, I recall several of Elio's best scenes with Oliver, thus "filling in" the meanings of his changing expressions as the memories seem to play across his face. This is a doubly loaded experience because I define *Call Me By Your Name* as a pre–AIDS crisis love story. As Spencer Kornhabor argues, subtle harbingers of death, such as the fly that appears on Elio's shoulder, as well as signs of bodily injury earlier in the film (Elio's bleeding nose, and Oliver's infected wound) gesture to the ways that so many gay bodies fell apart in the time period just after this story is set (1983).[6] The question repeatedly sung by Stevens, "Is it a video?" reverberates eerily in

this context, as if the singer is haunted by an electronic relic of a time just before the AIDS crisis broke out. Nevertheless, with this final scene I also have the sensation of holding the time with Elio, grounded in the grace of Steven's music. Timothée Chalamet was listening to the song through earbuds while he performed this scene,[7] though it is more amplified than it would sound from his/Elio's point of audition. As I live the song with him, the diegetic/nondiegetic divide breaks down between us.

The song's allusion to the biblical figure Gideon is about a triumph in battling against the odds, and one that is both divinely ordained and achieved by sound: Gideon fought with an army that was too small but God empowered them to make so much noise that their enemy believed them to be bigger than they were. Therefore, Gideon's army won because their noise was powerful. This connects with the idea of surprising triumph in *Call Me By Your Name* that matters so much to Elio's father. Despite Oliver's leaving, the love affair ending, and Elio perhaps wishing he could feel nothing about it, his father lovingly urges him not to wish away the pain, especially as a man who I deduce has remained in the closet and who now witnesses the love his son has been able to feel for another man. Elio's father says, "Our hearts and our bodies are given to us only once and before you know it your heart's worn out," and, "Right now there's sorrow, pain, don't kill it, and with it the joy you felt."

I believe that we are meant to notice and embrace the value of what Elio feels, as his father urges, enough to notice his freeze-frame technique of confronting pain, breathing differently, remembering joy, and finally listening to what his heart answers. Since his entire experience is so embodied, the film compels me to experience a physical and temporal reality of mimicry that often goes with hand-in-hand with empathy too. As Droit-Volet and Gil explain, a person can feel time differently based on the emotion *of a face* they are looking at. More specifically, time slows down if a person is empathetically engaged in another person's distress.[8]

The style of Stevens's song feeds my empathetic interest. The airy sound of the piano and the simplicity of the ostinato is soft and gentle toward Elio and to me. The reverberations position some of Stevens's vocal lines as if far away, along with the mix holding his lead line in the foreground. This suggests to me that the memories of Oliver feel both near and far to Elio, within and beyond reach, internalized while slipping away. In the overlapping lines of "Visions of Gideon" and "Is it a video?" at the song's end, ancient history and 1980s technology fuse harmoniously. Stevens's interweaving lines position

Elio in the broad scheme that is the cyclical patterns of life and unending flux, as opposed to the restrictions of temporal linearity or stillness. This gives the film's end a grand contour and provides a broader perspective that might help Elio step outside himself. Here, time does not simply slow down enough for me to fully absorb the song through a long take—time actually seems to *happen differently* because of the song's structure. The song compresses a lot of story and implication into a few minutes, communicating the scale of the whole film as well as the present moment and the imagined future that goes beyond the plot.

Time is forever changed for Elio. Along with trusting I have the patience to live with Elio's grief, the film inspires me to extend that patience to myself. The final take also inspires me to apply multiple levels of listening: downloading (rehearing the song I already know, at least partially), factual (recognizing that the song sounds differently now, as I hear its entirety while watching Elio's face), empathic (listening openheartedly, along with Elio and from his point of audition), and generative (realizing the significance of the wiser person Elio is becoming before me as he absorbs the song, while rethinking what I can withstand myself). Elio's lifeshock, my HeartMath in alignment with him, and my capacity to listen on multiple levels are folded together in this singular experience of transformative time.

I now turn to my second, closing example for this culminating chapter, one that also offers me lifeshocking, freeze-framing, and active listening opportunities. *Portrait of a Lady on Fire* is another love story, this time between two women living in Brittany in the eighteenth century, one of whom (Héloïse) is being married off by her mother to a wealthy man. The other protagonist is Marianne, the artist commissioned to paint Héloïse's portrait for her soon-to-be-husband. After an intense process of negotiations between the two women, and Héloïse's multiple sittings for that portrait, the two women fall in love.

Marianne paints Héloïse's face with different expressions—from a slight and ambiguous smile to a more serious expression that might be close to anger, to a nuanced expression in between. She is persistently trying to capture moments of Héloïse's fleeting states. The importance of Marianne's seizing such moments while everything is in motion is vital to the film. Having limited time is the big issue for these lovers and this shapes the overall story: the main characters repeatedly refer to Marianne's deadline to paint the portrait, the lovers have limited time together after having first revealed their mutual love to each other, and time runs out too suddenly before

they must say a final goodbye. The film further stresses time passing through many sudden cuts from day to night and back again.

Director Céline Sciamma honors her lovers by slowing the editing for the last time Marianne sees Héloïse. They are both at a concert performance, though seated separately, after having been apart from a considerable period of unspecified time. They are listening to the presto movement of "Summer" from Vivaldi's *Four Seasons*. The music moves very rapidly with the programmatic intention of communicating a sudden storm. Vivaldi drew inspiration from sonnets that may have been written by him, and the poetic lines for the presto refer to the terror of a shepherd anticipating the storm:

> Alas, how just are his fears,
> Thunder and lightening fill the Heavens, and the hail
> Slices the tops of the corn and other grain.[9]

Earlier in the film, Marianne plays part of "Summer" for Héloïse. She uses a harpsichord that is shrouded with a sheet, as if resuscitating a fragment of its musical life. She is attempting to demonstrate the impact of some music that comes from outside the church, the likes of which Héloïse has never heard before. The music signifies the possibility of the women being liberated from what suffocates them, despite being just a fragment that Marianne plays upon a mostly hidden instrument. The film's return to this music in all its glory, filling a concert hall in the final long take, suggests that Héloïse is more fully liberated by the end—even if that liberation can only happen during the performance. While this performance is obviously public, the film withholds a view of the musicians. *Portrait of a Lady on Fire* is not interested in the musicians playing so much as the impact they have, maintaining attention on Héloïse as she listens to them. The camera's steady gaze upon Héloïse is Marianne's point of view from across the concert hall and communicates her fascination with the perceivable change within Héloïse, albeit from a distance. While Héloïse is oblivious to Marianne's gaze during the performance, the camera's slow zoom-in on her suggests that Marianne moves closer to her on a metaphysical level while absorbing every detail of her physical reactions that signify her profound and heart-led change from within.

Similar to Elio's changing expression through his final take, Héloïse's embodied reaction to the music matches the freeze-frame technique. First, she shows distress. Then, she makes a visible effort to control her breathing while she closes her eyes, presumably remembering Marianne. Her

intensifying agitation is obvious as her inhalations of air become increasingly rapid, but she soon regains control by slowing her breathing down. After some time, she gives a smile that suggests her joy in revisiting the best and most glorious memories with Marianne, and then she exhales more deeply, indicating her new, heart-led awareness (see Figure 6.2). She does not see Marianne, and she does not look at the camera as Elio did. Because of this, I feel the film positions me as an unseen onlooker instead of a potential interlocutor. I observe Héloïse so that I might learn from her process of coming to terms with grief, while knowing that her changing state is too private to accommodate my presence. I am every bit as privileged to observe her as I was to watch Watanabe swinging and singing on his last night of life. Like both *Ikiru* and *Call Me By Your Name*, the film is teaching me about how to hold on to the best memories along with letting go. The final take of *Portrait of a Lady on Fire* invites me to hold onto multiple levels of listening too: downloading (rehearing the well-known "Summer"), factual listening (recognizing that the song sounds differently, as I now hear it being "about" Marianne and Héloïse), empathic (listening with Héloïse, and as Marianne witnesses her absorbing the music), and generative (noticing Héloïse's rising ability to absorb and control her own feelings in relation to the music, which reminds me that I can be similarly brave).

Figure 6.2 After controlling her own breathing and reliving her memories with Marianne, Héloïse smiles.

This brings me back the story of the sock and me. What if, instead of being frustrated and annoyed by not being able to put on the second sock right away, I had instead put on a song that reminded me of Danijela and her love of Thom Yorke: Radiohead's "Planet Telex"? What if I had given myself a full four minutes and eighteen seconds to listen to that song and practice the freeze-frame technique? I would have allowed myself to feel the distress of not being able to hear her, and heard the lyrics match my incapacity to just get on with the day: "You can force it but it will not come," and "You can crush it but it's always near," and "everything is broken/Everyone is broken." I might have then been able to slow my breathing to dwell on my memories with Danijela. I might have weighed the emotional heaviness of the song against the absurdity of struggling to put my sock on, and this might have even made me smile as I remembered Samuel Beckett's line, "I can't go on, I must go on," from *The Unnameable*, a novel Danijela and I laughed about. Maybe I would have cried with the music, but I *might have* also smiled like Elio. I am sure my breathing would have sped up and then slowed down, like Héloïse's. I would have connected my pain to love. I would have experienced that few minutes more like a movie where all the energy is intentionally directed. And I would have experienced that few minutes in relation to the truth of my heart's power.

As Danijela said, "When we connect with art on a profound level it can transform us in the same way that human relationships can." *Call Me By Your Name* and *Portrait of a Lady on Fire* mattered to me when Danijela was alive, but they mean even more now she has died. Like the people I love, they have become greater to me with time. Cinema will never be death to me: it helps me stay alive.

Notes

Introduction

1. Pema Chödrön, *The Places That Scare You: A Guide to Fearlessness in Difficult Times* (Boulder, CO: Shambhala, 2001), 18.
2. Daniel Frampton, *Filmosophy: A Manifesto for a Radically New Way of Understanding Cinema* (London: Wallflower Press, 2006), 3.
3. Brené Brown, *Braving the Wilderness: The Quest for True Belonging and the Courage to Stand Alone* (New York: Random House, 2019), 55.
4. *Lion* tells the true story of a little Indian boy named Sheru ("Lion") who mispronounces his own name as "Saroo" and the place where he came from (*Ganash Talai*), both of which become critically significant as he gets lost and cannot correctly tell authorities how to help him back home. The film shows him adopted by an Australian family and separated from his mother for decades before eventually locating his birthplace twenty-five years later using Google Earth. The film reminded me and my class of the extent we needed technology to stay in touch and feel part of the same world.
5. This is already well-documented, and was widely acknowledged within weeks of the pandemic outbreak in America. For instance, in their article about ethnic and racial disparities in COVID-19–related deaths, *Sanni Yaya* et al. summarize their findings as follows: "COVID-19 has further exposed the strong association between race, ethnicity, culture, socioeconomic status and health outcomes and illuminated monumental ethnoracialised differences reflecting the 'color of disease.'" Sanni Yaya, Helena Yeboah, Carlo Handy Charles, Akaninyene Out, and Ronald Labonte, "Ethnic and Racial Disparities in COVID-19–Related Deaths: Counting the Trees, Hiding the Forest," *BMJ Global Health*, June 7, 2020. https://gh.bmj.com/content/5/6/e002913.full.
6. Brown, *Braving the Wilderness*, 44.
7. Danijela Kulezic-Wilson, *Sound Design is the New Score: Theory, Aesthetics, and Erotics of the Integrated Soundtrack* (New York: Oxford University Press, 2020), 124.
8. Ann-Marie Dunbar, "Between Universalizing and Othering: Developing and Ethics of Reading in the Multicultural American Literature Classroom," *CEA Forum* (*College English Association journal*) 42, no. 1 (2013): 26–48 (26).
9. Ibid., 28.
10. Christian Metz, *Film Language: A Semiotics of the Cinema* (Chicago: University of Chicago Press, 1974), 10.
11. Many journalists have used the fire metaphor in relation to the 2020 Black Lives Matter movement especially. For a broader historical context, see Elizabeth Hinton, *America on Fire: The Untold History of Police Violence and Black Rebellion since the 1960s* (New York: Liveright, 2021).

12. Donovan O. Schaefer, *The Evolution of Affect Theory: The Humanities, the Sciences, and the Study of Power* (Cambridge: Cambridge University Press, 2019), 1.
13. Ernst van Alphen and Tomáš Jirsa, "Introduction: Mapping Affective Operations," in *How to Do Things with Affects: Affective Triggers in Aesthetic Forms and Cultural Practices*, ed. Ernst van Alphen and Tomáš Jirsa (Leiden: Brill Rodopi, 2019), 1.
14. Eugenie Brinkema, *The Forms of the Affects* (Durham, NC: Duke University Press, 2014), 34.
15. Ibid.
16. Ibid., 100.
17. Ibid., 106, 102, 104, 105.
18. Ibid., 109.
19. I have previously analyzed *Funny Games* in *Hearing Haneke: The Sound Tracks of a Radical Auteur* (Oxford: Oxford University Press, 2017), 41–64), but were I to reapproach the film in this book, I would be writing from a place that is more openly and unabashedly personal. Since my relationship with the film has deepened over the last several years, I would want to do that justice.
20. Eagan, Daniel. "Through a Child's Eyes: Kore-eda's *Nobody Knows* Tells Poignant Story of Abandoned Family," *Film Journal International* 108, no. 2 (2005), http://fj.webedia.us/kore-eda-hirokazu.
21. Robyn R. Warhol, *Having a Good Cry: Effeminate Feelings and Pop-Culture Forms* (Columbus: Ohio State University Press, 2003), 30.
22. Wyatt Moss-Wellington, *Narrative Humanism: Kindness and Complexity in Fiction and Film* (Edinburgh: Edinburgh University Press, 2019), 57.
23. Ibid., 56.
24. Warhol, *Having a Good Cry*, 57.
25. Florian Cova, Julien Deonna, and David Sander, "'That's Deep!': The Role of Being Moved and Feelings of Profundity in the Appreciation of Serious Narratives," in *The Palgrave Handbook of Affect Studies and Textual Criticism*, ed. Donald R. Wehrs and Thomas Blake (Cham: Palgrave Macmillan, 2017), 347–369 (349).
26. Ibid., 355.
27. Mulvey's book came out in 2006, but she continues to present the material to new audiences, and the influence of it remains strong. For example, she presented material from the book at NUI Galway, Ireland in April 2019, at a public lecture for the "Irish Screen Studies Seminar" preceding a screening of the film she made in 1977 with Peter Wollen: *Riddles of the Sphinx* (https://www.nuigalway.ie/filmschool/news/proflaura-mulvey-public-lecture-.html). Mulvey's presentation included detailed discussion of the beach scene from *Imitation of Life*, which I discuss further in the next chapter of this book. Laura Mulvey, *Death 24x a Second* (London: Reaktion Books, 2006).
28. Mulvey, *Death 24x a Second*, 15.
29. Ibid., 59. Mulvey draws heavily on the poignancy of Roland Barthes's writing about the photographic image of his dead mother in *Camera Lucida* (New York: Hill and Wang, 2010). While fixating on this photograph, Barthes wills his connection to the past that is irretrievably lost, which forces him to meditate on the gap between the photographed instant and himself in the moment (65).

30. Ibid., 18.
31. Ibid., 21.
32. Ibid., 22.
33. Ibid., 26.
34. Ibid., 66. Here, Mulvey references how she perceives André Bazin and Barthes also understood the still photograph. For a fuller explanation of this, see Mulvey, *Death 24x a Second*, 58–59.
35. Ibid., 27–28.
36. Ibid., 171.
37. Ibid., 83 (my emphasis).
38. Ibid., 79.
39. Ibid., 74.
40. Ibid., 70.
41. Ibid., 121, 81, 79.
42. Mulvey's fixation on death in cinema draws on a robust tradition of psychoanalysis and film theory that stretches back to Freud's well-known writings on the death-drive. She is also deeply influenced by entire writings on the still photograph by Bazin and Barthes. See Bazin's "The Ontology of the Photgraphic Image," in *What Is Cinema?*, ed. and trans. Hugh Gray (Berkeley: University of California Press, 1967), vol. I, and Barthes's *Camera Lucida*. Ironically, her own poetically moving responses to a range of films including *Journey to Italy/Viaggio in Italia* (1953), *Psycho* (1960), and *A Taste of Cherry* (1997) bring their details of representing mortality to new life.
43. Mulvey, *Death 24x a Second*, 196.
44. Here and elsewhere, I distinguish between soundtrack (as music only) and sound tracks (as *all* aural components of cinema, including music, speech, sound effects, and silences).
45. Smith analyzes the impact of sellable movie themes that maintain considerable cultural value even decades after their respective film releases: examples ran the gamut from Max Steiner's "Tara" theme from *Gone with the Wind* (1939) to John Barry's theme for *Goldfinger* (1964). See Jeff Smith, *The Sounds of Commerce* (New York: Columbia University Press, 1998).
46. Chattah explores the impact of musical properties like rhythm, pitch, and dissonance, and harmonic logic that work upon our brain activity, especially through "phenomenological" scores that kinesthetically correlate with visual action (12). See Juan Chattah, *Embodied Cognition and Cinema*, ed. Maarten Coegnarts and Peter Kravanja (Leuven, Belgium: Leuven University Press, 2015), 81–112.
47. Sophie Sabbage, "What Are Lifeshocks and What Can We Do With Them?," *The Irish Times*, June 28, 2018, https://www.irishtimes.com/culture/books/what-are-lifeshocks-and-what-can-we-do-with-them-1.3545670.
48. Sophie Sabbage, *Lifeshocks: And How to Love Them* (London: Coronet, 2018), 176.
49. Sabbage, "What Are Lifeshocks."
50. Ibid.
51. Sabbage, *Lifeshocks*, 218.
52. Ibid., 221.

53. Ibid., 363.
54. Ibid., 32.
55. Shirley Li, "When a Lie Becomes Your Breakout Film," *The Atlantic*, July 14, 2019, https://www.theatlantic.com/entertainment/archive/2019/07/lulu-wang-director-farewell-welcomes-your-tears/593806/.
56. Ibid.
57. "Symbolism of Colors, Associations of The Five Elements in Chinese Beliefs and Feng Shui," *The Nations Online Project*, ed. Klaus Kästle, 2015, https://www.nationsonline.org/oneworld/Chinese_Customs/colours.htm.
58. Simon Lei, "Why Is Blue Color Inauspicious in Chinese Culture?," *IFTM News Portal*, June 4, 2019, https://www2.ift.edu.mo/NewsPortal/why-is-blue-colour-inauspicious-in-chinese-culture/.
59. Li quotes a producer of *The Farewell*, Daniele Melia, who says that this kind of sharing has happened "at every single screening I've been to," because Wang has "created something that is touching people in such a universal way, [although] the story she's telling is as personal a story as any filmmaker has ever told."
60. National Qigong Association, "What Is Qigong?," https://www.nqa.org/what-is-qigong- (accessed July 11, 2023).
61. Wang breaks down the scene in "How 'The Farewell' Makes Exercise Fun and Bittersweet: Anatomy of a Scene," *New York Times*, August 30, 2019, https://www.youtube.com/watch?v=_W72YGX-PV0.
62. This flock of birds recalls other scenes in the film: a small bird suddenly appears in Billi's New York apartment, and another in her hotel room in China. Their presences seem less literal than symbolic since there is no evident point of entry on either occasion. Wang explains that these birds symbolize the magical, spiritual, and energetic connection between Billi's two countries, but only if the perceiver can allow for that possibility. Sharon Knolle, "What Do the Birds in 'The Farewell' Mean?," *Moviepaws*, January 10, 2020, https://moviepaws.com/2020/01/10/what-do-the-birds-in-the-farewell-mean/.
63. Frampton, *Filmosophy*, 7–8, 47.
64. Sabbage, *Lifeshocks*, 57. Perhaps Sabbage deliberately echoes lyrics from Leonard Cohen's "Anthem": "There is a crack, a crack in everything/That's how the light gets in." But her reference to "tissues" is important given her body's particular vulnerability while living with cancer.

Chapter 1

1. This quotation comes from Cobb's article tellingly titled "An American Spring of Reckoning," *The New Yorker*, June 14, 2020, https://www.newyorker.com/magazine/2020/06/22/an-american-spring-of-reckoning.
2. This quotation comes from one of Sarah Ahmed's landmark books that brings serious scholarly weight to the study of personally loaded responses to political events: *The Cultural Politics of Emotion* (Edinburgh: Edinburgh University Press, 2014), 200.

3. For the figures to support this claim, see Larry Buchanan, "Black Lives Matter May Be the Largest Movement in U.S. History," *New York Times*, July 3, 2020, https://www.nytimes.com/interactive/2020/07/03/us/george-floyd-protests-crowd-size.html?action=click&module=Top%20Stories&pgtype=Homepage.
4. Eric Levenson, "Former Officer Knelt on George Floyd for 9 Minutes and 29 Seconds—Not the Infamous 8:46," CNN, March 29, 2021, https://www.cnn.com/2021/03/29/us/george-floyd-timing-929-846/index.html.
5. Mark Morales, David Shortell, and Holly Yan, "Chants of 'I Can't Breathe' Erupt as the Officer in the Eric Garner Case Won't Face Federal Charges," CNN, July 17, 2019, https://www.cnn.com/2019/07/17/us/eric-garner-no-federal-charges-against-officer-reaction/index.html.
6. Eliot C. McLaughlin, "Three Videos Piece Together the Final Moments of George Floyd's Life," CNN, June 23, 2020, https://www.cnn.com/2020/06/01/us/george-floyd-three-videos-minneapolis/index.html.
7. To view the complete video footage by Christian Cooper, along with a commentary, see Vera Amir and Laura Ly, "White Woman Who Called Police on a Black Man Bird-Watching in Central Park Has Been Fired," CNN, May 26, 2020, https://www.cnn.com/2020/05/26/us/central-park-video-dog-video-African-American-trnd/index.html.
8. Kory Grow, "Riot on the Set: How Public Enemy Crafted the Anthem "Fight the Power," *Rolling Stone*, June 30, 2014, https://www.rollingstone.com/movies/movie-news/riot-on-the-set-how-public-enemy-crafted-the-anthem-fight-the-power-244152/.
9. Many journalists have used the fire metaphor in relation to the 2020 Black Lives Matter movement especially. For a broader historical context, see Elizabeth Hinton, *America on Fire: The Untold History of Police Violence and Black Rebellion since the 1960s* (New York: Liveright, 2021).
10. Filmmaker and political activist Michael Moore has called the video of Floyd's death by a sixteen-year-old girl, Darnella Frazier, "the most important nonfiction film maybe in years" because it is a major catalyst for the new BLM movement. See Moore's interview with *Late Night* host Seth Myers on June 11, 2020, at https://www.youtube.com/watch?v=hrighXDb98k.
11. For more on this, see Alisha Ebrahimji, Artemis Moshtaghian, and Lauren M. Johnson, "Confederate Statues Are Coming Down Following George Floyd's Death: Here's What We Know," CNN, July 1, 2020, https://www.cnn.com/2020/06/09/us/confederate-statues-removed-george-floyd-trnd/index.html.
12. Sean Davis Watkins calls attention to this weird audiovisual disjunct in these terms. See "The Turning Point of Who Shall Be Master: *Killer of Sheep*, Naming, Gender, and the Gaze of African American Women," MA thesis, Kennesaw State University, 2016.
13. For more on the significance of this slap, see TreaAndrea M. Russworm, *Blackness Is Burning: Civil Rights, Popular Culture, and the Problem of Recognition* (Detroit: Wayne State University Press, 2016), 71.
14. Here are just a few representative examples. James Naremore analyzes *Killer of Sheep*, claiming that music is "as important as imagery" (25) throughout the film, but he provides just three paragraphs of focused discussion of music in a 22-page analysis of

it (24–46). See *Charles Burnett: A Cinema of Symbolic Logic* (Berkeley: University of California Press, 2017), 24–46. An annotated screenplay of *Odds Against Tomorrow* that is 189 pages of analytical articles includes 14 pages of "musical commentary" that is dominated by biographical information and background on John Lewis's jazz style, with only one page of character-based analysis of the two potent songs in the film (the blues song "Johnny's Lament" for the main character, Ingram (Harry Belefonte), and a "swinging blues" song for Annie (Ma Barnes) titled "All Men are Evil"). Moreover, this special edition contains no consideration of the film's vocal performances, sounds, or subversive silences. See Abraham Polonsky, *Odds Against Tomorrow: The Critical Edition* (Northridge: California State University, 1999). TreaAndrea M. Russworm discusses *The Defiant Ones* as a key humanist text in *Blackness Is Burning* (37–41), with emphasis on its narrative and genre-driven form, but there is plenty of scope for examining the film's sonic significance further: Russworm does not consider the song Poitier sings several times, the way he uses his voice as a versatile instrument against his white oppressors, or the relative sparseness of the aural texture that makes every racist thing that his "buddy" (Tony Curtis) says all the more pointed and all the vocal moments of intensity between them more impactful (for example, that moment after the protagonists have a big tussle, when Curtis delivers the line, "I'm gonna kill you" and Poitier flatly responds, "that's right white man: kill me"). Poitier's infamous slap in *In the Heat of the Night* is often mentioned (and stressed by Russman in particular, 69–71) but the material impact of its sound is not. The *strength* of that Foley noise, especially with no music to soften it, is worth more consideration. *In the Heat of the Night* features a range of other deeply significant sonic components that deserve more discussion too, including: Poitier's extraordinarily controlled vocal performance in relation to the original music by Quincy Jones that frequently enters the sound track when his character cannot speak, Ray Charles's overtly emotive theme song ("In the Heat of the Night") that represents his trademark extremities of vibrato, range, dynamics, and falsetto phrases, and the poetically wrenching lyrics of the theme song, such as "So hard to keep control/Well I could sell my soul for just a little light." Moving beyond such examples, the dominant canon of soundtracks includes very few that revolve around racial politics or that are by composers/performers of color. For an illustrative example, see Roger Hickman's *Reel Music: Exploring 100 Years of Film Music*, 2nd ed. (New York: Norton, 2017). In this book of over 550 pages, there is but one section of three pages devoted to the "African American experience" (443–445).

15. Coogler makes these claims in Midge Costin's documentary *Making Waves: The Art of Cinematic Sound* (2019).
16. Laura Mulvey, *Death 24× a Second* (London: Reaktion Books, 2006), 151–158.
17. The only other sustained diegetic music is Sarah-Jane's obviously dubbed performance at a seedy night club. This dubbing works as a metacinematic commentary on the character fighting against herself, through her performing as and passing for a *white* object of desire for the pleasure of the men. Conversely, here, we recognize that Jackson's voice is her own, belonging to the mouth we see. This signifies her status as a comparatively unified being (even if we can discern that the recording was added postproduction).

18. I borrow the phrase "armchair conquistador" from Stam and Spence. Robert Stam and Louise Spence, "Colonialism, Racism, and Representation: An Introduction," in *Film Theory and Criticism*, ed. Leo Braudy and Marshall Cohen, 6th ed. (New York: Oxford University Press, 2004), 877–891 (880). Originally published in *Screen* 24, no. 2 (1983): 2–20.
19. In "Visual Pleasure and Narrative Cinema" Mulvey famously writes about those sequences when a female character "freeze[s] the flow of action" by performing for the protagonist *and*, by proxy, us (841). Laura Mulvey, "Visual Pleasure and Narrative Cinema," in *Film Theory and Criticism*, ed. Leo Braudy and Marshall Cohen, 837–848. 6th ed. (New York: Oxford University Press, 2004). Originally published in *Screen* 16 (3): 6–18.
20. I deliberately use the phrase "rescue action" to quote the Dogme '95 manifesto (http://www.dogme95.dk/dogma-95/). While the Dogme '95 group of filmmakers' aim to reinvigorate cinema by challenging all formulaic and insidiously consumable forms of it has had a relatively limited audience, the vitality of their commitment to redefining cinema parallels the boldness with which Lee refuses to compromise on making his audience awake to the truth as he sees it.
21. Ron Stallworth, *BlackkKlansmen: A Memoir* (New York: Flatiron Books, 2018), 1.
22. Ibid., 175.
23. Ibid., 177–178.
24. See "John David Washington talks *BlacKkKlansman*, HBO's *Ballers*, and family," *Hot Topics* (interview with Heather Catlin), August 9, 2018, https://www.youtube.com/watch?v=uQlqvv18Eks.
25. These conversations happened twice a week for a period of months in 1979, as documented in Stallworth's memoir upon which the film is based.
26. Washington explains this in his interview with Simms and Lefkoe for the *Bleacher Report*, August 8, 2018, https://www.youtube.com/watch?v=E1Odcf2F4yw.
27. Ibid.
28. Lee is well known for incorporating "the N word" with great care, partly in relation to his public debate with Quentin Tarantino on using it mindfully. Where Tarantino argues for stripping the word of its volatile power, Lee takes exception to how much Tarantino uses the word as an affectation without enough evident care for its historical impact, especially on African American audiences. For more on the history of this public argument, see: Army Archerd, "Lee Has Choice Words for Tarantino," *Variety*, December 16, 1997, https://variety.com/1997/voices/columns/lee-has-choice-words-for-tarantino-111779698/; and Rich Juzwiak, "The Complete History of Quentin Tarantino Saying 'Nigger,'" *Gawker*, December 21, 2015, https://gawker.com/the-complete-history-of-quentin-tarantino-saying-nigge-1748731193.
29. This musical blending is explained by Jonathan Broxton, "*BlackkKlansmen*: Terence Blanchard," *Movie Music UK*, August 28, 2018, https://moviemusicuk.us/2018/08/28/BlacKkKlansman-terence-blanchard/.
30. Heather Grace Fisher, "American Traditional Music in Max Steiner's Score for *Gone with the Wind*," MA thesis, Bowling Green State University, 2019, 88.

31. Scott Neuman, "Maryland Repeals State Song That Called Lincoln a 'Tyrant,'" May 20, 2021, https://www.npr.org/2021/05/20/983057655/maryland-repeals-state-song-that-called-lincoln-a-tyrant.

32. Mike Wilson, "Old Folks at Home (Swanee River)," *Music K-8*, 26, no. 3 (2016), https://www.musick8.com/html/current_tune.php?numbering=128&songorder=11.

33. Jennifer Conerly, "A Minstrel's Song Forever Changed the American South by Inspiring Its New Nickname, 'Dixie,'" November 2, 2018, History Collection, https://historycollection.com/a-minstrels-song-forever-changed-the-american-south-by-inspiring-its-new-nickname-dixie/2/.

34. "Dixie, by Daniel Decatur Emmett," Songfacts, LLL, 2022, https://www.songfacts.com/facts/daniel-decatur-emmett/dixie.

35. Wayne Bledsoe, "Tennessee Theatre Clears Up Confusion: It Won't Stop Showing *Gone with the Wind*," *Knox News*, September 1, 2007, https://www.knoxnews.com/story/news/2017/08/25/gone-wind-gone-orpheum/601949001/.

36. Lee has a special history with D. W. Griffith's film: he created one of his first shorts after studying *The Birth of a Nation* at New York University. Titled *The Answer* (1980), this short focuses on an African American screenwriter/director making a big budget remake of *The Birth of a Nation*. The film shows the young filmmaker caught off guard when a Klansman shows up in his full white-hooded uniform with contractual papers for him to sign. Through this short, Lee was protesting how Griffiths's film was imposed on him as an exemplary work of art by the "father of cinema" without mention of its racist impact and its being used to recruit Klan members. See Michael Nordine, "Spike Lee's 'Birth of a Nation' Short Almost Got Him Kicked Out of NYU," *IndieWire*, August 14, 2016, https://www.indiewire.com/2016/08/spike-lee-birth-of-a-nation-the-answer-nyu-1201716719/.

37. See Greg Evans, "Alec Baldwin Still Hates Playing Trump on *SNL* But Says Parody Helps Fans 'Manage Their Pain,'" *Deadline*, 6 September, 2019, https://deadline.com/2019/09/alec-baldwin-snl-saturday-night-live-donald-trump-kevin-nealon-interview-1202713730/. For a discussion of some of President Trump's most infamous racist comments (including his referring to African countries as "shithole" nations), see David A. Graham, Adrienne Green, Cullen Murphy, and Parker Richards, "An Oral History of Trump's Bigotry," *The Atlantic*, June 2019, https://www.theatlantic.com/magazine/archive/2019/06/trump-racism-comments/588067/.

38. As K. Austin Collins explains, Copland's "John Henry," is a "symphonic portrait of the 19th-century Black folk hero and steel driver who, the story goes, took American labor capital to task in a one-man race against a steam-powered hammer." Lee's using this music connects the contemporary action of *He Got Game* with an extended Black history of heroism and resilience, affirming the significance of basketball with the grandiosity and renowned "Americanness" of Copland's style. See Austin K. Collins, "20 Years After Its Release, Spike Lee's Basketball Epic *He Got Game* Remains Searing and Essential," *Variety*, May 2, 2018, https://www.vanityfair.com/hollywood/2018/05/he-got-game-20th-anniversary/.)

39. The film also features parallel editing between this Klan initiation screening and a Black Student Union gathering around Jerome Turner (Harry Belafonte) as he tells the tragic story of Jesse Washington's unfounded conviction and murder at the hands of white people on May 15, 1916. Washington was tried and tortured just a year after

the release of *The Birth of a Nation*, and Turner connects the force of the film with the 15,000 people who gathered to gleefully witness Washington's death like it was "the Fourth of July." Fragments of Blanchard's trilogy of cues (*Tale of Two Powers 1, 2,* and *3*) underscore every cut to Turner's somber speaking, in contrast with the sounds of the riotous *Birth of a Nation* screening.

40. Russworm, *Blackness Is Burning*, 10.
41. Ibid.
42. This speech echoes similar lists of racist slurs spoken by several main characters in *Do the Right Thing* to communicate a theme of unfiltered and energetic racism from several ethnic perspectives. In *Do the Right Thing*, these lists are for characters who break the fourth wall. They apparently speak to those they insult *and* confront us directly (albeit virtually) with the impact of their uninterrupted, fast-paced hate speech. For instance, Mookie, an African American, speaks against Italians as follows: "you dago, wop, guinea, garlic-breath, pizza-slinging, spaghetti-bending, Vic Damone, Perry Como, Luciano Pavarotti, solo mio, non-singing motherfucker"; and Pino, an Italian American, speaks against African Americans as follows: "You gold-teeth, gold chain-wearing, fried-chicken and biscuit-eating monkey, ape, baboon, big thigh, fast-running, high-jumping, spear-chucking, 360-degree basketball-dunking, titsoon, spade, mulignan, take your fucking piece of pizza and go the fuck back to Africa."
43. See Dan Reilly, "Terence Blanchard Talks About the Toughness of Scoring BlacKkKlansman," *Vulture*, February 14, 2019, https://www.vulture.com/2019/02/terence-blanchard-on-the-toughness-of-scoring-BlacKkKlansman.html.
44. For more on Blanchard's consistent emphasis on a humanitarian outlook in keeping with Lee's approach, see Mikael Wood, "Why the *BlacKkKlansman* Score Could (and Should) Earn Terence Blanchard His First Oscar Nod," *Los Angeles Times*, January 12, 2019, https://www.latimes.com/entertainment/music/la-et-ms-terence-blanchard-blackkklansman-oscars-20190112-story.html. For more on Blanchard's atypically strong collaboration with Lee, watch "Grammy Winning Composer Terence Blanchard on his Original Score in *BlacKkKlansman*," December 20, 2018, *KTLA 5*, https://www.youtube.com/watch?v=boi36NRQ4oA.
45. Chris O'Falt, "Spike Lee, on Fire: An Exclusive Conversation About Netflix, Domestic Terrorism, and the Brilliance of 'Get Out,'" *IndieWire*, November 13, 2017, https://www.indiewire.com/2018/08/blackkklansman-spike-lee-editor-barry-alexander-brown-charlottesville-david-duke-do-the-right-thing-1201998055/.
46. Anne Thompson, "How Spike Lee, John Singleton, and John Ridley Left Their Marks on the 25th Anniversary of the Los Angeles Riots," Indiewire, April 21, 2017, https://www.indiewire.com/2017/04/spike-lee-rodney-king-la-riots-john-ridley-john-singleton-1201807540/.
47. O'Falt, "Spike Lee, on Fire."

Chapter 2

1. bell hooks, *Teaching to Transgress: Education as the Practice of Freedom* (New York: Routledge, 1994), 185.

2. Mehta is cited by *The Kennedy Center* brief biography for him: https://www.kennedy-center.org/artists/m/ma-mn/zubin-mehta/ (accessed July 6, 2023).
3. Kore-eda is quoted in "With *Shoplifters*, Hirokazu Kore-eda Becomes First Japanese Director to Win Cannes Palme d'Or in 21 Years," *The Japan Times*, May 18, 2020, https://www.japantimes.co.jp/culture/2018/05/20/films/hirokazu-kore-edas-shoplifters-steals-show-win-cannes-palme-dor/.
4. hooks, *Teaching to Transgress*, 84. hooks died while I was writing this book, but I continue to write of her practice in the present tense: this is my salute to her living legacy.
5. hooks, *Teaching to Transgress*, 43.
6. Ibid., 19.
7. Diana Fuss, *Essentially Speaking: Feminism, Nature and Difference* (New York: Routledge, 1989), 117, as cited by hooks, *Teaching to Transgress* (85).
8. hooks, *Teaching to Transgress*, 89.
9. Ibid., 152.
10. Ibid., 150 (emphasis in original).
11. Ibid., 135.
12. Ibid., 84.
13. Ibid., 19.
14. Judith Grant, *Fundamental Feminism: Radical Feminist Theory for the Future*, 2nd ed. (New York: Routledge, 2021), 72.
15. Sara Ahmed, *Living a Feminist Life* (Durham, NC: Duke University Press, 2017), 22.
16. Ibid., 125.
17. Ahmed, *Living a Feminist Life*, 191.
18. Ahmed borrows the term "space invader" from Nirmal Puwar, in referring to diversity work that entails not fitting with predetermined processes (125).
19. Ibid., 9.
20. Ibid., 56.
21. Ibid., 10.
22. For more on how this reality registers linguistically, see Maki Motapanyane and Kit and Dobson, "Interrogating the Language of Diversity in Academe," *Mothers in the Academe* 6, no. 2 (2015): 125–139.
23. Loren Marquez, "Narrating Our Lives: Retelling Mothering and Professional Work in Composition Studies," *Composition Studies* 39, no. 1 (2011): 73–85 (75, my emphasis).
24. Marquez, "Narrating Our Lives," 75.
25. Ibid., 84.
26. Marquez, "Narrating Our Lives," 76–77.
27. Michelle Schlehofer, "Practicing What We Teach? An Autobiographical Reflection on Navigating Academic as a Single Mother," *Journal of Community Psychology* 40, no. 1 (2012): 112–128 (116–117).
28. Marquez, "Narrating Our Lives," 75.
29. Schlehofer, "Practicing What We Teach?" 112.
30. hooks, *Teaching to Transgress*, 205.
31. Karen Lury, *The Child in Film: Tears, Fears and Fairy Tales* (London: I. B. Taurus, 2010); Ian Wojik-Andrews, *Children's Films: History, Ideology, Pedagogy, Theory* (New York: Garland Publishers, 2000).

32. Hannah Devlin summarizes a recent study of mice that verified a surge in oxytocin, the so-called cuddle hormone, after the mice gave birth. This hormone led the mice to respond much more actively to the sounds of babies' crying. Virgin mice that were injected with the hormone responded with similarly new attentiveness to crying babies. For the entire story, see Hannah Devlin, "Mothers More Sensitive to Crying Babies Thanks to Hormone, Study Says," *The Guardian*, April 15, 2015, https://www.theguardian.com/science/2015/apr/15/mothers-more-sensitive-to-crying-babies-thanks-to-hormone-study-says.
33. hooks, *Teaching to Transgress*, 191.
34. hooks's anti-authoritarian approach, and her commitment to personal engagement with her students is echoed by other practitioners who similarly stress listening to their students. In *What the Best College Teachers Do* (Cambridge, MA: Harvard University Press, 2004), for example, Ken Bain stresses the significance of listening to students, along with a balance between students listening to their professor and "reasoning aloud" (100). He advocates for a truly conversational approach, bringing "students inside the subject," both intellectually and emotionally (123). Similarly, in *Small Teaching: Everyday Lessons from the Science of Learning* (Hoboken: Jossey-Bass, 2016), James M. Lang urges teachers to not shy away from engaging emotional responses because "when we feel strong emotions, our attention and cognitive capabilities are heightened" (174). Parallel to hooks, he writes about creating an atmosphere of trust and reciprocity—the professor can fold the students into their own fascination with any text by saying, "let's wonder together" (178). Moreover, since students typically outnumber the professor, their emotional engagement can have "powerful potential" to "boost each other's motivation for learning" (177).
35. hooks, *Teaching to Transgress*, 21.
36. Otto Scharmer, "Otto Scharmer on the Four Levels of Listening," *YouTube*, November 23, 2015, https://www.youtube.com/watch?v=eLfXpRkVZaI.
37. For more on Scharmer's holistic approach to leadership ("linking the intelligences of the head, heart, and hand"), see Scharmer's official website: http://www.ottoscharmer.com (accessed July 6, 2023).
38. These quotations come from my personal email correspondence with Shoch in April 2017. Shoch founded 5 to 1 Consulting Group, which is devoted to training, coaching, and consulting executive leaders and teams through a holistic understanding of how our brains and bodies influence our behaviors. For more information, visit https://5to1consulting.com.
39. Daum builds on Scharmer's teaching in his own instructional video, "7 Principles for Generative listening," April 1, 2017, https://www.youtube.com/watch?v=YTMWbkymiS0.
40. The clip of this musical performance is included in Scharmer's lecture titled "Generative Listening," December 2, 2016, https://www.youtube.com/watch?v=dlAYK6zaKDg. The performance took place on the eve of the 1990 FIFA World Cup Final, and it marks a highlight in Mehta's career. He was conducting the orchestra of Maggio Musicale Fiorentino and the orchestra of Teatro dell'Opera di Roma in a performance of *La tabernera del puerto* (also known as *Romance Marinero*), a zarzuela in three acts

by composer Pablo Sorozábal. The clip Scharmer uses includes Domingo singing the aria "No puede ser."

41. Kore-eda's *Shoplifters* (2016) runs parallel to *Nobody Knows* in the most palpable ways, by dwelling on an ensemble cast living in poverty, though the central family is able to mediate their struggle by becoming small-time crooks and their predicament is represented by Kore-eda with light humor. *Nobody Knows* is a much quieter, more consistently serious exploration of need.

42. In the actual Sugamo child abandonment case, a mother abandoned her several children (by different fathers) for nine months in 1988. The second daughter was killed by one of her sibling's friends. (For more on this case, see Consulate General of Japan at Chicago, "Japan Information Center: Ask Monshiri," 2006, http://www.chicago.us.emb-japan.go.jp/JIC/Weblettr/archfeat.html, accessed July 6, 2023.) Kore-eda's film is restrained by comparison with the violence of the real-life circumstances, which makes it an unusual adaptation of the truth. The film is designed to quietly inspire change rather than shock its audience in a way that might disable them from thinking about the familial and social circumstances of the tragedy. In summarizing his avoidance of melodramatic formulas and his commitment to clear-eyed compassion, Kore-eda says, "I'm not interested in creating heroes, superheroes, or antiheroes . . . I simply want to look at people as they are." See Cleo Cacoulidis, "Talking to Hirokazu Kore-eda: On *Maborosi*, *Nobody Knows*, and Other Pleasures," *Bright Lights Film Journal* 47, January 31, 2005, http://brightlightsfilm.com/talking-to-hirokazu-kore-eda-on-maborosi-nobody-knows-and-other-pleasures/#.Vp1SZzZuJSU.

43. Nicolette Schneiderman, "5 Facts About Child Poverty in Japan," *The Borgen Project*, September 9, 2020, https://borgenproject.org/child-poverty-in-japan/.

44. Justin McCurry, "Japan's Rising Child Poverty Exposes True Cost of Two Decades of Economic Decline," *The Guardian*, January 16, 2017, https://www.theguardian.com/world/2017/jan/17/japans-rising-child-poverty-exposes-truth-behind-two-decades-of-economic-decline.

45. Schneiderman, "5 Facts About Child Poverty in Japan."

46. For more on these concepts—the "point of audition" (the place in time and space from which a sound is heard) and "extension" (the expansion of the diegetic world through sounds that evoke space beyond the cinematic frame), see Michel Chion, *Audio-Vision*, 2nd ed., ed. and trans. Claudia Gorbman (New York: Columbia University Press, 2013), 84–90.

47. In relation to this, an earlier bittersweet scene shows Akira speaking to his younger siblings about Santa Claus, reassuring them of his existence as well as his ability to get gifts for all the children of Japan.

48. This inevitably reminds me of how Akira's mother smuggled his siblings into their apartment in suitcases near the film's beginning, but now that action is a means toward a caring end: Akira transports Yuki's body this way to honor her wishes instead of to hide her existence.

49. The only nondiegetic music with lyrics in *Nobody Knows* comes in the final sequence following Yuki's burial by Akira and Saki at the airport, finishing the thoughts that they cannot voice. As Akira and Saki stand by the mound of Yuki's buried body, and

as we see them returning to the streets of Tokyo to rejoin Kyoko and Shigeru, we hear "houseki" ("The Jewel") by Tate Takako (2.12.36–2.15.56). (Takako also appears in the film in a supporting role as the unnamed mini-market teller, a character who takes unusually kind interest in asking Akira about his mother's return and how he can get help.) She has a clear, young, gender-neutral-sounding singing voice, one that therefore potentially stands for all the children who grieve for Yuki. The lyrics resonate with great poignancy, through phrases like "will the angel even give me a backward glance?," "want to splash around in my heart?," "with eyes wilted as ice," and "I'm growing up."

50. Pamela Robertson Wojcik writes about how the city space *can become thrilling* for the unsupervised child (12), but *Nobody Knows* does not play that out straightforwardly—even when the children have moments of liberation (such as when they visit a public playground), the film places greater emphasis on how they must be careful of being noticed lest their absences from school will be reported. For a fuller discussion of representations of children moving independently within cityscapes, see Pamela Robertson Wojcik, *Fantasies of Neglect: Imagining the Urban Child in American Film and Fiction* (New Brunswick, NJ: Rutgers University Press, 2016).
51. Eagan, Daniel. "Through a Child's Eyes: Kore-eda's *Nobody Knows* Tells Poignant Story of Abandoned Family," *Film Journal International* 108, no. 2 (2005): 20.

Chapter 3

1. Fred Rogers, *A Beautiful Day in the Neighborhood: Neighborly Words of Wisdom from Mr. Rogers* (New York: Penguin Books, 2019), 23.
2. These lyrics comes from the song titled "Triumph of a Heart." Spike Jonze directed the music video for it in 2005, just five years after the release of *Dancer in the Dark*. It blends a plausible *mise-en-scène* with fantasy, through a story focused on a young woman (Björk) running away and returning to her boyfriend who is played by a real cat. She has a night on the town, and happily sings with strangers at a club, but winds up hurt and isolated on an empty road. Her cat boyfriend finds her and drives her home. Then he grows into a human size, and dances with her before they joyfully pose inside an animated heart at the video's close. The visual style is representative of Jonze's style that often externalizes interior life as animals or humorous conceits (for instance, the monsters that externalize Max's troublesome emotions in Jonze's adaptation of *Where the Wild Things Are* [2009]). The video also showcases Björk's surprising ability to embody assertive womanhood along with child-like vulnerability, which ironically parallels her performance in *Dancer in the Dark*. Despite the light-heartedness of this video for "The Triumph of the Heart" in comparison with Björk's tragic presence in *Dancer in the Dark*, the song lyrics still resonate movingly and uncannily with the most uplifting moments of *Dancer in the Dark* when Selma's heart-led music takes over.
3. Doc Childre and Howard Martin, *The HeartMath Solution* (New York: HarperCollins, 1999), 104.

4. Doc Childre is founder of The HeartMath Institute and CEO of the training/consulting firm HeartMath, LLC, while Howard Martin is an executive vice president. The HeartMath Institute was founded in 1991 and its mission is "to help people bring their physical, mental and emotional systems into balanced alignment with their heart's intuitive guidance. This unfolds the path for becoming heart-empowered individuals who choose the way of love, which they demonstrate through compassionate care for the well-being of themselves, others and Planet Earth." The entirety of *The HeartMath Solution* is informed by scientific research about the functions of the heart, dating back to the 1970s, though most of the studies referenced by Childre and Martin were conducted in the 1990s. For more information, visit the official HeartMath website: https://www.HeartMath.org/about-us/; for a listing of numerous HeartMath-based research links, visit https://scholar.google.com/citations?user=frIB6zgAAAAJ&hl=en (both accessed July 19, 2023).
5. Linda Williams, "Film Bodies: Gender, Genre, and Excess," in *Film Genre Reader IV*, ed. Barry Keith Grant (Austin: University of Texas Press, 2012), 159–177.
6. Childre and Martin, *The HeartMath Solution*, 110.
7. Ibid., 10.
8. Ibid., 11.
9. Ibid., 6.
10. Ibid., 145.
11. Ibid., 13 (my emphasis).
12. Ibid., 140.
13. Ibid., 141.
14. Ibid., 33, 36.
15. Ibid., 46.
16. Ibid., 38.
17. Ibid, 33.
18. Ibid., 160.
19. Ibid., 33, 34.
20. Ibid., 161 (emphasis in original).
21. Ibid., xvii, 36.
22. Ibid., 36. Changing heart rhythms can be charted as tangibly and precisely as sound waves too. A shift from emotional disturbance to equilibrium is paralleled by jagged versus regular graphic patterns of heart rate variability. For more information, and to see such graphic representations of heart patterns that shift in relation to changing moods, see Childre and Martin, *The HeartMath Solution*, 37.
23. Ibid., 150, 143.
24. Ibid., 130.
25. Ibid., 50 (my emphasis).
26. Ibid., 192.
27. Ibid., 209.
28. Ibid., 45.
29. Ibid., 65.
30. Ibid., 66.

31. Ibid., 67.
32. For the complete Dogme '95 manifesto, see this official tribute site: http://www.dogme95.dk/the-vow-of-chastity/ (accessed July 19, 2023).
33. Rachel Joseph, "'Only the Last Song If We Let It Be': *Dancer in the Dark*, *The Sound of Music* and Song and Dance as Traumatic Container," *Studies in Musical Theater* 10, no. 1 (2016): 81–92 (85).
34. As Joseph points out, *Dancer in the Dark* self-consciously uses *many* musical precedents as "points of departure" (ibid., 86), including *The Umbrellas of Cherbourg* (1964), a film released in the same year in which *Dancer* is set, and which features Catherine Deneuve, who also plays Selma's best friend, Kathy.
35. Scenes that grow brighter include the factory sequence where Selma sings "Cvalda" before she breaks a machine, the post-murder scene where she sings "Scatterheart" before running away, and the courtroom scene where she sings "In the Musicals" before her conviction. In all these examples, music delays destructive action. This makes the unchanging color palette of the final death chamber scene even more harrowing than it might otherwise be.
36. I adapt Michel Chion's concept of "added value," as he defines it in *Audio-Vision*, 2nd ed., ed. and trans. Claudia Gorbman (New York: Columbia University Press, 2013): "the expressive and informative value with which a sound enriches a given image so as to create the definitive impression, in the immediate or remembered experience one has of it, that this information or expression 'naturally' comes from what is seen and is already contained in the image itself" (5). I think we could usefully reverse this definition for the opening of *Dancer in the Dark*: here, the aural/visual relationship is so tight that the montage looks as if it grows from the music.
37. The hand-held camerawork that dominates *Dancer in the Dark*, and which lends a feeling of near-constant movement and subjectivity to every shot, is the visual equivalent of this embodied-sounding music. Such camerawork is always potentially reminding the audience of the bodies recording the film that is to be absorbed by their bodies in turn.
38. T. S. Eliot, "Little Gidding," from *Four Quartets* (London: Faber & Faber, 1969), 191–198 (197).
39. Childre and Martin, *The HeartMath Solution*, 65.
40. While the action is set in 1964 in Washington State, the film of *The Sound of Music* was released a year later (Joseph, "'Only the Last Song If We Let It Be,'" 86).
41. As Charles Burnnets argues, "in musicals such as *West Side Story* (1961), *Oliver!* (1968), and *The Sound of Music* (1965), to name but a few, musical numbers provide relief from the tense events of their plots, invoking moral legibility and Utopian idealism despite the profusion of tragic events that take place around them." Charles Burnetts, *Improving Passions: Sentimental Aesthetics and American Film* (Edinburgh: Edinburgh University Press, 2017), 148.
42. The feel-bad film is one that imposes great and deliberate discomfort upon the audience. Nikolaj Lübecker explains that such cinema "*creates, then deadlocks, our desire for catharsis.*" Lübecker also overturns the negative connotations of the term "feel-bad" to engage with how many films, including von Trier's *The Idiots* (1998), engage

with the bodies of audiences in order to explore the ethical possibilities of disturbance. Nikolaj Lübecker, *The Feel-Bad Film* (Edinburgh: Edinburgh University Press, 2015), 1 (emphasis in original).
43. Burnetts, *Improving Passions*, 151.
44. Graham Rhys, "Dancer in the Dark," *Senses of Cinema* 11, December 2000, https://www.sensesofcinema.com/2000/current-releases-11/dancer/.
45. Peter Bradshaw, "Dancer in the Dark," *The Guardian*, 14 September 2000, https://www.theguardian.com/film/2000/sep/15/1.
46. Joseph, "'Only the Last Song If We Let It Be,'" 87.
47. Ibid., 89.
48. Jennifer Iverson, "Dancing out of the Dark: How Music Refutes Disability Stereotypes in *Dancer in the Dark*," in *Sounding Off: Theorizing Disability in Music*, ed. Neil Lerner and Joseph N. Straus (New York: Routledge, 2006), 57–74 (73).
49. Davina Quinlivan, *The Place of Breath in Cinema* (Edinburgh: Edinburgh University Press, 2012), 148.
50. Ibid., 152–153.
51. Ibid., 157. Unfortunately, Rogers's entire review is not currently available online, though explored by Quinlivan in some detail.
52. For more on Björk's sustained and increasingly detailed statements on the harassment she endured from von Trier, especially in the wake of the #MeToo movement and the Harvey Weinstein scandal in particular, see Dee Lockett, "Björk Describes 'Paralyzing' Sexual Harassment by Danish Director Following Lars von Trier's Denial," *Vulture*, October 18, 2017, https://www.vulture.com/2017/10/bjrk-details-harassment-by-director-amid-von-triers-denial.html. With regard to the reception of "Selmasongs," see Joshua Klein: "The Most Notable Feature of *Selmasongs* Is How Much It Sounds Like [Björk's] Most Recent Musical Adventures, Regardless of the Album's Intended Cinematic Context," AV Club, March 29, 2002, https://www.avclub.com/bjork-selmasongs-1798193932. *Popmatters* staff also argue that the album provides a level of intrigue quite independently of the film: "The minimalist and enigmatic verses in 'Selmasongs' give listeners a reason to listen to the album over and over to decipher what they could possibly mean"; *Popmatters*, September 19, 2000, https://www.popmatters.com/bjork-selmasongs-2495837714.html.
53. Childre and Martin, *The HeartMath Solution*, 101.

Chapter 4

1. This quotation comes from Sophie Sabbage's TED talk, "How Grief Can Help Us Win When We Lose," (https://www.youtube.com/watch?v=ZDuZXSL-0zg), April 8, 2019. Other subsequent, nonpaginated quotations from Sabbage come from the same talk.
2. Paul T. P. Wong and Adrian Tomer, "Beyond Terror and Denial: The Positive Psychology of Death Acceptance," *Death Studies* 35, no. 2 (2011): 99–106 (103).
3. The stages of Kübler-Ross's grief process are listed in this order, and as separate chapters in *On Death and Dying*, providing the foundational framework of her entire book. Wong and Tomer give credit to her "for making death a legitimate topic

for research and medicine." That said, "her sequential stage concept has been widely criticized" since it does not match many people's actual experiences (Wong and Tomer, "Beyond Terror and Denial," 101). See E. Kübler-Ross, *On Death and Dying* (New York: Macmillan, 1969). While Kübler-Ross's original text does allow for persons to experience the stages of grief in nonsequential order, it is still in common currency as a guide to step-by-step recovery. For example, see Daniel Scott, "The Six Stages of Coronavirus Grief," *EdNC*, August 26, 2020, https://www.ednc.org/perspective-the-6-stages-of-coronavirus-grief/.

4. Margaret Stroebe, "The Poetry of Grief: Beyond Scientific Portrayal," *Omega: Journal of Death and Dying* 78, no. 1 (2018): 67–96.
5. Ibid., 86–87.
6. Ibid., 67.
7. Ryan M. Niemiec and Stefan E. Schulenberg, "Understanding Death Attitudes: The Integration of Movies, Positive Psychology, and Meaning Management," *Death Studies* 35 (2011): 387–407 (388).
8. Mary Anne Sedney, "Maintaining Connections in Children's Grief Narratives in Popular Film, " *Journal of Orthopsychiatry* 72, no. 2 (2002): 279–288.
9. Yann Martel, *Beatrice and Virgil* (New York: Spiegel and Grau, 2010), 7.
10. Yann Martel, *Life of Pi* (Orlando: Harcourt, 2001), 132–133.
11. The familiar line from The Book of Common Prayer is "in the midst of life we are in death."
12. Tedeschi and Calhoun explain the concept of "post-traumatic growth" as follows: "For many persons, the struggle with loss and grief can be accompanied by the experience of positive change, that is, posttraumatic growth." Richard G. Tedeschi and Lawrence G. Calhoun, "Beyond the Concept of Recovery: Growth and the Experience of Loss," *Death Studies* 32 (2008): 27–39 (31).
13. Irwin N. Sandler, Sharlene A. Wolchik, and Tim S. Ayers, "Resilience Rather Than Recovery: A Contextual Framework on Adaptation Following Bereavement," *Death Studies* 32, no. 1 (2008): 59–73 (59, my emphasis).
14. Jamison S. Bottomley, Melissa A. Smigelsky, Benjamin W. Bellet, Lauren Flynn, Justin Price, and Robert A. Neimeyer, "Distinguishing the Meaning-Making Processes of Survivors of Suicide Loss: An Expansion of the Meaning of Loss Codebook," *Death Studies* 43, no. 2 (2019): 92–102 (93, my emphasis).
15. Lois Tonkin, "Growing Around Grief: Another Way of Looking at Grief and Recovery," *Bereavement Care* 15, no. 1 (1996): 10.
16. Kathrin Boerner and Jutta Heckhausen, "To Have and Have Not: Adaptive Bereavement By Transforming Mental Ties to the Deceased," *Death Studies* 27, no. 3 (2003): 199–226 (220–221).
17. Williams et al. explain the positive impact of "restorative retelling" in these terms. Joah L. Williams, Madeleine M. Hardt, Evgenia Milman, Alyssa A. Rheingold, and Edward K. Rynearson, "Development and Psychometric Validation of the Dying Imagery Scale-Revised," *Death Studies* 46, no. 5 (2020): 1–10 (1).
18. Juanita Meyer and Hané Fourie, "Exploring a Narrative Approach Through Music as a Pastoral Care Means to Human Flourishing," *Verbum et Ecclesia* 40, no. 1 (2019), https://verbumetecclesia.org.za/index.php/VE/article/view/1919.

19. Neil Field, "Continuing Bonds in Adaptation to Bereavement: Introduction," *Death Studies* 30, no. 8 (2006): 709–714 (710).
20. This is Niemic and Schulenberg's summary of Wong's definition of "meaning-reconstruction" ("Understanding Death Attitudes," 390). For the original context for this and more on Wong's entire theory of meaning management, see Paul T. P. Wong, "Meaning Management Theory and Death Acceptance," in *Existential and Spiritual Issues in Death Attitudes*, ed. Adrian Tomer, Grafton T. Eliason, and Paul T. P. Wong (New York: Psychology Press, 2014), 65–87 (69, my emphasis).
21. This is Field's phrase ("Continuing Bonds in Adaptation to Bereavement," 709). Freud's contention that we must disengage from the dead (as detailed in his essay "Mourning and Melancholia") is explained by Boerner and Heckhausen and as follows: "The underlying idea of this formulation is that people have a limited amount of energy at their disposal. Consequently, only by freeing up bounded energy will the person be able to reinvest in new relationships" ("To Have and Have Not," 201–202).
22. Robert A. Neimeyer, Scott A. Baldwin, and James Gillies, "Continuing Bonds and Reconstructing Meaning: Mitigating Complications in Bereavement," *Death Studies* 30, no. 8 (2006): 715–738.
23. Boerner and Heckhausen, "To Have and Have Not," 221.
24. See Michel's Chion's definition of "added value," in *Audio-Vision*, 2nd ed., ed. and trans. Claudia Gorbman (New York: Columbia University Press, 2013), 21.
25. In citing this range of instruments, I draw from Broxton's useful emphasis on the cultural diversity represented within Danna's score. See Jonathan Broxton, "*Life of Pi*— Mychael Danna," *Movie Music UK*, December 10, 2012, https://moviemusicuk.us/2012/12/10/life-of-pi-mychael-danna/.
26. Ibid.
27. In an interview with Peter F. Ebbinghaus, Robert Kraft (former head of music at Fox Music) explains that the chairman of the studio told him to change Danna's music entirely because it lacked percussive momentum. He negotiated with Kraft to ask Danna to revise his own music, and Danna consequently added a shaker to many cues to communicate a sense of time that made the film "feel faster" overall. Though the change was relatively minimal, the Chairman heard the changed music and concluded it was "so much better." See *Kraftboxenentertainment*, "Beyond the Audio: Robert Kraft on the Music Business Behind *Titanic* and *Life of Pi*," December 20, 2017, http://kraftbox.com/home/2017/12/20/behind-audio-robert-kraft-music-business-behind-titanic-life-pi/.
28. Danna explains his intention to parallel Martel's metaphorical storytelling when he describes the musical representations of Pi's home life and multicultural identity with the very opening lullaby cue. "Mychael Danna Breaks Down His Opening Score in *Life of Pi*," *CBC Music*, October 3, 2017, https://www.youtube.com/watch?v=v3iPIRYSUjA). (https://www.youtube.com/watch?v=v3iPIRYSUjA.
29. Meyer and Fourie, "Exploring a Narrative Approach," 7.
30. Nancee M. Biank and Allison Werner-Lin, "Growing Up with Grief: Revisiting the Death of a Parent Over the Life Course," *Omega* 63, no. 3 (2011): 271–290 (272).
31. Martel, *Life of Pi*, 285 (my emphasis).

32. Danna, "Mychael Danna Breaks Down His Opening Score."
33. Lisa Smartt, *Words at the Threshhold: What We Say as We're Nearing Death* (Novato, CA: New World Library, 2017).
34. For more on the therapeutic power of metaphorical language, especially for bereaved persons processing grief in a group context, see Elizabeth Young, "Metaphors of Grief: Metaphors from a Bereavement Writing Group," *Omega: Journal of Death and Dying* 56, no. 4 (2007–2008): 359–367.
35. I quote Danna's interview with Paul Goldowitz, in *Pop Disciple*, February 1, 2019, https://www.popdisciple.com/interviews/mychael-danna.
36. Sabbage, *Lifeshocks: And How to Love Them* (London: Coronet, 2018), 251.
37. Scott Allen Nollen, *Takeshi Shimura: Chameleon of Japanese Cinema* (Jefferson, NC: McFarland & Company, Inc., 2019), 65.
38. Claudia Gorbman, "Artless Singing," *Music, Sound, and the Moving Image*, 5, no. 2 (2011): 157–171 (158).
39. Ibid., 166.
40. Geoffrey O'Brien, "To the Tune of Mortality: 'The Gondola Song' in *Ikiru*," *Criterion*, August 17, 2021, https://www.criterion.com/current/posts/7501-to-the-tune-of-mortality-the-gondola-song-in-ikiru.
41. Ibid., 168 (my emphasis).
42. Michelle Aaron, *Death and the Moving Image* (Edinburgh: Edinburgh University Press, 2014), 123.
43. Ibid.
44. Aaron provides an extensive study of common "gaps between a 'truth' of death and its cinematic representation," particularly with regard to physical reality (*Death and the Moving Image*, 102). As she explains, too often cinema spares its audiences "the pain or smell of death, the banality of physical, or undignified, decline, [and] the dull ache of mourning" (1). She writes movingly about how often films shy away from or withhold "truths of the body in decline" (2). In *Ikiru*, death is not handled graphically but the film still avoids many of the cinematic clichés that Aaron mentions, such as making death a "glorious sacrifice" or a "bloody retribution" or an "ecstasy of agony" (1). Instead, *Ikiru* represents death as the commonplace event that it is, although Watanabe's terminal illness prompts him to do something remarkable.
45. After the fallout of Nagasaki, many Japanese were literally ingesting nuclear toxins. Prince therefore reads Watanabe's cancer as the "sign of social dysfunction" and "the war's lingering results in Japan." The rate of mortality due to stomach cancer remains high in Japan compared with other industrialized countries, largely due to everyday nutritional and other lifestyle choices, though it has been declining in recent decades. For more on this reality, see Truong-Minh Pham, Pham Nguyen Quy, Takahiro Horimatsu, Manabu Nuto, Lorraine Shack, Winson Y. Cheung, Tatsuhiko Kubo, Yoshihisa Fujino, and Shinya Matsuda, "Premature Mortality Due to Stomach Cancer in Japan: A Nationwide Analysis from 1980 to 2015," *Annals of Epidemiology* 47 (2020): 19–24.
46. Francis G. Lu and Gertrude Heming, "The Effect of the Film *Ikiru* on Death Anxiety and Attitudes Toward Death," *Journal of Transpersonal Psychology* 19, no. 2 (1987): 151–159 (151).

47. Ibid., 157.
48. Ibid., 157.
49. Niemic and Schulenberg, "Understanding Death Attitudes," 395.
50. Ibid., 396.
51. Chion, *Audio-Vision*, 80.
52. Ibid.
53. Hayasaka's opening music for the film starts with a similarly delicate iteration of "Gondola no Uta" after a fanfare for the Toho Co., Ltd., led by woodwind and then strings with harp. However, this iteration is musically interrupted by a melodramatic, brass-heavy passage that meanders away from melody and ends on a sour note before the film begins (0.00–2.25).
54. See, for example, Aryeh Kaufman, "A Study of Kurosawa's *Ikiru*," *Offscreen* 13, no. 4 (2009), https://offscreen.com/view/ikiru_part_1.
55. Here, I quote the voiceover from *Ikiru* again.
56. Dennis Klass, "Grief, Consolations, and Religions: A Conceptual Framework," *Omega* 69, no. 1 (2014): 1–18.
57. Joey Nolfi, "Lady Gaga Breaks Music Record as *A Star Is Born* Soundtrack Debuts at No. 1," *Entertainment Weekly*, October 14, 2018, https://ew.com/music/2018/10/14/a-star-is-born-soundtrack-sales-lady-gaga/.
58. Hannah Malach, "*A Star is Born* Soundtrack is Certified Double Plantium in U.S.," *Billboard*, June 25, 2019, https://www.billboard.com/articles/news/8517526/a-star-is-born-soundtrack-certified-double-platinum-us. As a nice piece of historical symmetry, the soundtrack for the 1977 version of the film (starring Barbra Streisand and Kris Kristofferson) also hit number 1, and was the top album for six weeks from February 12 to March 19, 1977. (Yohana Desta, "*A Star Is Born* Soundtrack Catapults to No. 1 on the Billboard 100," *Vanity Fair*, October 15, 2018, https://www.vanityfair.com/hollywood/2018/10/a-star-is-born-soundtrack-no-1-billboard.
59. Catherine H. Stein, Catherine E. Petrowski, Sabina M. Gonzales, Gina M. Mattei, Jessica Hartl Majcher, Maren W. Froemming, Sarah C. Greenberg, Erin B. Dulek, and Matthew F. Benoit, "A Matter of Life and Death: Understanding Continuing Bonds and Post-traumatic Growth When Young Adults Experience the Loss of a Close Friend," *Journal of Child and Family Studies* 27 (2018): 725–738 (726).
60. Ronnie Susan Walker, "After Suicide: Coming Together in Kindness and Support," *Death Studies* 41, no. 10 (2017): 635–638 (636).
61. Here I use the idea of bringing closure in relation to this article: Mark A. Generous and Maureen Keeley, "Wished for and Avoided Conversations with Terminally Ill Individuals During Final Conversations," *Death Studies* 41, no. 3 (2017): 162–172.
62. Ibid., 169.
63. Ibid.
64. Similarly, when Esther (Judy Garland) in *A Star is Born* of 1954 is being groomed for a test screening, she is warned by studio doctors that her "nose is the problem.'" That said, Streisand's atypically prominent nose is *often* the focal point of articles about her image and fame. For example, see Franca Sozanni, "Editor's Blog: The Pride to Be the Only One in Hollywood without a Nose Job (Barbra Striesand)," *Vogue*, April 30, 2012, https://www.vogue.it/en/magazine/editor-s-blog/2012/04/april-30th.

65. Lady Gaga reveals this personal story in the featurette "The Road to Stardom: Making *A Star Is Born*," included on the 2019 Warner Bros. Blu-ray release of the film.
66. Cooper explains this in an interview with Sonia Rao, as quoted by Emily Yahr, "Yes, Bradley Cooper's Voice in *A Star Is Born* was Physically Painful to Create," *Washington Post*, October 5, 2018, https://www.washingtonpost.com/arts-entertainment/2018/10/05/yes-bradley-coopers-voice-star-is-born-was-physically-painful-create/.
67. This quotation from Libatique comes from "The Road to Stardom: Making *A Star Is Born*," 179.
68. Yasmine A. Iliya, "Music Therapy as Grief Therapy for Adults with Mental Illness and Complicated Grief: A Pilot Study," *Death Studies* 39, no. 3 (2015): 173–184 (179–180).
69. Illiya, "Music Therapy," 179–180.

Chapter 5

1. Hugh Prather, *Notes to Myself* (Moab, UT: Real People Press, 1977), 21.
2. David Augsberger, *Caring Enough to Hear and Be Heard* (Scottdale, PA: Herald Press, 1982), 17.
3. As of November 7, 2022, the Center for Disease Control attributes 1,067,160 deaths in America to COVID-19, as recorded on death certificates. This number excludes those deaths in which COVID-19 was a contributing factor. See "COVID-19 Mortality Overview," CDC, https://www.cdc.gov/nchs/covid19/mortality-overview.htm (accessed July 20, 2023).
4. See the invitation at https://www.facebook.com/FilmatSalisburyUniversity/posts/pfbid02Vc7EusdkuK3oEjiPdE3aPfACBnCF3BJWH4MD5gw4TZyEQuSCguD2WDr9FjCenRNEl (accessed August 23, 2023).
5. Jean-François Lyotard, *The Postmodern Condition: A Report on Knowledge*, trans. Geoff Bennington and Brian Massumi (Minneapolis: University of Minnesota Press, 1984).
6. For instance, along with many others, I recognize the danger in an enduring grand narrative that dates back to the Enlightenment of eighteenth-century Europe—the assumption that progress happens because humanity is becoming more advanced, despite the ongoing prejudicial and exclusionist realities of life for many historically marginalized groups. For more on this contestation, see Alison Assiter, "Why Universalism?," *Feminist Dissent* 1 (2016): 35–63 (39).
7. Kimberlé Crenshaw, "Mapping the Margins: Intersectionality, Identity Politics, and Violence against Women of Color." *Stanford Law Review* 43, no. 6 (1991): 1241–1299.
8. Assiter, "Why Universalism?," 35.
9. With this definition, and several others on this list, I quote from a parallel list by Gillies et al. (212–213). In their profound "codebook" of meaningful ways to process grief, they define subjective and feeling concepts like "compassion" in relatively precise and pithy ways. Given the subjectivity involved in everything my survey asks, as well the emotionality of every participant's responses, I find this reference for conceptualizing palpable personal gains very helpful. James Gillies, Robert A. Neimeyer, Evgenia

Milman, "The Meaning of Loss Codebook: Construction of a System for Analyzing Meanings Made in Bereavement," *Death Studies* 38 (2014): 207–216.
10. Ibid., 212.
11. Ibid., 212.
12. Ibid., 212.
13. Ibid., 212.
14. Here and elsewhere, I use two words ("sound track") for all aural components of a film, as opposed to a single word ("soundtrack") that refers to the music of a film only.
15. Spring gives detailed instructions on how to set up and conduct a soundwalk, and I have adapted her article into an assignment for my students to complete in the second week of my "Hearing Cinema" class. Katherine Spring, "Walk This Way: The Pedagogical Value of Soundwalking to the Study of Film Sound," *Music and the Moving Image* 5, no. 2 (2012): 34–42.

Chapter 6

1. The quotation by Danijela Kulezic-Wilson comes from a short film by her son, Adam Wilson, *It Makes Your Forget*, July 27, 2020, https://www.youtube.com/watch?v=HmQ7pzzTlL4&t=909s.
2. Sylvie Droit-Volet and Sandrine Gil, "The Emotional Body and Time Perception," *Philosophical Transactions of the Royal Society* 364 (2009): 1943–1953 (1943).
3. For example, see Jonathan Rosenbaum's wonderful article titled "Is Ozu Slow?," *Senses of Cinema*, March 2000, https://www.sensesofcinema.com/2000/feature-articles/ozu-2/. Rosenbaum provides a strong aesthetic and cultural statement on why Ozu's film have a certain tempo, but without considering what an audience could personally gain from this.
4. For a much fuller exploration of HeartMath, refer back to chapter 4.
5. Doc Childre and Howard Martin, *The HeartMath Solution* (New York: HarperCollins, 1999), 67.
6. Spencer Kornhabor, "The Shadow Over *Call Me By Your Name*," January 3, 2018, *The Atlantic*, https://www.theatlantic.com/entertainment/archive/2018/01/the-shadow-over-call-me-by-your-name/549269/.
7. Digital Editors, "Timothée Chalamet Wore a Hidden Earpiece in 1 Heartbreaking *Call Me By Your Name* Scene," October 3, 2021, *Showbiz Cheatsheet*, https://www.cheatsheet.com/entertainment/timothee-chalamet-wore-hidden-earpiece-in-heartbreaking-call-me-by-your-name-scene.html/.
8. Driot-Volet and Gil, "The Emotional Body," 1949.
9. Christopher Warren-Green, "Vivaldi's "Four Seasons" Poems," *Charlotte Symphony*, December 29, 2017, https://www.charlottesymphony.org/blog/vivaldis-four-seasons-poems/.

Select Bibliography

Aaron, Michelle. *Death and the Moving Image*. Edinburgh: Edinburgh University Press, 2014.

Ahmed, Sara. *Living a Feminist Life*. Durham, NC: Duke University Press, 2017.

Doc Childre, Doc, and Howard Martin. *The Heartmath Solution*. New York: HarperCollins, 1999.

Frampton, Daniel. *Filmosophy: A Manifesto for a Radically New Way of Understanding Cinema*. London: Wallflower Press, 2006.

hooks, bell. *Teaching to Transgress: Education as the Practice of Freedom*. New York: Routledge, 1994.

Kulezic-Wilson, Danijela. *Sound Design is the New Score: Theory, Aesthetics, and Erotics of the Integrated Soundtrack*. New York: Oxford University Press, 2020.

Mulvey, Laura. *Death 24x a Second*. London: Reaktion Books, 2006.

Lu, Francis G., and Gertrude Heming. "The Effect of the Film *Ikiru* on Death Anxiety and Attitudes Toward Death." *Journal of Transpersonal Psychology* 19, no. 2 (1987): 151–159.

Gillies, James, Robert A. Neimeyer, and Evgenia Milman. "The Meaning of Loss Codebook: Construction of a System for Analyzing Meanings Made in Bereavement." *Death Studies* 38, no. 4 (2014): 207–216.

Kübler-Ross, E. *On Death and Dying*. New York: Macmillan, 1969.

Russworm, TreaAndrea M. *Blackness Is Burning: Civil Rights, Popular Culture, and the Problem of Recognition*. Detroit: Wayne State University Press, 2016.

Wong, Paul T. P., and Adrian Tomer. "Beyond Terror and Denial: The Positive Psychology of Death Acceptance." *Death Studies* 35, no. 2 (2011): 99–106.

Sabbage, Sophie. *Lifeshocks: And How to Love Them*. London: Coronet, 2018.

Sophie Sabbage. "What Are Lifeshocks and What Can We Do with Them?" *The Irish Times*, June 28, 2018, https://www.irishtimes.com/culture/books/what-are-lifeshocks-and-what-can-we-do-with-them-1.3545670.

Scharmer, Otto. "Otto Scharmer on the Four Levels of Listening." *YouTube*, November 23, 2015, https://www.youtube.com/watch?v=eLfXpRkVZaI.

Ron Stallworth. *BlackkKlansmen: A Memoir*. New York: Flatiron Books, 2018.

Stam, Robert, and Louise Spence. "Colonialism, Racism, and Representation: An Introduction." In *Film Theory and Criticism*, 6th ed., edited by Leo Braudy and Marshall Cohen, 877–891. New York: Oxford University Press, 2004.

Strobe, Margaret. "The Poetry of Grief: Beyond Scientific Portrayal." *Omega—Journal of Death and Dying* 78, no.1 (2018): 67–96.

Walker, Elsie. *Understanding Sound Tracks Through Film Theory*. New York: Oxford University Press, 2015.

Walker, Elsie. *Hearing Haneke: The Sound Tracks of a Radical Auteur*. New York: Oxford University Press, 2017.

Index

For the benefit of digital users, indexed terms that span two pages (e.g., 52–53) may, on occasion, appear on only one of those pages.

Figures are indicated by *f* following the page number

Adaptation (2002), 172–73
added value, 90–91, 97
Ahmed, Sara, 24, 55–57, 58, 59, 78–79
All That Heavens Allows (1955), 99
Amour (2012), 20–21, 152, 159–60, 161–62, 174–75
Antichrist (2009), 99
Arrival (2016), 149–50, 153–54, 158, 171–72
aural motifs, 2–4, 66–67, 164–65
Australia (2008), 166
Away We Go (2009), 178

Babies (2010), 2–4, 59–60
Baldwin, Alec, 40–41
Baldwin, James, 33–36, 38–39
Bamboozled (2000), 38–39, 149, 168–69
Beasts of the Southern Wild (2012), 156–58
A Beautiful Day in the Neighborhood (2019), 82–86, 183
Beginners (2010), 163–64
The Birth of a Nation (1915), 40–41, 41*f*, 42
Björk, 22–23, 78, 90–91, 96–97, 99–100, 102
Black Lives Matter (BLM), 2–4, 21–23, 24–26, 27–28, 48, 50, 52–53, 142, 146, 148–49, 162, 181
 See also Eric Garner; George Floyd
Black Panther (2018), 29–30, 162
BlacKkKlansman (2018), 7–8, 22–23, 26, 33–34, 35–51
Blanchard, Terence, 22–23, 37–39, 41–50
Blinded by the Light (2019), 156–58
Blow Out (1982), 161–62
Breaking the Waves (1996), 99
Brokeback Mountain (2005), 150, 156–58

Brown, Brené, 1, 4, 5–7
The Bucket List (2007), 109

Call Me By Your Name (2017), 7–9, 22–23, 156–58, 160, 174, 178, 181, 182–86, 187–89
Can You Ever Forgive Me? (2018), 163–64
Carrie (1976), 163–64
Casino Royale (2006), 178
Cat People (1942), 163–64
Chion, Michel, 129–30, 202n.46, 205n.36
 See also added value; extension; internal sound; point of audition; spatiotemporal turntable
Chödrön, Pema, 1, 5
Chungking Express (1994), 159–60
closely miked sounds, 58, 75–76
closely miked voices, 33–34, 39, 72–73, 131
Code Unknown (2000), 60–61
COVID-19 pandemic, 1–4, 25, 27–28, 33, 142, 155, 169, 175, 179–80, 181

Dan in Real Life (2007), 155
Dancer in the Dark (2000), 7–9, 22–23, 52–53, 59, 78–79, 80–82, 84–103, 105, 106, 109–10, 120, 128, 156–59
Danna, Mychael, 22–23, 109–10, 113–17, 118–20
Dead Man (1995), 158–59
The Defiant Ones (1958), 28–29, 195–96n.14
The Departed (2006), 166
Do the Right Thing (1989), 26–27, 30, 148–49, 199n.42
Domingo, Placido, 63–64

entrainment, 22–23, 80, 91, 92–93, 183
Eternal Sunshine of a Spotless Mind (2004), 155–56
extension, 68, 202n.46

Fanny and Alexander (1982), 155
The Farewell (2019), 14–19, 153
Fearless (1993), 109
filmind, 19–20, 30, 67, 72–73, 87–88, 93–94, 115, 125–26
Floyd, George, 24–25, 26, 27–28
Fly Away Home (1996), 109
The Fountain (2006), 109
Frampton, Daniel, 1, 9–10, 19–20, 30, 87–88, 125–26
 See also filmind
freeze-frame technique, 79, 81–86, 87–88, 89–90, 92–93, 96–97, 102–3, 128, 183, 185, 186, 187–89
Frozen II (2019), 178–79

Garner, Eric, 24–25, 26, 27–28
Gattaca (1997), 167
Get On The Bus (1996), 158–59
Get Out (2017), 29–30, 164–65
Godard, Jean-Luc, 10–11
Gone With the Wind (1939), 37–40, 42–45, 46–47, 50–51, 193n.45
Gontiti, 2–4, 22–23, 68–69, 73–74
Good Will Hunting (1997), 173

La haine (1995), 2–4, 149–50
hearing anew, 2–4, 22–23, 27, 37, 39, 58
HeartMath, 22–23, 79–83, 87–88, 102, 128, 180–81, 182–83, 186
 See also entrainment; freeze-frame technique
Heavenly Creatures (1994), 151–52, 156–58
The Homesman (2014), 178–79
hooks, bell, 52–56, 57–60, 78–79, 102

I Am Not Your Negro (2016), 33–36
The Idiots (1998), 205–6n.42
Ikiru (1952), 7–9, 22–23, 106–7, 109–10, 120–34, 135–36, 140–41, 162–63, 181, 187–88
Imitation of Life (1959), 7–9, 22–23, 30–34

In the Heat of the Night (1967), 28–29, 195–96n.14
In the Mood for Love (2000), 153–54, 156–58
Inside Man (2006), 47–48
Inside Out (2015), 107, 178
internal sound (or music), 90–91, 92–93, 98, 100

Jackson, Mahalia, 32
Jackson, Samuel L., 33–36
Jaws (1975), 169

Killer of Sheep (1978), 28–29, 195–96n.14
Kore-eda, Hirokazu, 7–8, 12, 52, 65, 75–76
Kulezic-Wilson, Danijela, 4, 5–7, 12, 108–9, 178, 181

La La Land (2016), 153–54
Lady Bird (2017), 54–55, 163–64
Lady Gaga, 139
Lee, Ang, 120
Lee, Spike, 22–23, 26–27, 33–34, 35–37, 38–39, 41–42, 47–50
Life is Beautiful (1997), 60–61, 164, 175
Life of Pi (2012), 7–8, 22–23, 106–7, 109–20, 123, 135–36, 141
lifeshocks, 13–15, 17–20, 21–23, 30, 35, 45–46, 55–56, 57–58, 60–61, 95, 106–7, 110–11, 123, 126–27, 133–34, 142–43, 147, 152, 153–54, 155, 175, 176, 178, 181, 182–83, 186
Lion (2016), 2–4, 191n.4
listening, 7–8, 20–21, 22–23, 26, 47, 49–51, 52–53, 54, 57–59, 61–65, 66–67, 68, 69–70, 71–72, 73–76, 78–80, 81–83, 92–93, 97, 103, 120, 147, 156–58, 160–61, 162, 171–72, 173, 178–79, 182–83, 184–85, 186, 187–89
A Little Princess (1995), 109

Magnificent Obsession (1954), 99
Magnolia (1999), 152–53
Manchester By the Sea (2016), 160
Mehta, Zubin, 52, 63–65
Melancholia (2011), 99

Minari (2020), 180–81
Moonlight (2016), 165–66, 170, 174
Mulvey, Laura
 and *Death 24x a Second*, 10–13, 19–20, 24, 30–33, 35–36, 84–86, 108–9, 131–33, 144
 and "Visual Pleasure and Narrative Cinema," 197n.19
My Girl (1991), 109

Never Let Me Go (2010), 150–51
No Country for Old Men (2007), 156–58, 167
Nobody Knows (2004), 2–4, 7–9, 22–23, 52–53, 59, 61–62, 64–77, 78–79, 106, 162–63

Odds Against Tomorrow (1959), 28–29, 195–96n.14
Oliver! (1968), 205n.41

The Pajama Game (1957), 34–35
Pan's Labyrinth (2006), 158–59
Parasite (2019), 170–71
parenthood, 5–7, 14–16, 17–19, 21–23, 52–53, 54–59, 61–63, 70, 71–72, 77, 78–79, 95, 111–12, 166
Paris Is Burning (1990), 60–61, 156–58, 175–76
Persona (1966), 168
Peter Pan (1953), 54–55
point of audition, 2–4, 68, 92–93, 184–85, 186, 202n.46
Portrait of a Lady on Fire (2019), 7–9, 22–23, 181, 182–83, 186–89
Prince, 49–50
The Pursuit of Happyness (2006), 60–61

Queen & Slim (2019), 29–30

Rabbit-Proof Fence (2002), 150–51, 152–53, 158–59, 166
Rebecca (1940), 162
The Red Balloon (1956), 153–54, 176, 177f
The Remains of the Day (1993), 172
Romuald et Juliette (1989), 2–4
Room (2015), 60–61, 178–79

Rosemary's Baby (1968), 153–54, 163–64
Rust and Bone (2012), 169–70

Sabbage, Sophie, 13–15, 20, 106, 107–8, 109–11, 120, 123
 See also lifeshocks
Scharmer, Otto, 22–23, 52–53, 61–65, 70
The Searchers (1956), 169–70, 173
Secrets and Lies (1996), 2–4, 19–20
Shine (1996), 59–60
Shutter Island (2010), 156
Sirk, Douglas, 22–23, 30, 31–32, 33, 99
Sorry to Bother You (2018), 160
Soul (2020), 179–80, 181
Sound of Metal (2019), 178–79
The Sound of Music (1965), 91–92, 98–99
sound tracks (all cinematic sound), 7–8, 13, 16, 17, 20–21, 22–23, 28–30, 34–35, 36, 39–40, 52–53, 57–58, 61–62, 64, 65, 70, 78–79, 92–93, 121–22, 133–34, 141, 147, 160–62, 193n.44
soundtracks (music), 2–4, 13, 28–29, 41–42, 45, 47–48, 50, 80–81, 92–93, 114–15, 129–30, 135, 145, 146, 156, 158–59, 161, 164, 178–79, 193n.44
spatiotemporal turntable, 129–30, 135, 139
Stagecoach (1939), 33–34
A Star Is Born (2018), 7–9, 22–23, 106–7, 109–10, 135–41, 153–54, 181
A Streetcar Named Desire (1951), 168

talking back, 22–23, 24, 25, 33–34, 40–41, 43–45, 48–49, 48f
Taxi Driver (1976), 164, 166
Ten Canoes (2006), 59–60
Thelma and Louise (1991), 151–52, 158–59
Three Brothers (2020), 26–28, 30, 35–36
Tokyo Story (1953), 160
Tree of Life (2011), 152–53
The Umbrellas of Cherbourg (1964), 205n.34

Unforgiven (1992), 158–59

The Village (2004), 158–59

218 INDEX

Washington, John David, 22–23, 36–37
Waxman, Franz, 22–23, 31, 32
West Side Story (1961), 205n.41
Whale Rider (2002), 154–55, 171
White Christmas (1954), 88–89, 155–56, 163–64
Whip It (2009), 58
Wings of Desire (1987), 109
Wonder Woman (2017), 178–79